teaching
children
to draw

The Art & Design Series

For beginners, students, and working professionals in both fine and commercial arts, these books offer practical how-to introductions to a variety of areas in contemporary art and design. Each illustrated volume is written by a working artist, a specialist in his or her field, and each concentrates on an individual area—from advertising layout or printmaking to interior design, painting, and cartooning, among others. Each contains information that artists will find useful in the studio, in the classroom, and in the marketplace.

teaching

Marjorie Wilson/Brent Wilson

children
to draw

a guide for teachers & parents

A SPECTRUM BOOK

Prentice-Hall, Inc., Englewood Cliffs, New Jersey 07632

Library of Congress Cataloging in Publication Data

Wilson, Marjorie.
 Teaching children to draw.

 (Art and design series)
 "A Spectrum Book."
 Includes index.
 1. Drawing—Study and teaching (Elementary)
2. Drawing, Psychology of. I. Wilson, Brent.
II. Title. III. Series: Art & design series.
NC630.W5 741.2 82-425
ISBN 0-13-891614-4 AACR2
ISBN 0-13-891606-3 (pbk.)

This Spectrum Book can be made available to businesses
and organizations at a special discount when ordered
in large quantities. For more information, contact:
Prentice-Hall, Inc.; General Book Marketing;
Special Sales Division; Englewood Cliffs, New Jersey 07632

THE ART & DESIGN SERIES

Teaching Children to Draw: A Guide for Teachers & Parents
by Marjorie Wilson/Brent Wilson

ISBN 0-13-891614-4

ISBN 0-13-891606-3 {PBK.}

10 9 8 7 6 5 4 3 2 1

Editorial/production supervision by Alberta Boddy
Interior design by Maria Carella
Page layout by Mary Greey
Manufacturing buyer: Cathie Lenard

PRENTICE-HALL INTERNATIONAL, INC., *London*
PRENTICE-HALL OF AUSTRALIA PTY. LIMITED, *Sydney*
PRENTICE-HALL OF CANADA, LTD., *Toronto*
PRENTICE-HALL OF INDIA PRIVATE LIMITED, *New Delhi*
PRENTICE-HALL OF JAPAN, INC., *Tokyo*
PRENTICE-HALL OF SOUTHEAST ASIA PTE. LTD., *Singapore*
WHITEHALL BOOKS LIMITED, *Wellington, New Zealand*

To: Andy B. and Andy S.,
Anthony, and Becky, and Bobby G.,
David, and Dirk and his Change Bugs,
Jonathan and his Bats,
Holly and Lindsey, and Kelly,
Lana and Leif,
Michael L.,
Oak and Philip,
Sam and Brent R.,
Steven and Michael B.,
Tony and Tami,

and all the rest who allowed us
to share in their
special graphic worlds, and
those who were eager
to draw with us and for us,
and without whom this book
would not have been possible.

Contents

Foreword

This book is for all people who interact with children. It will help parents, teachers, and others understand the critical role of children's drawing as records of their efforts to make sense out of their world. Drawings illustrate children's awareness of the dynamics between things as well as things themselves, of what they feel as well as of what they know. Adults who attend only to what children say or do miss much of what they may be experiencing and learning.

Marjorie and Brent Wilson have provided us with an important, vital perspective on the role of drawing in the development of children living in our media-dominated culture. The book draws on their years of studying children's drawings and children's reactions and processes while drawing. However, this is not a heavy analysis of their research data, but rather a lucid and enchanting report of selected case studies of children with whom they have worked. They clearly illustrate differences among children, as each child's drawing develops.

They illustrate the effects of culture on children's drawing, whether it is the influence of school art traditions or the values transmitted through technologically disseminated symbols and values. They provide examples and suggestions for helping children increase the complexity of their inquiry and differentiation in their drawing.

The Wilsons document their rationale that there is a place for adult intervention or teaching. But it is a teaching that helps children grow out of their own interactions, rather than having to learn through others' models for learning about "reality."

The theoretical positions that underlie their analysis of children's drawings and their suggestions for practice are identified for more advanced students. Notes are provided that relate their work to other theorists and to their own stud-

ies so that the ideas generated in the book can be traced to their sources.

The importance of this book lies in the quality of the years of research that preceded it, and the lucidity with which it is written. This makes it a critical bridge between theory and practice that both theoreticians and practitioners can utilize. But perhaps most important is the very real way in which children and their drawings permeate the pages.

JUNE KING McFEE
University of Oregon

Introduction: spontaneous art & school art

There are two distinct kinds of "child art." The one termed *school art* is generally characterized by large, brilliantly colored tempera paintings of everyday events, or richly elaborated designs of tree, house, and flower, of sun and sky. The subject matter of these drawings and paintings is frequently encouraged by a teacher, parent, or other adult and ranges from depictions of the child's family to such experiences as "brushing my teeth" or "a trip to the supermarket/zoo/farm/park." We are regaled by these works on the walls of schools and shopping centers, and on posters and Christmas seals.

The other, the art that comes from the child's own desire to create, we call *spontaneous art.* This often small, often media-influenced dynamic work is usually done at home or in spare and stolen time in school, on the edges of notebooks or on any available paper, in pencil or ballpoint pen—and often in great quantities. Lamentably, this spontaneous art is often ignored and sometimes not seen at all.

School art is viewed by adults as an important creative and learning activity, whereas the tiny, sometimes raggedy, spontaneous drawings are dismissed by many of the same adults as mere play. School art is seen as educational; it meets adult conceptions of what child art should be. On the other hand, spontaneous art, which is seen as less colorful and less visually compelling, meets few adult expectations.

Yet of the two separate arts of the child, we believe that spontaneous art is by far the more important. It deserves the close attention of adults—of parents and teachers alike. Spontaneous drawing discloses a set of symbols through which the child might present and experiment with personal and developing ideas about himself and about his world—ideas that once recorded on paper, leave a perceivable record.* Incredibly,

*Each chapter in the book features a prototypical child. Odd-numbered chapters use the feminine pronoun; even-numbered chapters, the masculine.

ideas can be seen; they can be reviewed and reexamined by the child and by others as well. Earlier than with written words and more fully than with numbers, with pictures the child can make concrete visual models of his own realities.

Some children seem almost compelled to produce spontaneous drawings in great numbers; others need sensitive encouragement and guidance for even spontaneous drawings. One of the purposes of this book is to elevate spontaneous art to its proper place, to explain its importance to the development of children, to explore the reasons children engage in such drawing activities, to understand what they learn from them, and most of all, because of the importance of doing so, to help adults to encourage children to produce spontaneous drawings.

We believe that spontaneous drawing activity is far too important to ignore. Indeed, it is so important to the child's development that adults should interact with the child in these activities, both verbally and graphically, whenever possible, so that his development may be continually enriched, broad-

ened, and extended. The time has passed when "benign neglect" is acceptable as the primary adult approach to spontaneous art. We will suggest activities and ways to talk to children about their art, ways to draw with them, and the many things to look for in their drawings that most adults have never even imagined.

A second and related purpose is to move the child's school art closer to his spontaneous art. Although it will necessarily remain in the realm of school art, by taking its cues from the more spontaneous work, school art can become richer in drawing and ideas and less self-consciously concerned with media and processes, and thus ultimately of greater benefit to the child's reality-building abilities.

Many of the illustrations in the book are spontaneous drawings that we have collected; others have the look of the spontaneous drawings because the directed activities were inspired by children's spontaneous art activity. Some readers may be surprised at the appearance of these drawings, which are often ideationally richer and more complex than those they may be accustomed to seeing; they gen-

erally contain more parts and more things are happening, partly because many children are inclined to draw in this way and partly because the children with whom we "played" were encouraged to do so.

We might also note that, while the typical school art adheres to a general adult concept of what child art should be, some of the work done by the children in this book may be construed as the embodiment of the authors' concept of what child art should be, as indeed it is.

This book is intended as a guide to the drawing of children from the ages of two to sixteen, for parents and for teachers working with the individual child or with groups of children. What sets this book apart from other books written about children and their art is that it presents a philosophy of interaction, both verbal and visual, between child and adult. It is dedicated to the child and to his drawing, to the periods in the child's life when he draws frequently, and to those fewer but still many children who produce great quantities of drawings from childhood through adulthood.

teaching children to draw

chapter one

Children's drawing activities

Alex is five months old. All of her boundless energy is concentrated on discovering her world, a world that is totally new— surprising, pleasing, interesting, exciting, amusing, and delightful in part, but also startling, frustrating, confusing, frightening, and utterly overwhelming. How will she learn about her world? How will she come to know the nature of the things and the beings about her? For now most of Alex's knowing is derived through the senses, by direct physical action upon or contact with an object—seeing, feeling, smelling, tasting, listening. When Grandpa sets her in his lap while he draws in his sketchbook, Alex grasps the moving pen, and, in doing so,

creates marks of her own. She is unaware that her action is in any way related to the marks on the paper, but the marks themselves become the next object of her interest. She touches the lines on the page, surprised to find that they have no substance. None of her turning and wriggling, none of her creeping or her attempts to sit, to crawl, to touch make a mark; only the movement of the pen leaves a permanent record.

It is only later, in her second year, that Alex will be able to employ symbols in order to gain knowledge about her world, an action that sets the human child above the kitten which, as much intrigued by the baby as she is by it, can only know through his

five senses. When Alex begins to engage in make-believe play, when the teddy bear that is presently bounced on its head and probed and poked and tasted comes to stand for a friend or a child, to be fed and bathed, to be spanked and scolded and kissed, then she will be making use of symbols, not only to act upon, but to create a world or world of her own. By the time Alex is four or five, her spontaneous activity will have become concentrated on a great variety of playful operations—singing, acting, pretending, storytelling, and drawing. Of all of these activities, only the drawing, like the scribbles she helped Grandpa to make, will leave a

3

permanent record of the action she has performed. She will not only recognize the marks made on the page as her own, but she will also be able to make the lines and circles she draws "stand for" a person, a house, a tree. It is largely because, of all the symbolic activities, drawing is the one that leaves this record that it plays a special role in the child's development.

What are the unique functions that drawing will serve for Alex and other children? When and in what manner might she engage in drawing activity? The functions, of course, relate to the exploration of her world that Alex, even now, engages in—exploration that we will pursue further in Chapter 2. Here we will be looking not so much at the drawings of children as the manner in which children engage in the act of drawing and the circumstances under which they choose to do so. Because all children draw to some extent during some period of their lives, it is useful to note the varieties of drawing experiences. We will examine some of the ways in which children choose to undertake drawing activity, the sometimes prodigious amounts of drawings they produce and the places they select in which to produce them.

A little or a lot: days filled with drawing

On almost any day, Steven can be found building complex structures with his Lincoln Logs, or drawing, or constructing objects from cut paper. These are the favorite activities of this handsome, outgoing third-grader, who neither lacks for friends nor misses an opportunity to "throw a football around" with his older brother, Michael.* Given the choice, though, Steven would opt for the building and constructing and the drawing over either friends or football, and faced with the possibility of being denied these pleasures, Steven would "faint."

Unlike most children, Steven engages in his creative activities while watching television. Curiously enough, the constant sound and action on the set never intrudes on Steven's concentration. At times the television and the creative activity exist independent of one another as in a collective monologue[1]; at other times, the television action may trigger the construction of a football field complete with football players and goal posts that are first drawn on a separate piece of paper, then cut out and then taped to the field in the appropriate positions—Steelers and Rams—as the Super Bowl game unfolds simultaneously on the televised field and on Steven's. Or a rock star, complete with sideburns and guitar, appears in conjunction with a movie depicting the life of Elvis Presley (1-1).**

Steven's day begins at home, before school, with creative activity—usually Lincoln Logs at this time—that continues through spare moments at school. Whenever the opportunity presents itself he will draw for his friends and classmates, who will sometimes pay a quarter for the privilege of owning one of his drawings. He once received a quarter for two drawings of Kermit (the Muppet frog) and another for two of Snoopy. Steven continues to draw partly because of the encouragement of his teachers—his second-grade teacher praised a book he had drawn as "the best in the class." There is also the coveted approval of his brother—he thinks Steven's drawing is "really good"—and there is his need for excitement, but primarily it is his own desire to know or to possess things that keeps Steven drawing. (Just as has been said of one of our greatest artists, in order to possess whatever he wanted Picasso could "acquire it by drawing it."[2]) His mother tells of Steven's desire for a particular Christmas present—a sled. When Santa failed to bring one, Steven built one for himself in miniature out of construction paper. And, too, Steven is motivated by the knowledge and satisfaction of doing something well and by the desire to do even better.

His brother, eleven-year-old Michael, is involved with music and sports, but sometimes

*Throughout we have chosen to use the actual names of the children of whom we have written and with whose drawings we have illustrated the book, as we wish them to be known for the individuals they are.

**Numbers in parentheses indicate corresponding illustrations.

FIGURES 1-1 and 1-2
Steven (age 8)
Elvis P. (black ballpoint)
7¾ x 10½"

Michael (age 12)
Rock Singers and Other Characters
(black ballpoint)
7¾ x 10½"

Steven drew at any time and in any place that he could; often it was in front of the television set. He may have received his inspiration for this drawing from a television program and his model from his brother Michael's many studies of the quintessential rock singer.

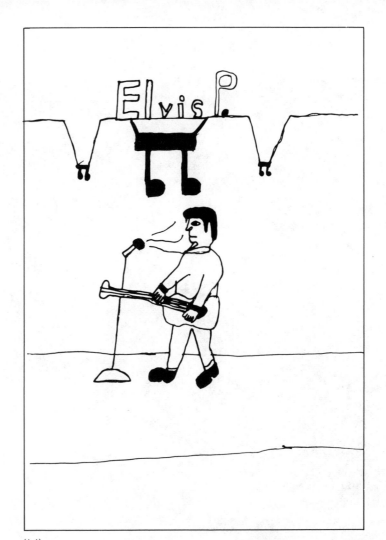

(1-1)

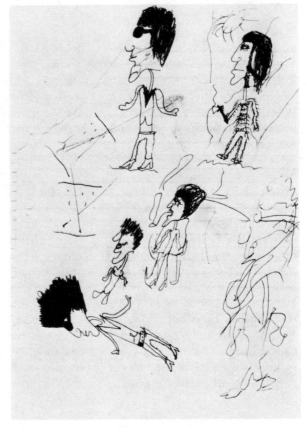

(1-2)

draws in school to keep from being bored. Although he drew quite a bit when he was younger, Michael's activity never reached the degree to which Steven draws. Although both brothers found the suggestion that either might get ideas from the other amusing, Steven's rock star curiously resembles the figures we found drawn repeatedly on the pages of Michael's notebooks (1-2). "Steve started watching me do figures," says Michael; and Steven pipes up, "Yes, I tried to do them and I can." While presently Steven's main preoccupation is with drawing, to Michael drawing is only a small part of his world.

Of all the children we have observed, Kelly[3] is probably the one for whom drawing consumed most working hours, in school as well as out. Like Steven, Kelly had admirers among her friends, but it was not approval that Kelly sought, nor was it an escape from boredom, as it was for Michael. For Kelly drawing served an even more basic need, a need shared with more mature artists—the need

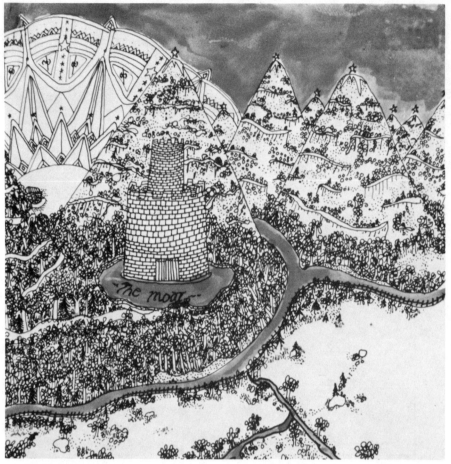

(1-3)

FIGURE 1-3
Kelly (age 14)
The Moat (rapidograph and watercolor)
Kelly learned to use the Rapidograph© pen from her older sister and spent hours alone, meticulously designing beautifully delicate settings where stories were waiting to happen.

FIGURES 1-4 and 1-5
Bobby (age 13)
Goldman (colored pencil and marker)
9 x 12"

Andy (age 7)
Cover for *"The Legend of the Theem and the Red Glob"* (colored marker)
9 x 12"
This visually exciting and exquisitely colored page of Bobby's 16-page *Goldman* adventure helped to spawn Andy's own 50-page *Theem* and a host of further adventures by Andy and some other of his classmates in the second grade.

for definition of her self and her world. At the age of fourteen, Kelly was creating marvelously elegant fairy-tale worlds. Whether they were idealized miniature replicas of her own world or a series of medieval settings, they were delicately, meticulously, and lovingly drawn (1-3). The trees in her drawings are like lace, and exquisite little villages nestle between gentle hills. These drawings and the hundreds more that Kelly produced in the three years that we knew her attest to the hours spent in her most satisfying occupation. Kelly said that she drew things as she did "to have at least some record.... I wanted to get it down so other people could

go there too." But then she added, dejectedly, that "nobody ever saw them or got the same feeling [from them as she did]." We wonder how many other children may be creating absolutely fantastic worlds to which little or no attention is paid.

drawing with others

Some children draw extensively, others very little. We know of children who will literally fight for a surface to draw on; others draw reluctantly even when they have been provided with reams of paper, pencils, and crayons. By describing the intensity of the drawing involvement of a few children, we hope

to convey the idea that the drawing activity of all children is tremendously important to them. And of those children who do not draw to the extent of those we describe, how many would enter the fantastic world of spontaneous drawing if given encouragement? Many, we think!

The encouragement to draw comes at times from adults, parents, or teachers or both, and at other times is derived from involvement with other children. We have often observed the ripple effect of one drawing child on others. Andy B. is a case in point. His older friend Bobby's exciting sixteen-page comic book of the origin of "Goldman" (1-4) became the model for

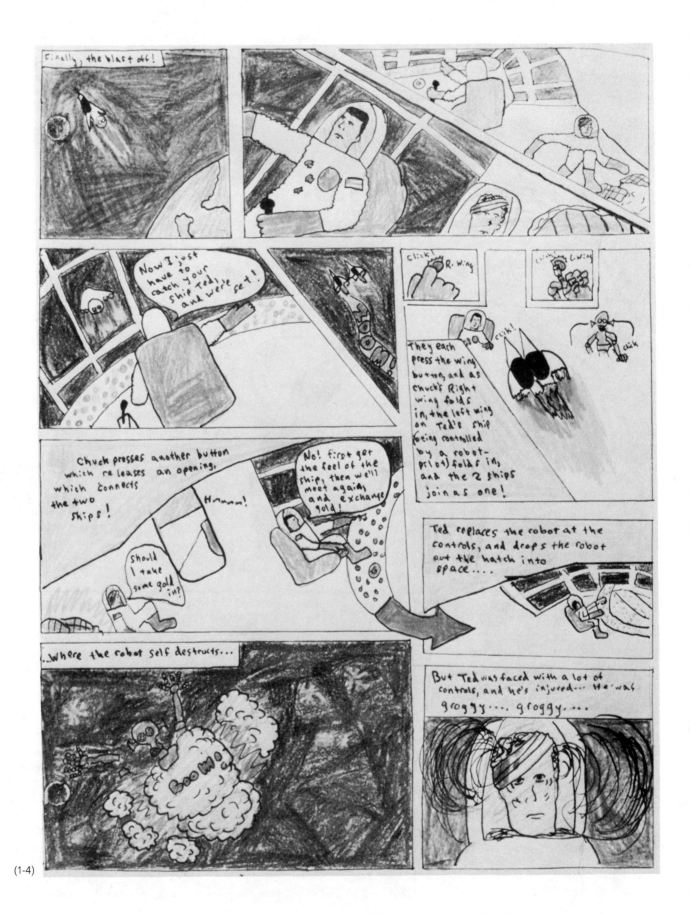

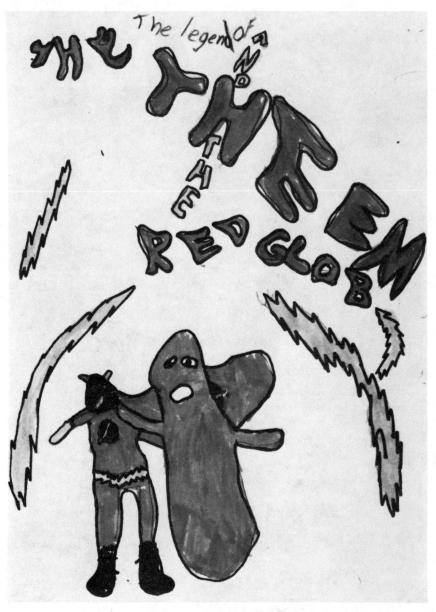

(1-5)

FIGURE 1-5
Andy (age 7)
Cover for *"The Legend of the Theem and the Red Glob"* (colored marker)
9 x 12"

FIGURE 1-6
Michael L. (circa age 7)
Underground World (pencil)
9 x 12"
Michael L.'s "real" world existed in the basement of the house; his imagined worlds, such as this one, existed further down in the bowels of the earth. In these caverns and passageways and underground colonies all sorts of exciting adventures were born.

Andy's own fifty-page saga of "The Legend of the Theem and the Red Glob," (1-5) which, in turn, has served as a model for similar adventures of various strange and exotic creatures drawn by several of Andy's classmates. Occasionally, instead of launching off on undertakings of their own, a group of children will choose to embark upon a joint venture. This was the case of Margie and the boys in the course of a long ago Boston summer.

When the streets became too hot for "King" or "Kick-ball" or even "Hide-and-go-seek," we kids sought the relative coolness of the house and there spent the days orchestrating a production which we named "Wham" comics. We jointly wrote the stories and the dialogue, delighted in seeing our creations come to life under the pencil of one or another of the members of the group. There, as we crowded around the glass-topped dining room table, the "Red Ruby" and "Lightning" and

a myriad of lesser characters were born. Each of us took turns at drawing or writing, often both; someone would be called home for lunch and another "artist" would take over.

Arthur could draw men that looked particularly virile; Freddie's attempts were not quite as handsome but the hero of the stories was drawn by first one and then the other as the excitement of getting the hero out of some peril impelled us to complete the adventure. As the only girl in the group I was assigned all of the heroines. It was even better than our Saturday afternoon forays to the mysterious Oriental Theater where we sat on the edge of those itchy red plush seats, breathlessly waiting to see what would happen next to "Dick Tracy" or "Tom Mix" of the weekly "serials." In our own "serials" we could engineer what would happen and what would happen next and it was ultimately more exciting and more stimulating and more satisfying than anything we could buy for a dime in the corner drugstore.
"Wham" comics was lovingly and carefully transported by me from place to place, from city to city, until years later it somehow sadly

(1-6)

disappeared, but the memory of "Red Ruby," first Arthur's rendition and then Freddie's, fighting the forces of evil, vividly remains along with the ice-cream man's bell and the front porch swing and Frank Sinatra and the Red Sox of that long-ago summer.[4]

spaces & places to draw

Perhaps Steven drew on the living-room coffee table because this location allowed him to be with the rest of the family and to listen to TV while also allowing him to move easily from his Lincoln Log play to constructing and collage activities and to drawing. Other children prefer their privacy and, very much like adult artists, they acquire

and arrange their own private "studios" to suit their individual needs. C. S. Lewis, describes the drawing place that he arranged for himself when he was young:

I soon staked out a claim to one of the attics and made it "my study." Pictures, of my own making or cut from the brightly colored Christmas numbers of magazines, were nailed on the walls. There I kept my pen and inkpot and writing books and paint boxes.[5]

By the age of seven, Michael L., who is now a professional illustrator, was drawing complex underground worlds that were mirrored by the place in which he chose to draw. His drawings depicted "complicated little caverns" into which invad-

ers forced their way down one passageway after another, in order to gain access to underground colonies. Sometimes there appeared whole cities "suspended from cavern ceilings by a huge chain," and battles, and fires and floods, all created in Michael's own private underground work area—a basement area he established "like a little studio, a little apartment, with fish tanks, books, supplies, and my prized possessions." There Michael was able to shift from drawing underground worlds (1-6) to the production of an eighteenth-century kingdom populated with elegant ladies and handsome gentlemen (1-7). The marvelous drawings he made were surely made possible partly because he had a special place to work.

FIGURE 1-7
Michael (circa age 13)
Eighteenth-Century Characters
(india ink and watercolor)
Michael L. says of these and other characters that he created early in his graphic life "[when I found them] in a book ... I had to laugh because that's what I used to do with my time.... They form a fantasy world with great mobility—the possibilities for numerous episodes.... [It is] interesting to see how someone who wants to maximize fantasy time works."

Aunt Bea

onnie bea

(1-7)

Establishing favorable conditions for drawing activities

Spontaneous drawing activities, whether they are performed alone or with others, occur in the lives of some children daily—even hourly—and yet often go virtually unnoticed by parents, teachers, or other adults. But anything that so fills the lives of young children is not without consequence, both in the flavor—the pleasure and the excitement—it provides to children's daily lives and in the effect it has on their acquisition of knowledge, in their learning about the world, themselves, and the future (see the next chapter).

Kelly's production of drawings was as much an in-school as an out-of-school activity. Other children whom we talk to and observe drawing draw in school as well. Nine-year-old Sheila draws in school whenever she gets a chance and when

the "teacher isn't looking." Although Sheila announces, "She hasn't caught me yet," she is quick to add that she is second to highest in the class; so it is clear that her drawing does not interfere with her schoolwork. Ten-year-olds Bobby and Sam also tell of "sneaking" drawing. "The best place to draw is in math," Bobby confided. "Any time you get ahead you just take your math book and put it there [in front of you] and draw." In spite of the prevalent attitudes of teachers described by Sheila and Bobby and Sam toward drawing in school, we think that the spontaneous drawing activities of children are necessary and important and require a more careful examination. It is important, too, that parents and teachers alike understand the purposes and functions of these activities and that children be

encouraged to engage in them.

display

Often, encouragement is as simple a gesture as offering one's approval or the acknowledgment of the existence of spontaneous work by providing a place for display. The refrigerator has become the typical showcase for art work, but for some work perhaps a more dignified spot might be required, such as a separate wall or an honored place in a parent's room. In schools we have seen entire walls and tack boards devoted to this spontaneous work, and we know of more than one previously undiscovered "artist" having surfaced because of the opportunity to exhibit spontaneous drawings (1-8 and 1-9).

FIGURES 1-8 and 1-9
J.C. (age 10)
The Black Canary (black marker)

J.C. (age 10)
Revised version of Superman
(ballpoint and colored crayon)
These drawings of the *Black Canary*
and a thirtieth-century Superman were
signed by the "Phantom Cartoonist"

whose cry to be recognized, "Would
you like to see more?… Write a note",
was answered with a good deal of
enthusiasm when it appeared anony-
mously on a schoolroom tack board.
Invitations by adults such as that
given by J.C.'s teacher to display
works done at home may afford other
aspiring "artists" the opportunity to be
discovered.

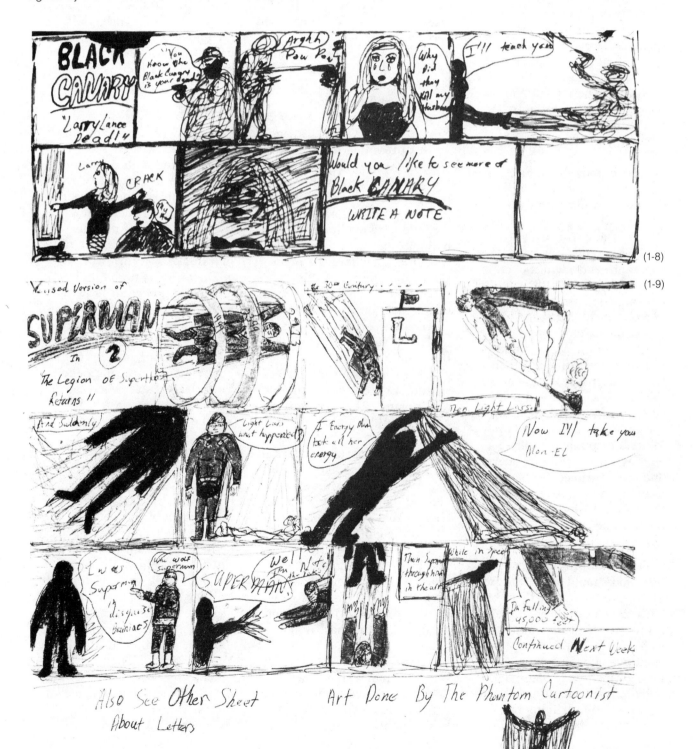

(1-8)

(1-9)

markmakers & surfaces

A grandfather we know recognized his young granddaughter's need to draw and indulged her by providing an unending supply of good drawing paper. Such a supply of paper may be an unnecessary expense, for children who draw will do so on any suitable surface from computer printout sheets to inexpensive newsprint and notebook paper; but certainly making supplies available is another way to encourage drawing activity.

Most of today's children have a supply of paper and pencils, crayons and markers with which to draw both at home and at school. It wasn't always so. One hundred years ago the spontaneous drawings of children were as likely to be found on walls, on fences, in the sand, and on school slates and blackboards as on paper. And as we shall see in Chapter 4, children's drawings were different then from now and at least some of the difference is probably a result of the materials with which the children customarily drew. Materials do make a difference. Here we discuss those materials and their various effects on drawing, and make suggestions for materials that we think ought to be available in every home and classroom.

First of all, the materials provided should allow children to achieve what they themselves wish to achieve through their art activities. If the child wishes to depict the intricacies of the workings of an automobile factory, an inch-wide brush and juicy tempera paint hardly suffice. If a child delights in color and pattern then a ballpoint pen is not a very satisfactory tool.

Consider the case of Nadia, a little British girl who by the age of three and one-half was producing drawings with the look and fluency of an adult artist. Nadia is a very special case—an autistic child who could hardly utter a word but who possessed perhaps the most unusual gift for drawing ever observed and recorded in a child.[6] When Nadia was brought for the first time to a child development clinic for observation, a psychologist, unaware of her drawing ability, presented her with a fat yellow wax crayon. Instead of the exquisite running horses that Nadia was capable of drawing, she produced a formless scribble. Her medium was the ballpoint pen with which she was able to achieve the precision she required. In this experience of Nadia's there may be a lesson for all children. Fat crayons and other inappropriate tools may inhibit drawing more than enhance it.

Then what kinds of materials should children have available for drawing? These general principles should be followed:

• A choice of marking tools and a variety of kinds and sizes of paper should be available. In general, let the child make the choices that suit her best.
• Help the child to make reasonable choices. Generally speaking, broad- and medium-tipped markers and large crayons work best with large pieces of paper (12 x 18 or 18 x 24) because on small paper the marks they make are too coarse and it is not possible to show detail. On the other hand, small pieces of paper (anywhere from 3 x 5 note cards to note pads to 8½ x 11 typing paper) seem to call for the precision of a ballpoint pen, thin-tipped marker, or pencil.

• Occasionally you might encourage children to use different marking tools or different sizes and shapes of paper, but don't be concerned if the child sticks to old favorites. Artists, too, experiment with a variety of media and then sometimes stay with their originally preferred medium for a lifetime.

markmaking tools

We now wish to present our views of the various types of markmaking tools available to children. You may be surprised at our praise of the common pencil and our questioning the widespread use of the wax crayon. We will take each of the markmakers in turn.

The pencil is probably the most common of all drawing tools used by children. We think that it is a good one. Generally, the lead should be soft (#2 or #3 for common pencils, or B or 2B for artists' drawing pencils). Thick-leaded soft pencils such as the A. W. Faber Black Magic #850 and the Dixon Beginners #308 are also excellent drawing tools for children of all ages, especially for scribbles; they smudge a bit, but what beautiful velvety black lines they make! And, of course, with pencils, a pencil sharpener needs to be handy. A blunt pencil is not a satisfactory drawing tool.

Ballpoint pens (including the Rolling Writer ®) are found in nearly every home and are among the most commonly used tools for spontaneous drawings. Yet they are not often used for school art lessons. They could be, as they are a responsive and precise drawing tool. Some of the most gifted and productive

young artists we have studied use ballpoint pens almost exclusively. They work especially well on file cards and typing paper. And remember that ballpoint pens come in lots of colors besides black and blue.

Felt and fiber-tipped markers are a favorite marking tool for children of all ages. They come in a wide range of colors and tip sizes. Our preference is for the fine- and medium-tipped markers. The broad-tipped markers just don't allow for the precision that most children like to get into their drawings. The primary advantage of the markers is the ease with which they make a mark. They require little pressure as they literally glide across paper—especially paper with a slick surface.

When markers begin to dry up, if they can't be revived by letting the tip sit in water for a few minutes they should be thrown away. There is no more frustrating drawing tool than a nearly dry marker.

Wax crayons are sometimes thought to be just about the only appropriate drawing tool for children. We disagree. They have their place but they are far more suited to coloring in than to making lines. For drawing, their broadness and softness make them quite unresponsive and if children spend most of their time "coloring in" they are not getting as much benefit from their drawings as they might.

Wax crayons are fine for scribblers and for younger children who like to work on larger sheets of paper. But if children choose small sheets of paper and are concerned with depicting lots of detail then they should be encouraged to use markers, pens, or pencils.

A special note should be made concerning *rapidograph or other technical pens* which are very popular among older children, who are able to handle them and wish to make precise drawings such as those done by Kelly (1-3). These are generally difficult to work with and clog frequently—recommended for older children only.

papers

Papers for drawing come in a few standard sizes and unfortunately they usually remain that way, when, with the snip of a scissors, or a paper cutter and tape, they could easily become almost any size and shape. And size and shape have a great effect on both the type and quality of children's drawings. As we talk about papers we need to consider three things— their size, shape and kind.

Size. For many years adults, and especially art educators, have believed that children should draw only on large sheets of paper. Blithely unaware of this edict, children draw away on small file cards and sometimes on scraps of paper hardly larger than postage stamps. Perhaps they are trying to tell us something.

The art educator's love for large paper stems from the belief that children's art is expressive and that expressiveness seems to be equated mainly with sweeping motions of the hand and arm. Yes, scribblers do sometimes need space to practice their motions, but children in general also need reasonable boundaries to fit the size of their ideas. It does no more damage to a child's spontaneity and creativity to work small then it does to work large. Children ought to be supplied with paper anywhere from about 3 or 4 inches in size, through the regular larger-sized paper to 6-, 12-, or 24-inch-wide paper on a continuous roll. (Tapes like those from cash registers and white wrapping papers work quite well.) Remember also that if an idea turns out to be too large for the paper on which it is being depicted then tape and some more paper can create a working sheet of almost any size. Some of the drawing dialogues shown in Chapter Eight started out on a single sheet of paper to which five and sometimes even more sheets were added.

Shape. Most papers come in standard shapes—a little longer than they are wide. But sometimes it's nice to draw on a square, a long, skinny rectangle, a circular-shaped paper, or even on highly irregular shapes. Children often adapt their drawings to fit the shape as well as the size of their paper. Papers of a variety of sizes may well lead to ideas and inventions that would be less likely to occur on standard shapes of paper. We suggest that adults cut papers in a variety of shapes and sizes, and that they consult children to learn the shapes and sizes on which they would like to draw.

Although newsprint and typing paper are among the most frequently provided, many other papers have characteristics that make them especially good for drawing. Here we list some of the most commonly available papers. Most are obtainable from variety stores and office and school suppliers as well as art supply stores.

Newsprint and manila papers. The best one can say about these papers is that they are inexpensive. Actually, newsprint is

nice to draw on, while manila has a bit too much tooth or roughness and it soaks up almost everything put to it. Besides that, both papers are most impermanent. If you can afford better paper, do.

Typing paper. White paper from note pads and typing, ditto, and mimeograph paper are reasonably inexpensive and they are responsive to pencil, markers, and ballpoint pens. Many children use the small sheets of notepad paper to make little illustrated books and sequential story drawings. For children's spontaneous drawing we recommend that an ample supply of at least one of these types of paper be available at all times.

White drawing paper. Most white drawing paper, available through school supply houses or in packages and in pads from art and variety stores, is most satisfactory for children's drawing, in fact better than most of the papers that we have mentioned. When we work with children this is what we like to use. We get it in 9 x 12, 12 x 18, 14 x 17, and 18 x 24-inch sizes and then cut it or tape it to the desired size. It works well with all marking tools.

Coated papers. Some papers have a very smooth and shiny surface. Actually the slick surface is a thin coating of "polished clay." Sometimes called finger-paint paper, these papers are excellent for markers, which glide across the surface wonderfully.

We have already mentioned file cards and paper of various widths on rolls. The stiffness of file-card stock makes it especially desirable as a drawing

surface for all kinds of drawing tools. A continuous roll of paper can lead to such things as exciting narrative drawings.

Another word needs to be said about the quality of paper. Artists are often concerned about the grades and types of paper that they use, as they wish their work to be permanent. Children's work, on the other hand, is usually quite "disposable." Drawings are often thrown away within a few days or months of completion. For adults who wish to save children's work, however, we advise against the use of newsprint and manila paper, as they become discolored and brittle in a short period of time. As collectors of children's art we sometimes have had to go to great lengths to preserve fragile pieces. We recommend the use of the best paper affordable; not only is better paper more permanent, but it is usually more enjoyable to use.

a special place

Children who draw a lot or who spontaneously engage in other art and creative activities by necessity find or make their own place to work. In this respect children such as the young C. S. Lewis or Michael L. are very much like adult artists and writers who must have their special place, arranged in their particular and sometimes peculiar ways, in order to work creatively. We have shown some of the variety of spaces and places required by drawing children, from elaborately equipped and private places to the communal atmosphere of the dining table. We think that there are many children who do not ac-

tively establish their "creative territory" and yet we believe that if parents and teachers would assist children in establishing work spaces and places in homes and schoolrooms, then the very existence of these inviting territories would facilitate drawing and other creative activities. Sometimes a space in the child's room where there is as little disruption as possible, where things may remain as the child leaves them—ready for another session—and where the valued work is safe from the hands of younger siblings or from exuberant pets is best. But wherever and whatever the spot set aside for the child's creative activity, it should be designated as such and decided upon by agreement between adult and child.

We asked an educational designer, Anne Taylor, and an architect, George Vlastos, of *School Zone, Inc.,* to help us in considering some of the requirements and of ways of designing places for children's creative activities in homes. Although the initial considerations were directed toward homes many of them would apply to schoolrooms in which teachers wish to establish a creative center.[7]

In interviews, children have told Taylor and Vlastos that they need private spaces both at school and at home, where they can work, play, and be alone. Children have indicated that they need a space that goes beyond a bed, a set of dresser drawers, and perhaps a bookcase. Children need a place of their own—a territory that provides seclusion and privacy, an area designed for and centered around the child. Such a place is called the "child's home zone" by Taylor and Vlastos.

FIGURE 1-10
Locating the child's home zone

locating the child's home zone

Taylor and Vlastos say that:

Locating a child's zone in a house requires an analysis of family life-style, the child's needs, and the space inside and outside of the house. The child's zone needs to be in just the right place! It is the physical manifestation of a very basic human need—a retreat, a place to work alone.

The zone should be in a significant place in the house, in which the child can be in control, yet where he may be helped by a facilitating parent if necessary.

Here are some questions to ask yourself when looking for a good location:

• Is the child gregarious?
• Does the child like to work alone in the bedroom?
• Does the child like to work alone but near the family activity?
• Does the child like to listen to music while she is working?
• Is the child messy?
• Is there a place for a child's work zone in the hallway? the bedroom? a niche in the kitchen? the family room? upstairs? downstairs? near the family? away from the family?

Is it big enough for one child, maybe two? Or a parent and a child? And surely the most important factor is that the child have a hand in the location and the design or arrangement of this special space.

components & requirements of the home zone

Some components that Taylor and Vlastos think you will need for the home zone are:

• A flat surface
• Components that are lightweight, movable, and flexible
• A place to be messy
• A place that is easy to clean
• A place to store materials
• A display space
• A tack-up surface
• A place scaled to a child that can grow with the child
• A zone that can complement other places in the house
• Tools and materials that encourage drawing and other art activities

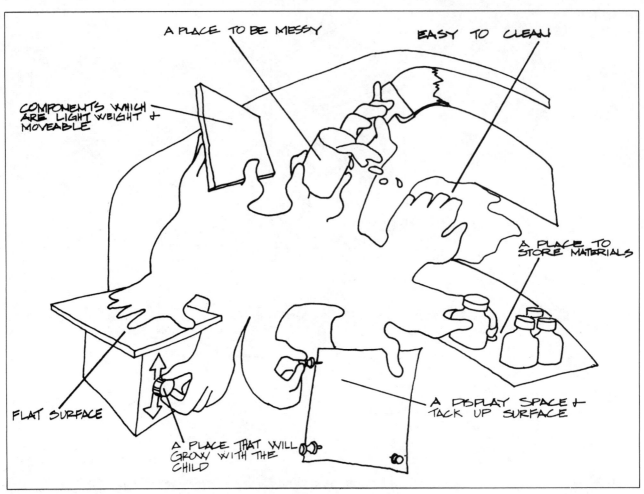

FIGURE 1-11
Components of the work zone

Every home and every school-room is different in some respects, of course. If a place is designated as the drawing or creative or art area and an ample stock of tools and paper is provided, this alone will be enough to encourage many children to draw. If, however, the space and means are available then we encourage the development of more fully designed facilities similar to those developed by Taylor and Vlastos.

keeping a record

We know adults who have carefully saved and documented (including age, date, and so forth on the back, and in the cases of younger children, what they said about the picture) all of the substantial output of a child's drawing, to the later surprise and delight of child and adult alike. This practice provides a record of the child's growth in ways that are often important and sometimes profitable.[8] It allows adults, too, to discuss drawings with children (Chapters 3, 5, 6, 7, and 8 of this book are devoted to *what to say* and *how to say it).*

a time to draw

Finally, having supplied the child with the necessary encouragement, materials, and the space to work, it is imperative

that adults allow children *time* for drawing as well. It is evident that children like Steven and Kelly will draw and will make time for their drawing come what may. Other children, however, who may benefit equally from these creative activities, may be kept so busy with other activities that there is literally no time to draw. Curiously enough, we think that today's adults, who try so devotedly to keep children from being "bored" by providing them with all sorts of lessons and sports activities—while these outlets are unquestionably valuable—are denying the very thing that has often given some of our most renowned artists

FIGURE 1-12
Variations of the work zone as the child grows

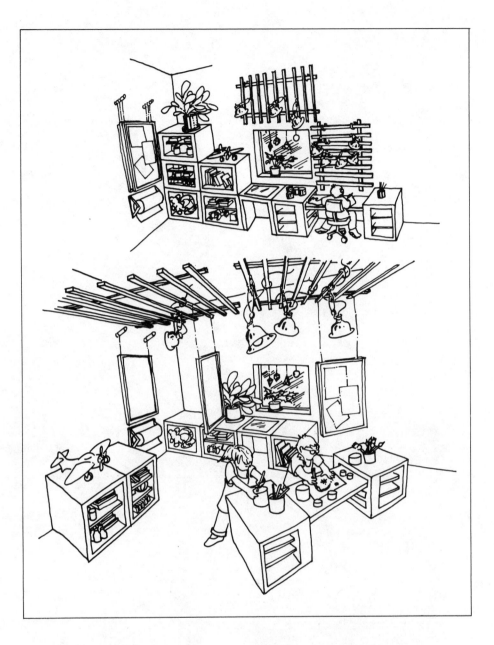

and scientists the impetus to create—boredom. Maurice Sendak, the author and illustrator of such popular children's books as *Where the Wild Things Are*[9] says, "I was the kind of child who has to live in fantasy as much as he does in reality—probably because I was very easily bored."[10]

Regardless of the role that drawing plays in the lives of children, whether it is a total immersion or merely a wetting of the feet, whether it requires a lifetime or only a few intense years, that role can be made more important and more exciting through the sensitive encouragement of concerned adults.

chapter two

Why
children draw

Of all the drawings produced during the months of September and October of the year in which Dirk was eight, only 114 survive: six about Mr. And and his Change Bugs (2-1–2-6)[1], in the course of which a giant Cyclopsian monster named the Dubser was born; the Dubser's own series of forty-seven sequential drawings; a coinciding nonsequential set of forty sheets, some containing as many as thirty drawings of "weird people" (2-7); three drawings of imaginary cities (2-8); three large panoramic depictions of the battles of the Dubser (2-9); an eight-drawing sequence of the adventures of an anthropomorphic jet plane; and seven illustrations of riddles and tales (2-10).

We have said that children draw in order to symbolically explore their worlds. But surely the world is not one of Change Bugs and monsters and weird people. What, then, do these things symbolize? What role do these fantasies play in Dirk's intellectual development? How do they relate to his sense of self, and of pleasure, to his dreams and desires, and to his understanding of such concepts as good and evil?

Let us explore these and other questions as we examine the drawings of Dirk and other children like him. It is the exceptional and varied nature of Dirk's somewhat unusual production that will enable us to answer these questions and to know some of the complex and important reasons why children draw.

Let us return to our original premise of coming to know the world. We believe that this is the key to understanding the nature of drawing activity. In order to know ourselves, we must also know the world. For Dirk, at eight, the world is still full of unknown terrors and pleasures about which he seeks to learn, not unlike adult adventurers before him, whose desire

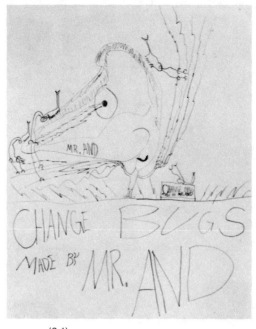

(2-1)

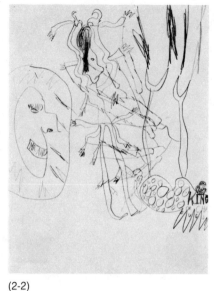

(2-2)

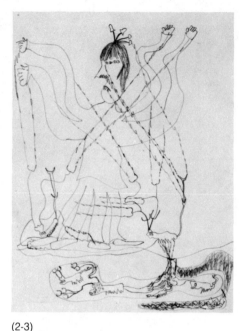

(2-3)

FIGURE 2-1
Dirk (age 8)
Change Bugs Made by Mr. And—1
(pencil) 10 x 13"
The character with the exaggerated head is identified by Dirk as Mr. And, who is sending shock waves from his hands and eyes to the Change Bugs on his nose and head. "The Change Bugs have been invented by Mr. And. He finds they have certain powers that can make things change. Mr. And is bad—a sort of crook. He is trying to rob banks to get more money to rule the world."

FIGURE 2-2
Dirk (age 8)
Change Bugs—2 (pencil) 10 x 13"
From the left of the drawing Mr. And looks on as the king of the Change Bugs does his evil work. "Mr. And," Dirk said, "directs his Change Bugs to change people into weird things so that they are almost helpless."

FIGURE 2-3
Dirk (age 8)
Change Bugs—3 (pencil) 10 x 13"
"Mr. And has directed the Change Bugs to dig a hole and anyone who passes over will be changed. Part of the changing is getting more arms and legs, but not always."

FIGURE 2-4
Dirk (age 8)
Change Bugs—4 (pencil) 10 x 13"
"King Change Bug is changing a woman into something that will squish all things or people that get into her way or under her feet."

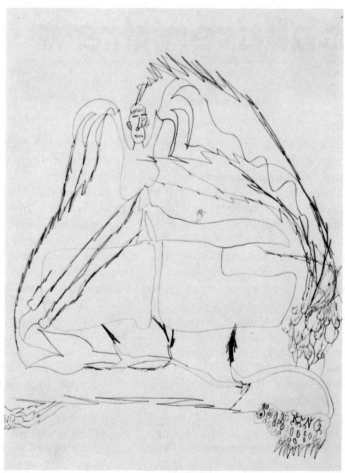

(2-4)

FIGURE 2-5
Dirk (age 8)
Imaginary City (pencil) 10 x 13"
This drawing combines Dirk's vivid imaginary *prophetic reality*—in one's everyday life it is difficult to stride from one building top to another; in drawing it is easy—and the *common reality* of the tall apartment buildings he had seen on a trip to Scotland and Germany.

FIGURE 2-6
Dirk (age 8)
Change Bugs—6 (pencil) 10 x 13"
In this last drawing Dirk says that "the new series is born—the weird people series. The Change Bugs have accidentally changed people into future-men."

FIGURE 2-7
Dirk (age 8)
Weird People (pencil) 10 x 13"
Dirk has followed the lead of Mr. And and has created this rogue's gallery of characters who appear to have been fashioned of Silly Putty. They sprout multiple chins, eyes, and sometimes heads; heads twist and turn and contort grotesquely; noses meander. Some characters appear sinister, some meek, and others simply bemused—a sort of play with characters and characteristics both.

FIGURE 2-8
Dirk (age 8)
Change Bugs—5 (pencil) 10 x 13"
In this picture the Dubser is born from the nose of a "changed person." The little figure (above) is a changed lady. The Dubser now has a tail but he will lose it. The Dubser down below is the adult Dubser and he is hanging onto "the change power."

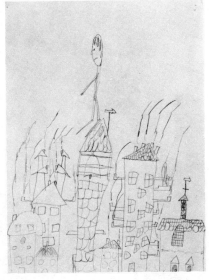

(2-5)

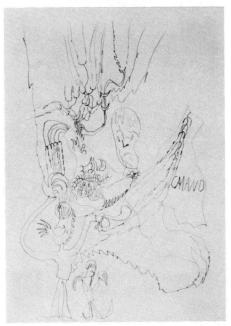

(2-6)

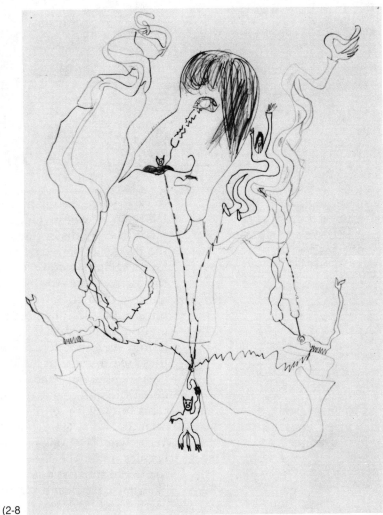

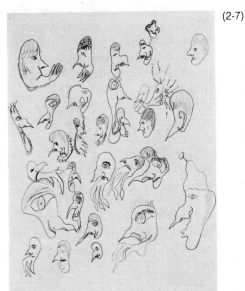

(2-7)

(2-8

FIGURE 2-9
Dirk (age 8)
The Dubser Under Attack (colored marker) 18 x 24"
The giant cyclopsian Dubser is being attacked by formations of airplanes, guns, rockets, helicopters, and parachutists, and barrages of assorted missiles. The sense of destruction is heightened by the scribbled smoke emanating from the nostrils of the Dubser and from the points of impact of the missiles upon his body. The Dubser is "bloodied but unbowed."

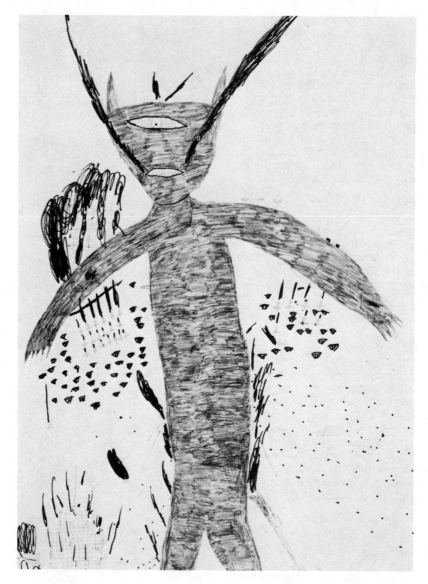

to experience the unknown has led them to explore foreign lands, the depths of the ocean, the mysteries of outer space, the layers of human consciousness, the microscopic worlds of biology, the theoretical realms of nuclear physics, the possible and the impossible.

And yet only a few can know these realms at first hand. A great deal of our "knowing" about the universe is imparted to us in the form of literature, of science, and of art. It was Jules Verne who first took us "20,000 leagues under the sea," "around the world in eighty days," on a "journey to the center of the earth," and from "earth to the

moon." In the Sistine Chapel frescoes Michelangelo depicted the entire biblical panorama from the Creation to the Last Judgment; Einstein gave us a relative universe; and these are only a few examples that may be derived from stories, novels, paintings, illustrations, scientific theories, films, photographs, and maps.

The presentation by writers, scientists, and artists of the inaccessible and otherwise unknowable realities is invaluable, even essential to the "coming to know" of each individual. But what of the special plight of children, who have the most learning to do and the

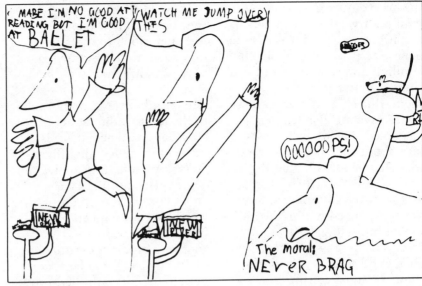

FIGURE 2-10
Dirk (age 8)
The Bragger (ballpoint) 5 x 8"
To brag or not to brag; that is the question that Dirk seems to be confronting in this playful drawing. Bingo! a full card for the *normative reality*.

(2-10)

fewest means of attaining it? Firsthand exploration is furthest from their grasp—imagine going to India when you aren't allowed to cross the street alone—and symbolic exploration of realities through the arts and other media is still out of reach because children have not yet attained the skill of "reading" books, maps, formulae, and diagrams as adults easily do. There is, however, one notable exception, in media that are primarily visual and correspond in at least some ways to the child's firsthand experiences of the world—television, films, drawings, and paintings. These visual symbols require "read-

ing" as much as do word symbols, but the skill is acquired early by the media-saturated child of our society; the process of reading visual symbols begins very nearly at birth with the continuous bombardment of visual stimuli that display actors, actions, objects, and places. These visual symbols—pictures—provide children with their primary symbolic means for understanding reality. The apple in the alphabet book is not edible—but it is a symbol for *apple* that the child understands.

By the age of three or four most children are able to master

the necessary rudiments for presenting their own ideas and experiments about reality in observable symbolic form. Years before they can set down their original ideas in writing and numbers, children are able to record their ideas, feelings, and experiences through their drawings, as artists do—a record to which the child may return time and time again and one that may be shared with others. This is what we believe to be the case with Dirk's drawings; with them and through them, he was developing, presenting and examining his own ideas about reality.

Drawing to *know*

We often talk to children as though there were only one "real" reality. We say, "Yes, but what *really* happened?"; "I think you are just imagining things"; or "You know there *really* is no tooth fairy." But what is this reality that we insist upon sustaining? It is only one of the four realities described by Hans

and Shulamith Kreitler[2]—the *common* reality, the reality that refers to the familiar and everyday perceptions and experiences of objects and events that we humans share in common. The other three realities, each of which we will examine, are the *archeological*, the *normative*, and the *prophetic*.

inventing the familiar

Almost as soon as he realizes that the circle he makes on the page, for example, can "stand for" an apple just as the shiny red orb in the alphabet book does, the child begins to draw

the everyday objects of the common reality. He draws a person, a house, a tree, and it is easy to believe that learning about the familiar things of his world is a simple matter of observing them. But is it? The well-known Swiss psychologist Jean Piaget has noted that what interests him about the creation of new thoughts or ideas is that they are not determined "by encounters with the environment, but are constructed within the individual himself … [that] the essential thing is that in order for a child to understand something, he must construct it himself, he must re-invent it."[3] This re-invention is necessary for the child in every aspect of the four realities, as we shall see, and no less so in the understanding of the world about him. Although Piaget's re-inventing is a mental structuring, drawing makes these thought structures perceivable to the child.

In their drawings children create characters, objects, and settings very much like those in make-believe play; but the marks representing Mommy, the house, and Baby are more concrete than are the simple declarations of play—"You be the mommy and I'll be the baby." Another psychologist, Erik Erikson, says of play what we know to be true also of much of the child's drawing—that it is "the infantile form of the human propensity to create model situations in which aspects of the past are relived, the present represented and renewed."[4] In this way children are the creators of their own worlds, in which things may be seen, and examined, to find out what they are like, what they can do, and how they work.

How do Dirk's drawings reinvent the common reality? Although upon first glance it may seem that the drawings about Mr. And and the Change Bugs (2-1–2-6) and the monstrous Dubser (2-9) do not relate in the least to the reality of our everyday existence, there is more to these seeming flights of fantasy than is immediately apparent. The story in fact is about control and the way in which one person can be controlled and forced to do another's bidding. Certainly a small boy feels that he is continually being controlled—by parents, teachers, other siblings, and, at times, even friends. It is speculation to say that Dirk's Mr. And series was an unconscious attempt to gain or to understand control through the symbolic practice of controlling, but surely it is a possibility. And could the metamorphosis undergone by the characters due to the action of the Change Bugs relate to the often bewildering physical and emotional changes occurring in children every day? And the birth of a new character—if only from the nose of a "changed person"—may be an effort to understand that most perplexing element of a child's life. Even the buildings in Dirk's cities seem to relate to the apartment houses he had seen a few months earlier on a trip to Germany, a continuous structuring and restructuring, "the past relived, the present re-presented" in terms that an eight-year-old boy could understand.

When Andy S. was eight and nine, he worked with an astonishing variety of themes and ideas, but unlike Dirk's seemingly more complex ideas, one persistent strand runs throughout his entire prodigious

output (in the course of three months he filled both sides of nearly 400 sheets of paper with drawings)—an attempt to master the depiction of the likeness of common objects. His work includes drawings of motorcycles in all of their mechanical detail (2-11 and 2-12), the dimensionality of shoes and cars, and recognizable portraits of the people in his world (2-13). And he is concerned, too, with the mechanics of things and the way in which they might work (2-14); he creates models of factories that manufacture not only automobiles but bionic parts and people as well (2-15, 2-16, 2-17). Sounds, too, find form in the common reality as Andy seeks to depict the tones emitted by a rock singer (2-18, 2-19, 2-20).

Hardly a drawing produced by children is without at least some aspects that relate to depictions of, or the making of models for, the common reality. At times, these depictions are symbolic of relations between people, of growth and other seemingly unfathomable mysteries; at other times they are an attempt to show details, to understand actions and the working of machines, or even to depict the unseen, such as the image of a sound.

delineating a concept of self

The *archeological reality* is the reality of the self. We might think of the human mind as being composed of layer upon layer of memories, feelings, thoughts, impressions, and desires. The Kreitlers believe that, just as the archeologist is able to uncover the artifacts or the

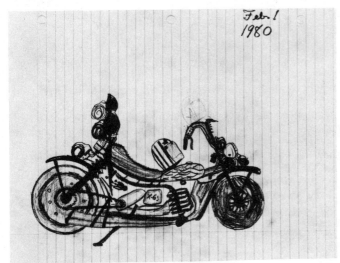
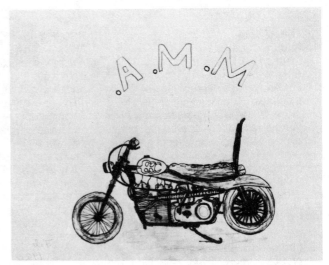

(2-11) (2-12)

FIGURES 2-11 and 2-12
Andy S. (age 9)
Motorcycle (pencil) 8½ x 11"

Andy S. (age 9)
M.M.A. (pencil) 8¾ x 12¼"
These are only two of the dozens of
motorcycles that Andy drew over a
two-year period. His attention to detail
and accuracy has fostered attempts
at shading in order to pin down as
clearly as possible the many nuances
of the common reality. And how better
to attain a desired treasure than to
create it in all its glorious detail, a
symbolic wish fulfillment?

FIGURE 2-13
Andy S. (age 9)
Portrait of an Old Woman (black
crayon) 8½ x 13¾"
Andy's father, who is an artist too,
sometimes draws portraits of his
friends. Perhaps this is where Andy
got the idea for this sketch of an
elderly neighbor. In recording this as-
pect of his *common reality*, he has
attempted some difficult feats and
has displayed amazingly good per-
ceptual abilities for a nine-year-old.
These may be seen in the angle of
the glasses and the interlocked
fingers.

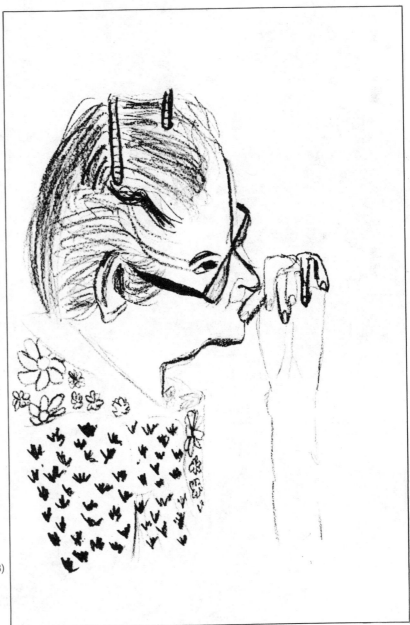

(2-13)

FIGURE 2-14
Andy S. (age 9)
Mechanical Characters (pencil)
8½ x 14"
For Andy's depiction of these robotlike creatures, he has surely referred to those things of the *common reality* that he repeatedly draws—the motorcycles with their shiny mechanical parts and the people with their bodily dimensions and movements. As with most drawings no one reality is isolated but elements of the four realities—the *archeological reality* of the self (what powers can a young boy envision?); the *normative reality* (the good and the evil); and the *prophetic reality* (what may the future hold?) are incorporated.

FIGURE 2-15
Andy S. (age 9)
Automobile Factory (pencil)
8½ x 14"
Andy's drawings of factories that manufacture everything from parts for bionic people to automobiles are much like diagrams, and although they are highly imaginative they are also attempts to show, or more accurately to understand, the *common reality*. After drawing one of his manufacturing plants, Andy would go to his father for approbation,—"Is this the way they do it?"—and for reinforcement,—"I'm pretty smart to have figured it out, aren't I?"

FIGURE 2-16
Andy S. (age 9)
Machine with a Brain (colored pencil and marker) 8½ x 14"
While the automobile factory requires no human assistance, this great machine appears to be manipulated by the small figure seated at the controls on the lower left. The homunculus and the humongous machine together may explore possibilities for manufacture, although only the workings are clear; no product of their collaboration is evident. The real subject appears to be control—at the touch of a button.

(2-15)

(2-14)

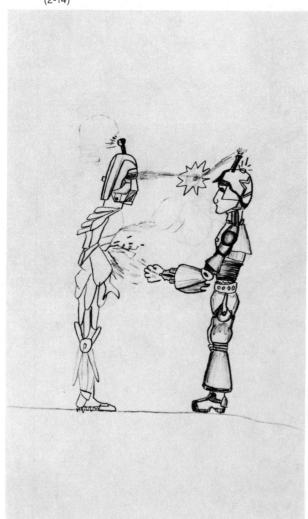

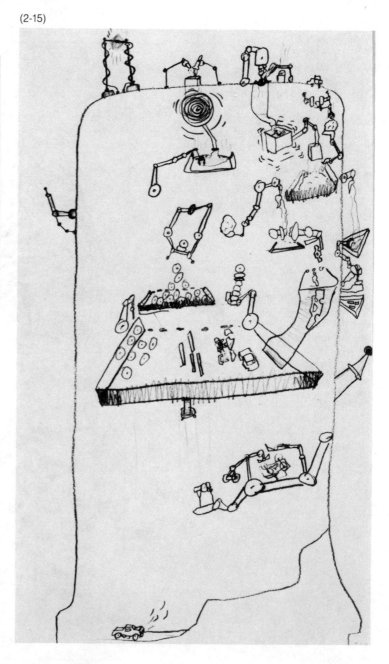

26

(2-16)

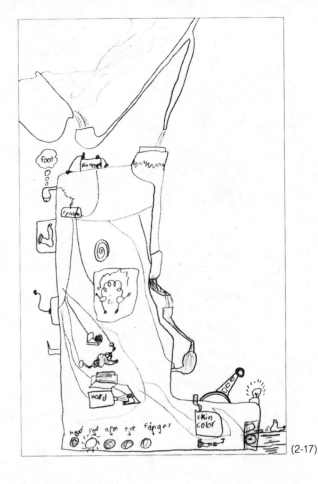

(2-17)

FIGURE 2-17
Andy S. (age 9)
Bionic Body Parts Factory (pencil)
8½ x 14"
Any one of the five buttons on this
machine—variously labeled head;
feet; arm; toe; and finger—can be
pushed to create the desired bionic
body part. We can see that the button
labeled "feet" is in operation and can
observe the complete process from
liquid state (boiling cauldron at top
left) to a fully formed skin-colored foot
coming off the conveyor belt at the
lower right.

FIGURE 2-18
Andy S. (age 9)
Rock Singer I (pencil) 8½ x 14"
Sounds find form in the *common real-
ity* as Andy seeks to depict the tones
emitted by a rock singer. This is per-
haps the simplest of Andy's series of
singers from whose titillating tonsils
sounds emanate.

(2-18)

FIGURE 2-19 (2-19)
Andy S. (age 9)
Rock Singer II (pencil) 8½ x 14"
The head of this singer appears to
disintegrate as the "sound" lines that
are so many and varied all but drown
the musician.

FIGURE 2-20
Andy S. (age 9)
KISS (pencil) 8½ x 14"
Although the frantic and grotesque
theatricality of *KISS* and the "reality" it
invokes are far from common and
Andy's depiction uncommonly good,
the group is nevertheless a part of a
young boy's experience. Andy is able
to convey the enormous energy of
these musicians in their attitudes, ar-
rangements, and actions, and
achieves a feeling of space and di-
mension through the use of overlap
and placement on the page.

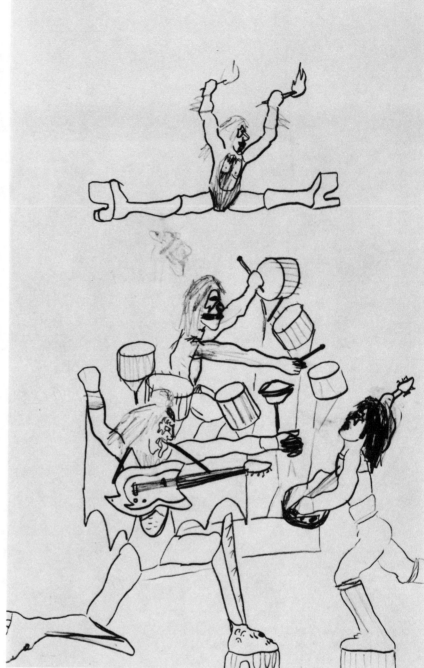

(2-20)

historical past by digging
deeply into the layers of the
earth, so the artist is able to
delve into the layers of his own
consciousness through his art
and to reveal a self, constructed
both from the ideas and images
near the surface and from those
imbedded deeply within the
mind. Art may help the child,
too, to hold up images of him-
self—in order to reveal the
essential self, the self that we

must come, individually, to
know. The questions Who am I?
What am I? How am I? What
will I be? and What will I be-
come? however implicitly asked,
require a lifetime to answer.
Nevertheless, none of us seems
entirely satisfied just to sit back
and see what will happen. We
all engage in an ongoing sym-
bolic investigation of the nature
of ourselves. We invent and re-
invent self-possibilities through

our Walter Mitty-like
daydreams, our measuring of
ourselves alongside associates,
historical greats, and fictional
characters.

This self-defining process is
an important dimension of chil-
dren's drawings. When Erik
Erikson spoke of how children
experiment with self-image
through their play, he might
well have been speaking of chil-
dren's drawings:

Childhood play, in experimenting with self-images and images of otherness, is most representative of what psycho-analysis calls the ego-ideal—*that part of ourselves which we can look up to, at least insofar as we can imagine ourselves as ideal actors in an ideal plot, with the appropriate punishment and exclusion of those who do not make the grade. Thus we experiment with and, in a visionary sense, get ready for a* hierarchy of ideal and evil roles *which, of course, go beyond those which daily life could permit us to engage in.*[5]

And how did Dirk's drawings represent the archeological reality? Returning to his depiction of the reprehensible Mr. And (2-1–2-6), we would hope that this creation represents a character whom Dirk found to be undesirable and whom he rejected as a possibility for himself. (We think that he did.) On the other hand, the monstrous Dubser presents some interesting possibilities for knowing one's self and one's feelings. The size and power of the Dubser, elements notably lacking in the person of a small boy, are certainly desirable, a fact to which the popularity of media heroes, anti-heroes, and superheroes attests. To possess the extraordinary powers of these larger-than-life heroes is the passionate desire of the small child, whether to fight the forces of evil or to stand nose to nose with the dominating adult. So it may have been with Dirk and the Dubser, as he experimented with the possibilities of power and size. In Dirk's drawings the Dubser (2-9) always stands alone, outnumbered but never overwhelmed by innumerable diminutive attackers (because like King Kong, the

image of whom the Dubser series evokes, he is so much larger than any of his adversaries). He is attacked by formations of jet planes, the artillery, meteorites, and fires as he stands, undaunted, feet planted firmly on the ground. The world, to a young child, is not only bewildering but threatening and it is necessary to marshal all the courage and strength one can in order to protect and fend for oneself as well as to solve one's problems. We see Dirk dealing with the layers of self, with ways that he would not wish to be as well as ways that he might like to be, with a myriad of "ideal and evil roles." This is evident in his "weird people" (2-9), depictions of characters who can each be seen to possess the potential for being and acting in particular ways, desirable and undesirable, and each representing possible ways that a person might be.

surrogate self

If the child is experimenting with the self-image and with self-possibilities, why do we not always see drawings that are recognizable as the child himself? Just as we recognize as ourselves figures in dreams who bear no physical resemblance to the self we see in the mirror, the dream and the child's drawing present a mirror of a different sort. The reflection we see is a substitute, or a surrogate self. The little girl who tells a story in which a child disobeys and defies authority makes her protagonist a boy, or sometimes the main character in a self-story is an animal, often a horse, or perhaps an insect, or even cars and trucks. It is important to note that, just as dream images are created in ways of which we are

unaware, so the drawn images of the child are created without his being aware of or recognizing them as self-images. In this way the child may safely experiment with even adverse feelings and ways of being that he wishes to understand, so that he might hold them up for examination and accept or reject them as possibilities for himself.[6]

When Tami was eight, she experimented with a multitude of images.[7] Many were beautifully drawn horses (2-21), a typical favorite of many girls of this age, and Tami told stories about horses, too—horses that were bigger and faster and more beautiful than any other. Ways that a child might wish to be? Certainly. But even more than ideal horses, Tami experimented with the ideal—and the evil—in her depictions of women (2-22 and 2-23). Most of Tami's women are beautiful, with long, dark, flowing hair, sometimes falling to the waist (Tami's hair is short and blonde). They are svelte, generously endowed, and sexy—full-lipped, sloe-eyed, elaborately costumed. The cast of characters in Tami's drawings includes dancers and acrobats, a genie, Wonder Woman, spies, detectives, and a vampire woman. These characters, ranging from benign to evil, seem to map the vast terrain of ways that one little girl might be.

experimenting with good & bad

The *normative reality* is the reality of good and bad, of right and wrong, of just and unjust, a reality of standards, subsuming the implicit and explicit rules by which an individual or a society behaves. Young children

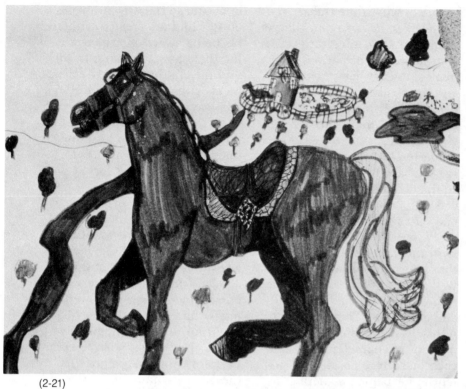

(2-21)

FIGURE 2-21
Tami (age 7)
Horse (colored markers)
8½ x 11"
For Tami, as for countless other young girls, the fascination with the image of the horse was great. This was only one of many, all of which stand or gallop regally, beautifully bedecked, their tails brushed and luxurious. In their proud stance and decorative-ness, these horses relate to Tami's many drawings of elaborately costumed women.

FIGURE 2-22
Tami (age 7)
"Evil" Woman (colored marker)
For a seven-year-old there are very clear lines of demarcation between good and bad, black and white, evil and ideal. This obviously evil woman is recognizable not only by her be-witching beauty but by her garments as well. Most of Tami's temptresses throw dark cloaks about them or the cloaks flare widely and surround them in darkness.

(2-22)

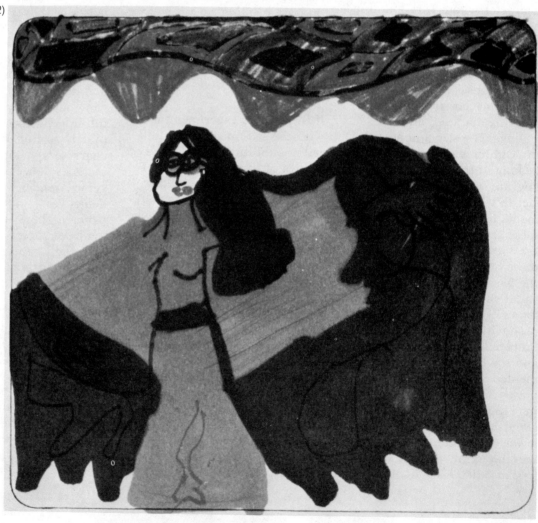

must reinvent for themselves the standards of right and wrong—which kinds of behavior are proper and which improper—in spite of the fact that they are continually being told to behave in ways perceived to be desirable by adults. Because the consequences of experimenting with or engaging in actual improper behavior are dangerous at best, symbolically engaging in this improper behavior through drawing makes the exploration of the normative reality a relatively safe pursuit. Through their drawings, children can portray themselves as either or both the evil or the good (in the same way that in their make-believe play children have universally been alternately *cop* and *robber, cowboy* and *Indian)* and may then plot

the consequences of each role. In this way they are able to symbolically determine how they might be and how they ought to be.

It is important to note that in most cases, it is not possible to isolate one reality, but that several realities are most often jointly explored and often fused so that, for example, the ideal and evil roles described as the archeological reality of self are held up to careful examination, as the normative reality and the archeological fuse. Dirk's drawing of the Ballet Bragger (2-10) shows a character—who claims that he may not be "good at reading" but that he is "good at ballet"—attempting to jump over the "new river." But— "Oops"—he lands in the water instead, while a little mouselike

observer quietly mutters, "Bragger." The story ends with the moral, "Never brag." Dirk was surely experimenting with proper and improper ways to behave and, as an observer like the mouselike creature, could safely stand at a distance, examine the consequences, and perhaps decide against bragging.

A more complex and possibly the most searching example of normative reality testing that we have seen is the comic-book format production orchestrated by Bobby when he was in the eighth grade. Instructed by his art teacher to create a superhero, Bobby responded by giving birth to "Goldman." Not part of the assignment, however, was the sixteen-page "origin" that Bobby painstakingly drew

FIGURE 2-23
Tami (age 8)
Three Hawaii Spies (colored marker)
4¼ x 4¾"
If her darkly cloaked women represent for Tami the ultimate evil, these three glamorous and beautifully costumed innocents represent the good (and certainly the "ideal" self strived for by a young girl). Like many a heroine that Tami can see on television, these spies fight the forces of evil, right all wrongs, and restore order to the world.

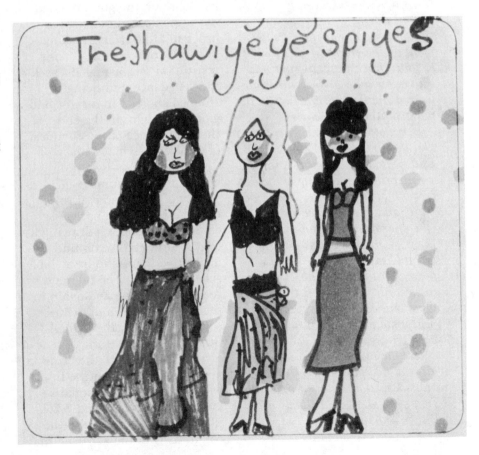

over a period of several weeks at home (2-24).

The themes of the story are duty, friendship, and moral obligation explored in a variety of scenarios within the larger framework of adventure, rebirth and restitution.

Two unemployed "astro-pilots" are forced to take part in a plot to rob Fort Knox. Because Ted has the obligation of a wife and children to support and a "status to live up to," he is more affected by the layoff than the bachelor, Chuck, and so becomes involved with and inevitably in debt to loan sharks. He must go along with their dastardly plan in order to repay his debts and implicates Chuck, who agrees because "what are friends for?" During the robbery, which is elaborately orchestrated to include space shuttles, lasers, underground tunnels, and a complicated joining of two ships in space, Ted is wounded by a guard's "lucky shot." Refused a doctor's treatment by the crooks, Ted is forced to join Chuck in taking the gold into outer space, where his head wound finally weakens him to the point of unconsciousness.

In an attempt to save his friend and the ship, Chuck jettisons the gold, which is then drawn toward a meteorite "containing fantastic powers far beyond the capacity of man" and is subsumed by it until "the characteristic properties of the gold are drastically altered ... the gold takes on all the awesome powers of the meteorite." Unable to save his failing ship, Chuck is then "hurled out into space where he'd instantly die ... if not for being sucked into the vacuum. He enters the meteorite ... the transformed gold pours all over him ... and so, in that moment that the gold supercharged the body of Chuck Salvin, renewed every cell, was created Goldman!"

After discovering that he has taken on all of the marvelous powers of the meteorite, Chuck returns to earth as Goldman and, as if to atone for his crimes, he performs all manner of good deeds, but foremost is his desire to avenge the death of his friend Ted. He locates and refines gold from the California mountains and restores it to Fort Knox, rounds up the gang of crooks, and finally confronts their leader. In an effort to retreat from the menace of the approaching Goldman, the villain backs through a window, crashes to the sidewalk below, and is killed. Goldman philosophizes, "He was killed by his own cowardice! Well, at least I've learned a lesson from this bloody mess—not to strive for vengeance—but for peace."

Consider the moral issues explored in this graphic narrative by Bobby in the guise of Goldman: the decision to steal in order to aid a friend, risking one's life for a friend, making restitution for past deeds, seeking vengeance, but being stopped short of that error and gaining insight, in the end, of the importance of the conquest of good over evil.

Most drawings by children do not display the number or complexity of good and evil roles that the sequential narrative character of Bobby's drawing allowed, although we do find normative themes to be a consistent concern. The theme we see repeated time and again in scores of children's drawings collected both in the United States and in Australia is that of a crime committed, the criminal apprehended, and, in the final frame, foiled or occasionally even executed (2-25 and 2-26). Although the depiction of the committing of the act itself may

FIGURE 2-24
Bobby (age 13)
Page from *Goldman* (colored pencil and marker) 9 x 12"
In this stupendous cosmic explosion, the figure of Goldman emerges like a phoenix from the ashes, renewed, reborn, immortal. Bobby's 16-page adventure has built both narratively and graphically to this climactic point. The themes that pervade the story—duty, friendship, and moral obligation—makes this an extraordinary depiction of the *normative reality*.

afford the child some measure of excitement or even satisfaction, the more important dimension for children seems to be that the crime is punished. The reaffirmation that *crime does not pay* seems to be a valuable outcome of exploration through drawing of the normative reality.

drawing the future

Not only do the drawings of children create Erikson's model situations "in which aspects of the past are re-lived, the present represented and renewed" but "the future [is] anticipated" as well. All of us anticipate the future and seek to control future wants in a variety of ways. We construct, refine, and rehearse anticipated events, encounters, and conversations. Art has served this future-anticipating function for countless civilizations, and probably for as long as art has existed. It is thought that the cave painters produced images on the cave walls in order to assure the success of the hunt by invoking images of the animals that they wished to control. Middle-Eastern Nasrudin tales are seen as "word pictures" which, in the creation of symbolic situations, prepare the listener for similar

Chuck's efforts are futile... both ships blow up... and Chuck is hurled out into space....

...Where he'd instantly die... if not for being sucked into the vaccum!

He enters the METEORITE!

His space suit, and clothes are instantly singed off! As his skin begins to burn...

The transformed gold pours all over him....

And so, in that moment that the gold super-charged the body of Chuck Salvin, renewed every cell, was created...
GOLDMAN!
Who takes on all the fantastic cosmic powers of the meteorite!

(2-24)

33

(2-25)

(2-26)

34

situations to be encountered in later life.[8] Possible worlds are symbolically created in science fiction; many decades before man traveled in space and before such travel seemed even to be a remote possibility, Flash Gordon was there and Jules Verne had journeyed to the

moon. Drawings provide a vehicle for children to develop models for their own future selves, actions, and worlds.

Each of Dirk's drawings that we have examined has involved the *prophetic reality* in some way. The control of Mr. And over the Change Bugs may be a way to understand both the present control of others over a little boy as well as an anticipation of future control or authority over others. The "changed people" and the "weird people," too, show layers of self-past, self-present, and possibilities for self-future.

Tami's drawings of mature women may serve as surrogate figures for exploring dimensions of her present self, as well as for anticipating what she may be and how she may look when she herself is a mature woman. In one of her story drawings— "Deth [sic] to the End" (2-27), drawn when Tami was nine years old—which creates all of

the tensions of a melodrama and deals with several dimensions of the prophetic reality, this reality is more fully explored. Tami sets an anticipatory scene in the first frame; a "dark sound" makes us wonder what will happen next. The next frames introduce a sinister vampire-type female whose evil powers are demonstrated through the depiction of a flower that has withered and died at her touch. This death-touch becomes prophetic of the story's end—would such a creature be content merely with the death of a flower? In the sixth frame a teenager, identified by Tami as her (obviously future) self, appears, followed closely by the appearance, in the next frame, of a boyfriend (also anticipated in the future). Contact with the vampire precipitates the death of boy and girl, who are reunited in heaven—in spite of the fact that Tami confided, "I don't believe in heaven."

(2-27)

In her story, Tami has dealt with a future life on earth and a possible, and perhaps hoped-for, life in heaven. Indeed, the drawing anticipates growing up, romance, danger, and death—but isn't death a morbid and frightening thing for a nine-year-old to anticipate? Death is, in fact, a theme commonly found in children's story drawings; frightening, yes, but simply another fact of the world to be examined and understood and anticipated, perhaps made less frightening, as are most of our fears, once revealed. Art once more serves these purposes, whether in a famous painting depicting the glories of heaven, as in Michelangelo's *Last Judgment*, or in a children's book parodying the child's innermost fears in the confrontation with … *A Nightmare In My Closet*.[9] Tami's anticipations are not frightening; on the contrary, they are playful, delightful, and optimistic.

the special role of drawing in shaping realities

Although the illustrations we have given of the ways in which children expand their conceptions of the four realities center upon drawings, other symbolic activities such as play, storytelling, dramatics, singing, dreaming, and daydreaming may also fulfill this function. Drawing, however, has special and unique reality-creating characteristics.

Drawings provide an early means, perhaps the first, by which ideas and feelings may be made concrete and perceivable—they leave a record as no other childhood means of modeling reality can do. Young children learn very quickly, and with no assistance, to form basic graphic symbols for people and objects. These early symbols for a person, a sun, a

vehicle have at least some visual correspondence to objects in the everyday world and are easily understood. With them the child soon learns to create complex meanings. The depiction, for example, of family members—the *person* repeated—inside the *vehicle* may convey a common reality or may anticipate the prophetic reality of a future holiday. More complexity is easily achieved with the addition of the *sun* or trees or buildings or clouds. Unlike the structure of language, the structure of a drawing does not demand a precise placement of elements in order to convey meaning. The elements in the child's drawing may even be placed at random on the page and still be understood.

In short, drawing provides a more flexible way for developing ideas about the four realities because it is easily acquired and understood and because it has a visual equivalence to the everyday world.

Beyond the four realities: other reasons children draw

In addition to the reality-building functions of drawings, the answers to the question, Why do children draw? are many. Some of these reasons have already been mentioned in Chapters 1 and 2; here we will review these reasons and make a few additional suggestions as well.

• Drawing is a source of aesthetic and kinesthetic pleasure. At times the act of drawing itself is enjoyable as in the movement of the hand and

arm—and at times the pattern, design, and quality of lines and shapes in drawing produce a pleasurable response.
• Drawing relieves boredom through the creation of excitement and stimulation. Indeed, children may relieve the general tension of boredom through the creation of specific tensions of plots, characters, and events in their drawings.
Drawing is a means by which children gain recognition or approval from peers, siblings, parents, teachers, and others.

• Drawing is sometimes done for the child's own satisfaction—for the pride of knowing that he can do something, and do it well.

• Through the act of drawing an object, a child may symbolically possess that object.

• In drawings, children convey their thoughts and ideas.

• Children are able to use drawing as a means for creating a working model or models of the world—its characters, settings, events, its dangers and joys.

Some children may then manipulate and control every aspect of that world as they cannot in the everyday world. Often children relate it to the directing of a play and the players. One young boy said in describing his eighteenth-century castle and its inhabitants, "They did whatever I wanted them to do."

• Drawing is a means by which the child can declare, as does the mature artist, "I am; I exist and I have been here."

For all of these reasons and more and for reasons that we may not even know, making drawings is an important, even necessary, activity for most children for at least some time in their lives. Drawing is an activity to be encouraged and nurtured; drawings should be looked at, talked about, appreciated, and understood and neither disdained, derided, nor ignored. There is more to children's drawing than has been recognized and certainly a good deal more than meets the eye.

Talking with children about their drawings

Would we know of the marvelous adventures of Mr. And and the Change Bugs or, for that matter, the birth of the Dubser or the mysteries of "Deth to the end" simply by glancing at the drawings? Probably not. Few children have either the ability or the inclination to produce a work like Bobby's "Goldman," which is a literary as well as a graphic narrative. Many would agree that if they had been able to write the story, there would have been less need to draw it, but most are more than happy to tell anyone who is interested the answers to the questions we generally ask and through which the wonderfully rich and exciting worlds of children like Dirk and Tami and others have been revealed to us.

The questions we ask are simple. Asking children any questions at all has long been thought inappropriate—it has been thought appropriate only to say "Tell me about it." "What is it?" was believed to be devastating to a child's ego. We say, "Nonsense." We consistently ask children "What is this?"; "Who is that?"; "What is he doing?"; "What is going on here?" Often even marks and configurations that appear to be minimal and insignificant have been found to contain tremendously important ideas.

Questions and even guesses about the contents of children's drawings may have at least two important outcomes. First, they can convince a child that adults are truly interested in their drawings and consequently in the child himself. Second, as we have shown, drawing is, for the child, often infinitely more than play. Every drawing has a purpose and a meaning and deserves both notice and a question or comment by adults. They may then be allowed to enter all of the realities of the child's drawing world, in which all manner of marvelous things may then be revealed. That is really half the fun.

chapter three

Learning to draw: nurturing the natural

Two hundred years ago, there was no child art, at least as we know it today. What we now know and refer to as child art is a nineteenth-century discovery and has gained its importance—along with studies of childhood play, language, and other symbol systems—with the discovery of childhood itself. Franz Cizek has been credited with the discovery of child art.[1] In his native Vienna, he found that the drawings of children to whom he gave paper and drawing instruments were very much alike, and yet not at all like the drawings of adults. Furthermore, he was surprised to find that children in Bohemia produced drawings that were similar to those he had observed in Vienna. He concluded that children's drawings were ruled by unconscious innate "laws of form"—that children follow inborn universal rules as they learn to use the language of drawing.

Since Cizek's observation, countless parents, educators, and psychologists have noted the regularities and similarities with which nearly all children draw. The psychologist Dale Harris has studied children who lived in a visually impoverished environment in the high Andes in which the only manmade forms were the huts in which they lived, where there were no printed pictures, no drawings or paper or pencils with which to draw. Even these children, he found, when given paper and pencil, made drawings containing expected shapes and sequences. After being shown how to use a pencil, a four-year-old boy made scribbles for four days and on the fifth day produced a drawing of a rudimentary man composed of a circle from which two leglike appendages emerged. This so-called tadpole person is one of the first recognizable forms drawn by children and seems to appear even where children have never seen others draw.[2] The form does indeed appear to come from within the child rather than from some external

39

influence.[3] The regularity with which children produce similar forms everywhere that children's drawing activity has been studied has led some observers to conclude that all children possess a universal language of visual symbols, one that is present at birth and needs only to blossom and flower.[4] This early theory of natural flowering led to a long-standing prohibition—a prohibition still current in many quarters—against interference with the natural course of the child's graphic development, lest the process and the child be adversely and irrevocably affected.[5] We disagree. On the contrary, we believe that this hands-off attitude on the part of adults and the resulting reluctance to become involved in any way with the child's developmental processes is itself detrimental. This attitude is more likely to impede or arrest drawing development, since

nonintervention means that a child who has a problem reaching a desired goal will not receive the help she needs to attain that goal. The same adult who shrinks from showing the child how to draw—let us say an apple—would laugh at the thought of withholding from her the information that the round red fruit is called "apple."

The process of learning to draw can be equated with that of learning to speak. Children seem first to break human sounds down into their simplest components and, in their babble, to experiment with all the possible relationships of sounds. They pass from sounds to single-word sentences, on to two-word sentences, and finally produce multiword sentences, while continuing to follow childhood's own grammatical rules. These rules are quite different from those of adult speakers, but children gradually

assume the standard grammar of the adult speakers with whom they interact.[6]

In this chapter we will illustrate some of the common forms drawn by children wherein they experiment with all possible relationships of lines and shapes. We will attempt to explain the natural principles that children appear to follow and that determine the nature of the things that they draw. We will discuss four steps to understanding the child's progress toward a grammar of drawing:

• The reasons children's drawings look as they do
• Determining where a child stands developmentally
• Anticipating the direction of the child's next possible developmental steps
• What to do and say to nurture a fuller and richer drawing vocabulary

Why children's drawings look as they do

We have said that we disagree with those who claim that intervention is tantamount to extinction of the child's natural creative inclinations. So, too, we disagree with their contention that there is a universal language of visual symbols. It is true that one human mind is structured in ways fundamentally the same as every other human mind; therefore it follows that all humans approach some basic tasks in essentially the same ways. Because of an innate preference for certain

types of visual order, children from one end of the world to another share a predisposition to arrange lines and shapes in certain ways. For this reason the drawings of children from around the world all appear to look the same (and just as surely as they look alike these drawings all look different because of cultural influences that interact and alter the application of innate principles[7]—a matter that will be discussed in the next chapter).

But at the same time that we

ask why children's drawings look the same in essential ways, we must explore the reasons the child draws humans composed of only a head and legs and why the drawings of humans have arms that come out of the head. To this end we will examine seven graphic principles employed by children in a great variety of situations in order to explain the nature of these sometimes curious and sometimes humorous drawings. Although it is usual that several of these principles should ap-

pear in a single drawing, for the sake of clarity, only one principle at a time will be examined.

It should also be noted that although these various principles are applied by many children much of the time, they are not employed by all children all of the time. The answer to the question of why this is so will give us greater insight into the complex nature of children's drawings. Finally, we need to add that the principles are applied differently by children at different levels of their development.

the simplicity principle

The most basic of all the graphic principles is the *simplicity principle*,[8] which seems to direct the child to depict an object in as simple and undifferentiated a way as conforms to the child's expectations for the depiction of the object.[9] (3-1) If an irregular circle with two dots for eyes meets a three-year-old's requirements for the depiction of a human, then only the irregular circle with its dot eyes will be drawn. If two unbent legs spread in scissor fashion are perceived by an older child as adequate to depict the action of running, then a running person will be drawn with legs in that way. Although it consumes less time and energy to depict objects with fewer details and variations, ease and economy of action alone cannot account for the practice of this principle. Nor can a mere aesthetic response—it looks good that way—although both reasons are surely factors. Just as the child's conception of "things" proceeds from simple to complex, from

general to specific, so the child's drawing necessarily follows; and although this may account for such phenomena as the three-year-old's global figure, the simplicity principle seems at times to dominate even in the work of adult artists. Drawing development derives from the alteration of simple and undifferentiated ways to conform to newly devised or borrowed, more complex or differentiated ways of drawing. Perceptions may be altered for example, when the three-year-old observes the drawings of others—drawings that have bodies, arms, and legs—or when the older child is shown a more convincing way to show the action of running.

the perpendicular principle

In addition to the need for simplicity, the human mind has a need for order that is satisfied for the child, at least in part, through the generation of images that display the greatest possible degree of contrast between the parts. This can be seen in early depictions of crosses and ladders and in the later orientation of objects at a 90-degree angle to the baseline. In most cases, as can be seen in these examples (3-2–3-4), the nearest line often serves as the "baseline" to which the object is anchored. At times the application of this principle and the satisfaction of the need for visual order overpowers many of the child's (and often the adult's as well) perceptions of the natural world.

The perpendicular principle explains such diverse graphic phenomena as chimneys and smoke that appear to defy the laws of nature as they stand at right angles to roofs, and people who climb hills in human-fly defiance of the laws of gravity, and buildings arranged so that those on one side of the street appear to be hanging upside down from the buildings on the other.[10]

FIGURE 3-1
The simplest figure serves as a human for the child as long as it conforms to the child's requirements for the depiction of the human.

FIGURE 3-2
The chimney of this house is oriented to the roof at a 90-degree angle.

(3-1)

(3-2)

FIGURE 3-3
Some of these buildings appear to be upside down. For the child, however, they are logically at right angles to their baseline.

(3-3)

(3-4)

FIGURE 3-4
These figures climbing the hill still adhere to the *perpendicular principle* and will continue to stand at a right angle to the hill whatever twists and turns it may take.

the territorial imperative principle

In order to present each element in a drawing with the most clarity possible, the child allots to each its own inviolable space. The territorial-imperative principle not only governs the lack of overlap of one figure by another but applies, as well, to body parts. If, for example, long hair is drawn first, then arms are often omitted rather than violate the space given to the hair (3-5 and 3-6).[11]

the fill-the-format principle

If you have ever wondered why children sometimes draw animals with too few or too many legs, or humans with six arms or with extra fingers, the fill-the-format principle[12] seems to account for these seeming inconsistencies (3-7–3-11). The size and shape of the format determine the number and size of the appendages, so that if the body of an animal by its length accomodates more than the four standard legs, then as many as will fill the space may be drawn, and if the animal is much too short for the proper number of legs then three or even two may do. But what is it that determines the size and shape of the format itself? The young child's inability to coordinate her movements produces animal bodies that are too long or too short; other factors are the size of the page itself, and the way in which elements are placed—so that there is more or less room in which to insert another element. This leads also to

the need to stretch limbs in order to reach an object or to lengthen or shorten features so that they may fit neatly and in an aesthetically pleasing way into a given space. Modern artists have made especially full use of the aesthetic dimension of the fill-the-format principle. An excellent example is Picasso's painting *Three Dancers*,[13] in which each of the three dancers' arms and legs are of markedly different lengths.

FIGURE 3-5
Not one figure touches another in this line of little girls. Each has been allotted its own space (territorial imperative), and there are no arms; how could there be, with hair and other figures in the way?

FIGURE 3-6
There is only one hand and arm drawn on this figure seen "inside" a car. The second hand and arm are omitted because to draw them would mean crossing the line representing the edge of the car.

(3-5)

(3-6)

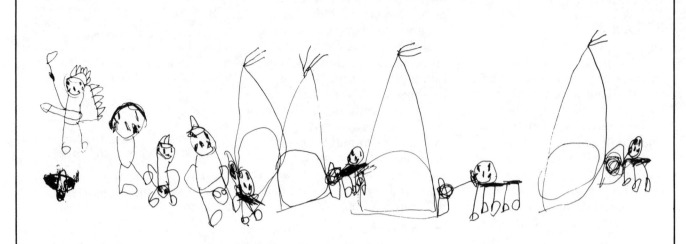

FIGURE 3-7
Philip (age 6)
An Indian Story (colored marker)
11 x 27"

In his Indian story Philip's horse was to have four legs. He adds one to the three he has drawn initially, but he is left with a gap between the third and fourth legs; he hesitates, draws in a fifth leg.

The "chief Indian" has a headdress that falls the length of the body so Philip can't put the second arm on that side lest the arm and the headdress conflict; he decides to draw both arms on the side opposite the headdress even though one arm must cross the body.

Four Indians need four tents with four horses tethered to the tent stake. As he squeezes in the fourth tent, he is chagrined to find that there is only a small space for the last horse. "I don't have room to write the horse—well, I'll have to make a small horse for him." This one has room only for three legs.

It seems that there is no planning at this point. Whatever we need we make to fit the space. If it's a large space, it can be a large horse; if it's a small space, the horse is condensed to fit. Fill *and* fit the format, as well.

FIGURE 3-8
The head/body in this drawing of "my mommy" has ample room for six arms.

FIGURE 3-9
Lack of control probably resulted in the arms of this figure, drawn with a single line, becoming very large. It then became necessary to accomodate the fingers to the size of the arms.

the conservation & multiple-application principle

It might be worthwhile for those who would conserve our natural resources to take a lesson in conservation from children, who apply the same configuration over and over again in a variety of ways. Suns are reemployed as hands, tadpole people reappear as trees, the head of the human serves also as a head for horses or cows, cats or dogs, arms can be interchanged with legs and hands with feet. For the child a limited vocabulary of already acquired configurations may serve as many uses as possible and desirable (3-12–3-15).[14]

FIGURE 3-10
Sometimes the necessity to *fill the format* also fulfills the aesthetic urge to decorate and to balance one shape with another until all the space is beautifully filled, as in these mandalas.

FIGURE 3-11
And sometimes the spaces inside houses need to be filled with decorations.

FIGURE 3-12
The exact configuration—a line with a loop at the end—serves for an arm with a hand, a tomahawk, and the two legs with feet.

FIGURE 3-13
The first head that the child draws is that of a human. Here it serves as an equally satisfactory head for a horse, until such time as the need arises for a more characteristic animal head.

FIGURE 3-14
The lollipop tree and the first human or tadpole have much in common. Each consists of the elements that the child has at her disposal at that time—the circle and the line—placed with the circle on top from which two parallel lines protrude.

(3-11)

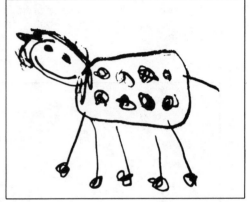

(3-13)

(3-12)

(3-14)

FIGURE 3-15
Sun shapes, which were probably developed independent of the figure, are recycled here as both hands and feet.

FIGURE 3-16
This Egyptian child shows the inside and the outside of the bus simultaneously.

FIGURE 3-17
This little girl was drawing a lady who was "too fat." To show just how fat she was, Peggy drew two babies in the lady's too-fat tummy.

FIGURE 3-18
The boy who drew this race car added two wheels on the bottom and two on the top in order to add up to four. The result is a flattened-out vehicle.

the draw-everything principle

The typical adult approach to drawing is to depict objects and humans from a single point of view. The child, on the other hand, has no such restriction, and like the Cubists and other artists, often draws what can be seen from several or all points of view and may include in drawings things that cannot actually be seen. The French philosopher Luquet, whose early-twentieth-century studies of children's drawings are well known, gave this phenomenon the name *Intellectual Realism*[15]—which referred to the fact that children seemed to be drawing, at a certain stage, everything that was known about an object. The draw-everything principle assumes a variety of forms in children's drawings—pictures showing both the inside and the outside of houses and cars and even of humans; tables seen simultaneously from the side and the top; a bus with half of the wheels on the ground and half appearing to rise from the roof (3-16–3-18).

(3-15)

(3-16)

(3-17)

(3-18)

FIGURE 3-19
Ryan drew the members of his family, including the baby on all fours, each about the same size, until he was reminded to put himself in the picture—the enormous figure that looms above the rest. Children will often exaggerate the person that they perceive as most important.

FIGURE 3-20
When I throw the ball, I use my right arm; it is almost as though the child wishes to show that all of the energy had been transferred to that limb. The other arm shrinks as it loses importance; at times it will disappear altogether.

the plastic principle

The artists in ancient Egypt depicted members of royalty as larger than their servants. Children, too, exaggerate those objects, persons, and actions in their drawings that are most important. In a family group, *me*, or perhaps one parent or another, is the dominant figure. The action of throwing a ball calls for the exaggeration of the vehicle performing the action—the arm—whereas the other arm may be smaller, shrunken, or even completely absent (3-19 and 3-20).[16]

As we have noted, the natural predispostion to apply these seven graphic-ordering principles is strong and governs most of the child's early drawing activity. When a principle is not applied—a child draws a chimney at the proper angle to a roof or arms and legs are the same length regardless of importance or a horse consistently has four legs regardless of the size of the body—and these principles are certainly not always applied, the reason may be that

• One principle has, for some reason, taken precedence over another.
• The child has learned, through practice and observation, to overcome the natural tendencies.

But many adult drawings are still governed by the force of some of these innate principles. Indeed, the fact that these principles continue to influence drawings for a lifetime is not undesirable—many so-called primitive painters, such as

Grandma Moses,[17] have produced paintings of great charm and elegance. The continued practice of these principles only becomes undesirable to the individual when she wishes to overcome them and cannot—either because she does not know how or when she fails to find assistance in learning how they might be overcome. A most important question is whether or not adults should help children to overcome the influence of these principles when their help is sought.

(3-20)

47

Should adults attempt to influence the way children draw?

As we have just illustrated, the nature of children's drawing is determined by an innate set of graphic-ordering principles, and we shall illustrate in the next section the naturally evolving process of the child's drawing development. If drawing is, then, in essence, "doing what comes naturally," then we need to ask, *What is the role of the adult in the graphic developmental process*? We began this chapter with a brief history of child art and Franz Cizek and the nonintervention theory, and we have also stated unequivocally that we do not agree with the hands-off edict. Beyond our strong disagreement with the commonly held view that adult influence upon or interference with what appears to be an entirely natural process will destroy the child's spontaneity and creativity, we believe that adult assistance is actually necessary to the actuating of the child's spontaneity and creativity.

Is it possible to avoid influence on the child's drawing activity? Can an adult, a parent or teacher, be so completely neutral that she does not, even unconsciously, influence in certain ways? Can visual material—the drawings of other children, their own growing perceptions of the world about them, illustrations in books and magazines, television, the work of artists in museums—all be withheld from the child? The answer is obviously no. If we cannot, in the natural course of the child's life, avoid influence,

then should not the adult assure the child's exposure to good influences that will allow her to develop as fully and as richly as possible? Without the exposure to influences such as fine art, that left to her own devices she might never discover, the child is forced to rely on those influences of the popular media that are easily and universally available. There are some children who will seek out for themselves sources of images and ideas, who can recite at will the names of artists and illustrators and cartoonists, who can tell you what these artists draw, how they draw, and how well. A good many others who do not have the same motivation would, nevertheless, continue to draw if given the encouragement and shown the way to greater graphic skills. Presently, however, few children are able to adequately explore the rich reality-inventing possibilities of drawing because the things they are able to draw are too few or are lacking both in complexity and expressiveness. And how do these *good* influences serve to help the child to develop her graphic capabilities other than offering models from which to draw—to copy? We believe that the innate principles interact with the structure of the world—with influence factors—by which, through a continual problem-solving process employing both the senses and motor capacities, the child formulates more complex sets of rules for drawing with greater accuracy and completeness.

In addition to supplying good models, what might the adult do to increase drawing activity? Returning to our earlier language analogy, it is a fact that children learn to speak through the interaction with adults—usually the mother.[18] It has been found that when the mother talks to her infant or young child, she will automatically simplify her speech so that it is just a level or so higher than that of the child. In this way she presents, in her own language, the models for the child's next level of language development or the next set of rules for the child to follow. In the same way, we think that one of the most effective ways to facilitate drawing development is to interact and to present the child with drawings at slightly higher levels than her own, as well as verbal descriptions of the next higher level. We have observed that when a young child draws alongside an older child there is a natural flow in the process to the next higher model of drawing attainment, since the older child is likely to be drawing at this higher level. Few adults, however, are as familiar with the order and sequence of drawing skills as they are with those of language. In order to interact with children sensitively and spontaneously in the course of the graphic developmental process, it is important that adults be able to anticipate the subsequent steps in the child's drawing development. They must, therefore, become familiar with the general course of that development.

Influencing the course of drawing development

The general course of the development of the child's ability to draw can be most easily described and understood through the development of the one object most frequently depicted by children—the human figure. We will therefore trace the evolution of the figure from its genesis in the child's first scribbles through its unfolding to its conclusion as a complex depiction of the human form.

This section is organized into three columns. In the left-hand column are illustrations. In the middle column are descriptions of drawings characteristic of the developmental steps. The right-hand column consists of suggestions presented to provide adults with possible words and actions that will help them to lead children easily and smoothly to higher levels and richer realms of drawing.

In this overview of the sequence of steps in the child's drawing development we have purposely avoided any indication of the ages at which these steps occur. We have found that what one child draws at eighteen months, another child draws at age four; what one child draws at four another draws at six; and what a few gifted children can draw at age six may easily surpass the drawing of most adults. It is also true of the child's development that, although essentially linear in nature, the child may at any time jump ahead or return to an earlier type of depiction for reasons and purposes that are her own. This moving back and forth among the various phases is a normal part of the process of development, and should not be regarded as regression.

irregular scribbles

drawings, descriptions & explanations

suggested responses

FIGURE 3-21
Scribbles like this are the result of the child's heavily punching, poking, and jabbing the crayon on and often right through the surface of the paper.

This scribble and other early scribbles are the result of the child's grabbing the marker in her fist, her tongue thrust between her teeth, and heavily marking, as well as punching, poking, and jabbing, sometimes right through the paper.

Although seemingly random, upon close inspection these scribbles can be seen to contain virtually every conceivable direction that a line might take. Just as the babbling child makes the sounds that will, in combination, become words, the scribbling child makes the lines and shapes that will, in combination, become recognizable objects. Through this endless variety of irregular scribbles the child is developing graphic

When markers and paper begin to interest the young child and tentative scribbles appear, attention and enthusiasm are the best encouragement. You might respond with "ooohs" and "aaahs" or you might join in, scribbling along with the child, on the same page or on a separate one.

Plenty of paper and pencils, crayons, or markers as well as your attention and interest should be easily available.

drawings, descriptions & explanations

suggested responses

skills not only through patterns of muscular movement but also in the ability to perceive the more regular shapes that will be "lifted out" of these first scribbles.

regular scribbles

Out of the chaos of the irregular scribbles, the child surely discerns basic shapes and configurations, which she then begins to repeat, in a more orderly array, of circles, ovals (3-22), vertical and horitontal lines, crosses, ladders (3-23), squares, and rectangles. At this time the repetition of shapes, particularly the circle, which

The appearance of shapes that are more coherent—at least to an adult—makes referring to "circles," "zigzags," and "ladders," as we recommend that you do, an easier task. Of course, the child's naming of the elements makes talking about the scribble drawings easier still, although you should not be surprised if what was a

FIGURE 3-22
In this scribble, shapes begin to emerge—the circle and the square—in addition to some writinglike lines or decorations at the bottom.

FIGURE 3-23
Vertical and horizontal lines dominate this picture, and the ladders, which are common occurrences, are the result of the child's natural preference for depicting a maximum amount of contrast.

FIGURE 3-24
The circle is repeated over and over again and will soon be used to "stand for" any number of things—eyes, nose, mouth, head, body, arms, legs, fingers, toes, and so on.

FIGURE 3-25
In this scribble, shapes are clearly seen as rectangles with a circle in the lower right of the drawing. One also wonders whether the child has purposely attempted to show the letters A or F, both of which are letters of his name.

FIGURE 3-26
Scribbles are often balanced or symmetrical in nature, as in these concentric circles with matching vertical scribbles on either side.

precedes the square and the rectangle (3-24), seems to be almost endless. This repetition serves as a means to mastery of skills needed to produce the desired size, form, and arrangement of shapes and configurations to be called upon wherever and whenever needed throughout a lifetime of drawing.

The child often proclaims these configurations to be daddies or eyes or pillows or animals or whatever other object suits her immediate fancy. This *romancing*[20] (Figure 3-27) rarely refers to any recognizable element in the scribble but confirms for the child the fact that drawn shapes can not only "stand for" or represent "things" but can also present ideas.

As the child begins to repeat

"mommy" on first telling becomes a "doggie" or a "pillow" in subsequent versions. Your asking "What is it?" may elicit some exciting and excited responses and is often the first step in the child's ventures into narrative (Chapter 6).

Now is the time to show the child, as you draw along with her, circles that are rounder, lines that are straighter, and squares that are squarer than those she has drawn. These should not in any way be held up for comparison and the child's efforts should still be praised, but the presenting of models is designed to show the child the possibilities for her future productions. You might even attempt the more complex designs that will shortly

(3-24) (3-25)

(3-26)

FIGURE 3-27
Jonathan (age 5)
This Robot's Dead (pencil and crayon)
14 x 17"

Jonathan's scribbles, as is true of most "as if" scribbles—these we describe as scribbles that serve merely as accompaniment to the child's verbal narrative and are treated "as if" they were true graphic illustrations—changed identity as quickly as Jonathan's imagination dictated. He began by drawing (on the left of the page) a house on fire, changed it to a giraffe, and soon just as positively declared it to be a Martian with a long neck. "There's his nose; there's his mouth," added a flying "saw-saw" to his picture, and a snake to bite his Martian. Anxious to describe his completed drawing, Jonathan announced that it was "war." His final recounting of the parts of his scribble drawing was the best story of all.

"That robot's dead; *that* robot's dead—yeaaaa!" (creaking sound effects)

"And this robot's dead" (sound effects of bullets—killing him on the spot)

"*Zero!* Gotta make it a zero!"

"And these robots are dead. And this is a building. This building—all the people are dead so ex that out."

"And—one sole survivor."

"All the people are dead in that house so—ex that out."

"That one's exed out now."

"The building's out" (making marking noises to illustrate and emphasize the complete annihilation).

At this point B., who had been listening to Jonathan's commentary—and urging him on with questions such as "That's gone too?" and "One sole survivor?"—declared, "I think it's going to just destroy everything." Jonathan answered gleefully, "Yeah!" and making a few more stabs at the page with his crayon announced, "That's it!" and settled back in his chair, pleased that his story had reached such a satisfactory conclusion, a beatific smile on his elfin face. B. agreed, and concluded, "That's it; everything is gone."

Jonathan's scribble has little relationship to his story except in the spirited movements of Jonathan's crayon and pencil as he marked off the area of the page and the marks that would stand for a house, a giraffe, a Martian, a flying "saw-saw," a robot. The marks simply emphasized the workings of Jonathan's rich imagination—and almost like musical notations—marked with this jumble-tumble, higgledy-piggledy hodgepodge, the highpoints of the story.

drawings, descriptions & explanations

suggested responses

basic shapes in her drawings, letters and numbers often appear. Sometimes they are letters of the child's name, sometimes simply those letters that are appealing because they include the circles, lines, and crosses that the child delights in producing.

emerge—circles surrounded by other, smaller circles, crosses superimposed on circles, suns and radials and even heads with facial features or arms and legs.

combining simple configurations

FIGURE 3-28
The sun shape is one of the first designs to appear in the drawings of some children and is generally made use of consistently thereafter.

FIGURE 3-29
The radial is a variation of the sun theme, but with all of the rays emanating from a single point.

FIGURE 3-30
Once the child has mastered the circle it can be employed in all sorts of decorative ways. Here is a typical concentric circle design.

Some children may combine the circles, crosses, and straight lines of their early scribbles to produce an astounding variety of images—suns (3-28), radials (3-29), imbedded circles (3-30), and mandalas, i.e., a circle or square containing a superimposed cross or geometric form. At times mandalas are as elaborate and exquisite as baroque jewelry (3-31).

The decorative images indicate the child's natural preference and feeling for symmetry, for order, and for contrast. It is important to note that there are some children

Your cue, when these designs appear, is to simply enjoy them with the child. Your verbal expressions of appreciation— "how beautiful," "great," "fantastic"—might be accompanied by queries as to how the designs were made. You might ask the child to demonstrate as you draw along, creating designs very much like those of the child, with only a little more sophistication and complexity.

(3-28)

(3-29)

(3-30)

drawings, descriptions & explanations

who may draw large quantities of such designs while others, even those who may spend a good deal of time drawing, produce hardly any designs at all.[21] The child who rarely or never draws designs may be very much involved in presenting ideas or in narrating stories.

FIGURE 3-31
Some designs that include crosses within circles have been seen by some as *mandalas*.

figure drawings

FIGURE 3-32
This *global* person consists of a circular shape which follows the contour of the page, inside of which are facial features and sometimes even body parts.

There are many children who move directly from the drawing of circles and straight lines to human heads or figures. Others arrive at the human only after a journey through the world of pattern and design.

A first human sometimes consists of a circle with eyes, nose, mouth. The circle often follows the edges of a sheet of paper or, in other cases (3-22), the edge of the paper itself serves as the boundary into which facial features are placed.[22] Although there is the inclination to consider this presentation as a kind of disembodied head, for the child it is likely the whole human, and often arms, legs, and even "tummy" appear inside the circle (3-33).

Other first humans are characterized by the head, with or without features, atop a pair of legs consisting of two parallel lines, with sometimes two other straight lines protruding horizontally from either side of the head, and known as the "tadpole" person (3-34). Still other of these first humans appear to be

The circle that the child draws may "stand for" the head and body. Therefore a question— "Where are the legs?" "Where are the arms?"—may lead to the addition or indication of appendages either outside of the circle or within it. Perhaps the best way to provide a model for arms or legs coming from the circle is simply to draw the tadpole for the child, indicating, as you do so, "These are arms and these are legs." The child may not begin to add these features on her own immediately. Again you will simply be providing a model for features that the child may later include in her drawings.

The child may also respond to suggestions that there might be something omitted from her drawing. A game may result in which child and adult together attain more and more complexity as "What else?" suggests feature after feature to the child, or asking for an unexpected feature such as the "tummy" may produce surprising results (3-36).

(3-33)

(3-34)

(3-35)

ovoid Humpty Dumptys with a belt about the midsection (3-35). These last first humans have in common the arms that seem to extend from the head. These figures may represent both head and body or else the body may exist in the space between the legs. If, on the other hand, the circle "stands for" the head alone then the questions arises, "Why do the arms come from the head?" Freeman found that when he presented children with predrawn figures consisting of either a large head segment and a small body segment or vice versa, children were most likely to attach the arms to the larger segment.[23] And why do the arms emerge from the head with a horizontal orientation? Here we see children following the "perpendicular principle" (here either the contour of the circle or the implied vertical body line seem to serve as the baseline to which the arms are oriented at a 90-degree angle).

FIGURE 3-33
To the child this *global* figure, complete with navel, "stands for" the complete person, body as well as head.

FIGURE 3-34
This is the figure best known as the *tadpole* person because like the tadpole it generally consists of a head and legs only.

FIGURE 3-35
This Humpty-Dumpty-like *tadpole* represents the child's attempts to delineate where the head ends and the body begins.

a body is achieved

The next step in the development of the drawing of a person is the indication of a separate body. Sometimes simply a line of buttons (3-37) or a navel placed in the open space between the two parallel "legs"

Just as it is possible to add complexity to the circle and see it transformed to a full-fledged figure by simply suggesting that parts have been forgotten, so the addition of a body may be accomplished.

FIGURE 3-36
Becky (age 3)
Where's the Tummy? (rolling writer©)
14 x 17"
A tadpole was drawn by Becky as a result of a playful exchange. Her many earlier drawings had consisted of colorful scribbling. She was told that this time she would be shown how to draw with lines.

Adult: Do you ever draw people? Show me how you draw people. (Becky draws a circle.)
Adult: Anh, huh, and what else do people have? (A leg and a shoe appear; another leg and "another shoe.")
Adult: What else do people have?
Becky: Eyes (she draws one)
Adult: Oh, that's a beautiful eye—and what else do people have?
Becky: ... need to do the other eye.
Adult: ... other eye; and what else do they have?
Becky: A nose.
Adult: Where is it? Right there? (as Becky draws) And what else do they have?
Becky: Hair.
Adult: Hair, OK, yeah; and what else do they have?
Becky: Uhhh ...
Adult: I think you're forgetting something important (indicating arms by emphatically waving his own).
Becky: Arms!
Adult: Right! Where do they go?—and what else?
Becky: Hands!
Adult: And what else besides hands?
Becky: Nothing else (thinks of something—draws)
Adult: Aha! what's that?
Becky: Fingers.
Adult: Yeah, 'cause I thought there was more, and I think there's some-

thing else you're forgetting, too. You know that? (There is a discussion about talking.)
Becky: Needs a mouth.
Adult: Where is it?
Becky: I don't know (then adds mouth). Right here!
Adult: Oh, I'm wondering something else now.
Becky: What? (she is intrigued)
Adult: Where is the tummy?
Becky: Tummy? Where can I put her tummy? (Becky is truly baffled. If here is a head and there are legs, where can the tummy possibly fit?)
Adult: There's a way you can do it! (Becky sets aside the question of tummies while she works it out.) Oh, how about the cheeks?

Adult: Yeah! Get 'em.
Becky: Gotta have cheeks.
Adult: Gotta have cheeks—oh, that's so beautiful!
Becky: Oh, I forgot something! (Becky has solved the problem of fitting in the tummy and quickly draws a line connecting the two legs) ... Need that across.
Adult: Then what can you do? Where's the tummy button? (Becky is pleased to have found the solution. She places a "tummy" in the space between the legs which has now become a body, and with a triumphant squeal, adds the button in the center.)
Adult: There—now you have the whole thing!

a body is achieved (continued)

drawings, descriptions & explanations

(3-38) signals that the child is ready to locate a body in her depiction.[24] At this time the child may indicate the presence of a body by closing off the space between the legs with a line (3-39).

The addition of a shape such as a larger circle, an oval, a square, a rectangle, or another

suggested responses

While drawing with Philip, M was asked to "make" a girl, and she proceeded to draw her own concept of "girl" with long hair and a skirt, but soon realized that the skirt no longer identifies a girl in today's culture. Asked how he could tell the difference between boys and girls, Philip replied, " 'Cause girls

(3-37)

(3-38)

(3-39)

FIGURE 3-37
The space in between the legs of this *human* is filled with buttons, one of the first efforts to indicate a body as separate from the head.

FIGURE 3-38
The tummy of this figure also indicates that the child is endowing her figures with a separate body. Often the navel exists only as a single dot.

FIGURE 3-39
Here the line that closes off the space between the legs of the figure is often the step before a deliberate and separate body part appears.

geometric or amorphous shape is a more definite indication of the body (3-40).

have long hair and you can't see their ears." Philip draws a boy—the ears are clearly seen. The figure designated to be a "girl" has hair covering the area of the head where the ears would be. M persists (still looking for a skirt): "And how else do we know it's a girl? Sometimes girls wear … what?" Philip's answer is clear. "Ummm … shirts—like the boys." (Only he differentiated by adding stripes to the girl's shirt.)

the development of characters

Once the child has a complete program for depicting the figure including the body and all of its parts, she can attend to such features in her figures as maleness and femaleness, role, age, what they do (action) and how they feel (emotion).

This is accomplished through elaboration—the addition of detail, variation of an astounding number of geometric and amorphous forms, and a seemingly infinite number of combinations of shapes and patterns. It is as though the earlier experimentation with decoration is now being employed to enrich drawings of people.

At this time, also, notice the way in which the arms begin to

As figures gain in complexity it becomes possible to speak to the child about spacemen and spacewomen, princes and princesses, hockey and football players, cowboys, dancers—the list is as long as the child's imagination and her ability to depict.

Just as complexity was added to the tadpole figure through the suggestion or discussion about parts that may have been left out, so asking and telling about characters that the child has depicted can help the drawings to become more rich and exciting.

Questioning often leads to the best results—calling up the child's own mental images.

FIGURE 3-40
These nine drawings show the multiple forms that a body, once established, may take—the square, the triangle, the circle, and a variety of irregular and amorphous shapes.

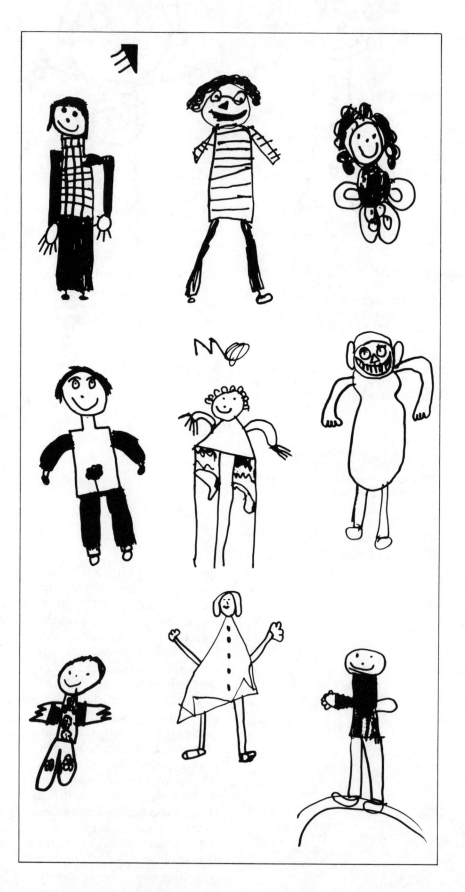

the development of characters (continued)	drawings, descriptions & explanations	suggested responses

emerge from the shoulders and to curve down at the sides of the body, replacing the former perpendicular appendages. Elbows and knee joints, however, seem not to appear until later.

• How does the spaceman breathe?
• What sort of suit does he wear?
• Does he carry special equipment?
• How does he move through space?

All of these questions are by way of providing more information about the character and enabling the child to add complexity to her drawing.

limbs are fused to bodies

Although some children may spend years drawing figures composed of separately formed body parts—arms, legs, hands, and feet, other children move quite rapidly to drawing people whose bodies, arms, and legs are joined in one single embracing contour.[25]

The newly acquired embracing line may join together two or more bodily parts, i.e., torso, head, arms, legs; torso, arms; torso, legs; head, torso (3-41).

These fused figures drawn by young children have few details; heads are often large in relation to the body and they frequently resemble a gingerbread man or the Pillsbury doughboy.

It is usually not until this time that the child is able to show the more extreme human actions, such as running, falling, and climbing. The effect of action is generally accomplished through the curving of limbs, which may eventually come to be bent sharply at the knees and elbows (3-42).

As with the ascent to each level in turn, the very best response remains approval and enthusiasm. Verbal encouragement needs to transcend the usual "Oh, that's very nice" and to show a genuine interest and involvement. One such exchange ensued when Philip was ready to show figures in action.

Adult: This boy is running, right?
Philip: Right.
Adult: How do you know he's running?
Philip: 'Cause he's got his arms (demonstrates that they are spread out).
Adult: 'Cause he's got his arms out like that. What about his legs?
Philip: Well, I couldn't get 'em very runned.
Adult: Well, what would you have to do to make him look like he was running? When you run what happens?
Philip: Put one foot here and the other foot there (indicating legs apart).
Adult: Right! OK, and what else happens? What are these?
Philip: Knees.
Adult: They're knees. Do they bend?

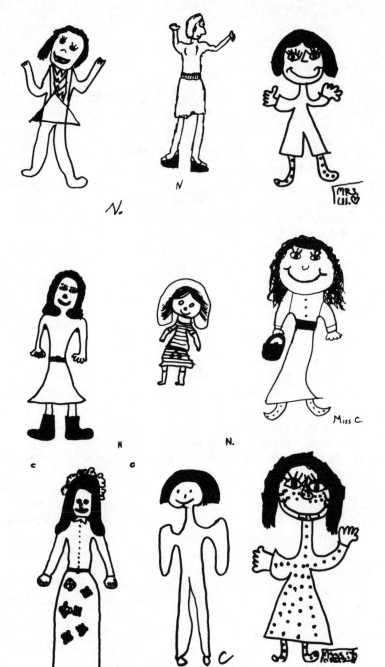

FIGURE 3-41
In these nine drawings the children have begun to draw figures in which bodily parts are fused within a single contour—heads fused to bodies; and in one instance, head, arms, legs, and body have been made with one continuous encompassing line. Some figures at this stage are still geometric, while others have begun to conform to the contours of the human body.

FIGURE 3-42
These figures are able to perform all manner of gymnastic moves through the simple device of curving limbs and bodies.

(3-42)

drawings, descriptions & explanations

suggested responses

Philip: Mmm hmm.
Adult: Well, how could you——
Philip: I don't know how to make knees—and that's the reason I can't do it [make the boy running].

M demonstrates drawing a boy running, knees bent. Philip's subsequent running figures show legs apart in a running posture, but knees are still a problem (8-17).

When the child reaches the point where the body and limbs of her drawn figures are encompassed in a single contour, where clothing detail is added and the depiction of the bending of elbows and knees indicates action, she has passed the bounds of the natural unfolding process. Only by overcoming or going beyond the principles of simplicity and horizontal/vertical contrast is it possible for her to show action and to depict complex characterization. In the next chapter we will direct our attention to the full extent of drawing development beyond innate principles and natural unfolding and to the factors that effect this further development.

In this chapter we have shown the ways in which children's natural preferences for certain kinds of shapes, relationships, arrangements, and order, coupled with children's developing mental capacities, lead them to apply innate principles in increasingly advanced ways as they draw.

We have stated also that, in the course of the natural development from simple to complex, the child cannot avoid influence either from implicit or explicit criticism or approval from adults, or from her growing perceptions of the world about her.

We have provided a map of the child's growing ability to depict from the first kinesthetic poking and jabbing at the paper, through the stages of the scribble, irregular and regular, to simple configurations and figure drawings from tadpole to fused figures.

We have also suggested ways in which adults may help children to broaden and to extend drawing development. We have certainly encouraged the acceleration of development and the surpassing of the natural principles. Although this might be viewed as a bias against child art or as implicit criticism of the way in which children draw, on the contrary, we share the view of most adults that child art has a particular rare spontaneous charm that is to be valued. We go beyond this adult view, however, to the child herself, who so often expresses frustration that her work does not look as she would wish it to and even frustration with the adult who believes that it should look exactly the way he wishes it to be. Just as we record and value the development of the child herself, from the very first cry through the many and marvelous stages of her growth, we value the child's graphic development from mark to scribble to drawing. We would not retard the child's growing at, say, the crawling stage or the one-word stage; neither should we retard the child's drawing at the point at which we, the adult, find it most delightful, or spontaneous, or flavorful. Child art is simply *child* art and should be allowed to grow and develop along with the child who produces it. If the child's graphic abilities keep pace with her growing perceptions and knowledge about herself and about the world, then her art will be seen by the child as not only satisfactory but pleasing as well, and many more children than presently do so may continue to construct, through drawing, ever more complex and elaborate realities.

chapter four

Learning to draw: the cultural aspects of graphic development

Two small boys are playing together. One boldly takes hold of the other's toy. The first child puts up a dreadful fuss and runs to his mother, crying, "Johnny took my airplane!"

Two young boys are drawing together at a table at school. One sees the other drawing a picture of a football player; he draws a football player on his own paper. The first child puts up a dreadful fuss and runs to the teacher, complaining, "Johnny copied my drawing!"

Two boys kneel on the floor drawing together; a large roll of paper is spread out before them. Each is intent on his own drawing but always with an eye on the other's. One boy sees something interesting happening in his partner's figures. He picks up on it, draws his own version, and adds details of his own. The two are surprised and pleased with the mutations and permutations of images that result from this continuous interaction. The scroll, and their delight, continue to build.

What is the difference between the last two scenarios? Why is the child who copies another child's drawing seen to be much like the child who takes another's possession? Are the boys drawing on the scroll simply close friends who have learned to share in their art-making activities or are they following in some measure a time-honored artistic tradition?

We will respond to these questions and raise others, as well, as we attempt to trace the course of various influences on the drawings of children and to show the ways in which the interaction of natural and cultural forces determines not only the form but the style of an individual child's drawing. For although the shapes of the child's first scribbles and tadpole people are almost entirely determined by natural forces working within the individual, very little time passes before the influences of the culture begin to interact with the natural forces.

Cultural images & children's drawings

The process of building reality and thus knowledge is, for the child, essentially a matter of searching out information about his environment, which he then uses to construct or to invent models of the world or models of reality. Thus the child builds his own realities in which are incorporated bits and pieces of the already existing world of his own culture or models of the four realities named in Chapter 2 that exist within that culture. The reality-making drawings of children combine innately determined features and features that have been experienced in the culture, as well as those influences from drawings, illustrations and other graphic materials of the culture that may have been assimilated perhaps consciously, perhaps unconsciously.[1]

Art in the culture. One function of art has always been to show the viewer a way to look at the world or at one aspect of the world or one reality. Does art, then, imitate life or life, art? The answer is "yes," on both counts. Art holds up the images of the culture as a mirror in which we may see ourselves reflected. The child, for example, sees himself both in the larger-than-life superheroes of the mass media and in the weak and little people whom the hero saves. But the figures in art and in fiction symbolize at once the small child afraid of the dark and the adult who turns on the light.

As the child employs his own drawing and fictions in order to work out his life's dilemmas and to construct his own realities, he then relies upon the models from the art and the literature of the culture. And the models that children know best are those of the popular media.

Therefore these are the models that we see most in the drawings of children in a plethora of Supermen, Batmen, Wonder Women, and Hulks. And before these superheroes became the dominant images in spontaneous drawings, children, especially girls, have had a long-standing fascination and love affair with the image of the horse.

As we stated earlier, we believe that these cultural influences are not only inescapable but also absolutely essential if the child is to develop drawing abilities beyond the most basic level and to take full advantage of all that drawing has to offer in developing knowledge about himself and about the world. But what do we wish to know of the influence of the culture on the drawings of children?

• When do cultural influences begin?
• Why do children borrow the images of other children?
• How are these images borrowed from the culture used in children's drawings?
• Can drawings that are influenced by adult art be considered creative?
• Should children's borrowing from the graphic images of others be encouraged or discouraged?

How children are influenced by the drawings of other children

Even before children begin to scribble they are subject to graphic influences. Perhaps the child's first visual experiences with horse or cow or even puppy and kitty are through illustrations—drawings and photographs in picture books and in magazines or images on television. These images provide some of the models for children's drawings; but there is another powerful influence that appears just about the time that children begin to draw their first human figures, the influence of other children. Young children observe the drawings of

children of their own age who are more advanced as well as those of older children. Since these drawings are closer to the level of their own graphic attempts, they are both easier and more appealing to emulate. Learning to draw from other children, at least in part, gives drawings done in different parts of the world or at different periods quite distinctively different characters.

Of all the rudimentary figures produced by young children today—the global and the tadpole person, in all their diverse forms—none of those forms resembles the one found regularly and consistently in the drawings of young children from, as nearly as can be ascertained, the 1880s through 1930 or so. This strange configuration,[2] like the tadpole, often consists of a head and legs, but the head, unlike any we are apt to encounter today, is turned to present a profile view and yet still includes two eyes (4-1).[3] When it was first discovered in 1882, the two-eyed profile was, in fact, declared to be just one phase in the natural development of children's figure drawings, and subsequently, in reports and studies of the drawings of young children from England, the United States, France, Belgium, Austria, and Germany, the two-eyed profile was accepted as standard, representing the stage between the front-view figure and the profile view. In those countries at that time the two-eyed profile flourished. Strangely enough, the incidence of these figures had sharply declined by 1923, until, as nearly as we have been able to determine, by 1953 they had disappeared in the United States. In a recent examination of thousands of figure drawings from Jordan, Egypt, Australia, and New Guinea we have not found a single two-eyed profile. Where did this strange figure come from and where, indeed, has it gone?

One thing that we can conclude with certainty is that, if the two-eyed profile once existed in such great numbers and now no longer exists, it could not have been the result of an innate or natural factor, but there were influences that were operative at that time and later ceased to function.

It is important to point out that nearly one hundred years

FIGURE 4-1
These figures showing the two eyes of the frontal face in a profile view were found extensively in drawings by children in the United States, Western Europe, and England from approximately 1883 until 1923, when they had virtually disappeared from children's drawings in the United States.

ago, today's interest in and encouragement of the drawings of children did not exist. Paper and drawing implements were in short supply and printing techniques had not yet developed to the sophisticated level of today's illustrations, certainly not those to which our children are treated daily in all their glorious color, and by which their drawings are influenced. And yet we have evidence that such drawing activities of children did exist—on walls and on fences and on any other available surface. If, as we contend, the culture and models from the culture so strongly affect the drawings of young children, and if the children of nearly one hundred years ago had no models from adults or from the media, where did they find them? Their models came from other children. With the advent of printed periodicals and the comics in the early 1900s, a great choice of models became available to children, and as they came into use the two-eyed profile disappeared.

Although it has long been considered wrong to influence the child in any way, it is obvious that influences are present from the time of the child's earliest art experiences.

why borrow from others?

Today the influence of children upon other children is still one of the most prevalent influence factors, and one of the most important. Children's drawings are infinitely more modelable for children because, as we have said, they are close to the level of the child who is doing the borrowing. By modeling his

drawing upon those that are more advanced, and thus represent a level that has not yet been reached, the child may more easily reach the desired levels. Because they are closest to his drawing experience, the child most readily calls upon the memory of his own previously drawn images. When he fails to see his own drawing as satisfactory, he turns to the graphic images of other children, of adults, and of the media.

The child who reacted to the borrowing of his image as though he had been deprived of a precious possession was reflecting the attitude of adults who for so long have lived by the edict, *Never let one child copy the work of another.* But why not? Why is it that for hundreds of years, artists have gone to the art of others before them to learn how to depict the turn of a head, the position of a limb? Why may we better learn to draw a horse by seeking out the wonderful horse drawings of Degas and Lautrec than by going to the horse itself? It is partly a matter of employing the means that are most expedient. Civilization might not yet have reached the horse and buggy age if man had continually had to reinvent the wheel. Art, too, would have remained in the dark ages if artists could not have benefited from the discoveries of other artists. Degas and Lautrec have already solved the problem of reducing the three-dimensional horse to a two-dimensional medium—no easy task for a novice artist. When a child sets out to draw a particular object or form, he relies on memory—memories of other drawn or graphic images—as well as per-

ceptions of objects in the phenomenal world. But the graphic image, already stated in two-dimensional terms, is more easily recalled because it is more simple and static than actual three-dimensional objects that move and change about in everyday experience.

is borrowing bad?

When they were young children, artists Picasso,[4] Beardsley,[5] and Millais[6] demonstrated a prodigious ability to copy the art of others. Indeed, borrowing, imitating, copying, modeling after—call it what you will—may be one of the most important factors affecting the early development of artists.

But won't such copying activity adversely affect the child's own creativity and spontaneity—the child who is, after all, neither Picasso nor Beardsley nor Millais—and force him to be forever dependent upon such crutches? The mature artist may borrow a technique or a style or even an image from another and then he extends, recombines, and uses these elements in new contexts and in new and individual ways; children do the same. Most children borrow images and turn them to their own purposes. The two boys drawing on the scroll in our third scenario were playfully involved in just such a situation. In other cases an idea is caught up as it sparks the imagination of one child and then another. Four-year-old Jonathan was watching a playful drawing exchange between his friend Holly and an adult, when a Martian entered the picture. Jonathan's face brightened; he added a Martian to his own

drawing, invented a "flying saw-saw," and was off on imaginary flights of his own (3-27). In this way, the child's drawings are certainly individual and personal, and most often inventive, original, and creative. The child only remains fixed on a single image or on a single way to draw if he is not presented with other models or encouraged to seek out other ways to draw.

From mickey mouse to spiderman: varieties of cultural influence

A hundred years ago the thought of giving a child paper or crayons and paints would have been generally unthought of. Today, the stores are filled with every variety of marker and paper, paint sets, and other paraphernalia to please the heart of an aspiring young artist. This emphasis on the child's creative graphic endeavors is perhaps the first and most vital aspect of cultural influence. For children who are encouraged to draw, provided with all manner of drawing materials, and the model of drawing adults and children, drawing becomes almost second nature, and its continual practice leads them to develop much more quickly and easily than children in cultures where little encouragement is given.

In a culture like ours with the visual materials at the disposal of children in the form of photographs, illustrations, comics, television, and movies, it is natural that these materials should influence their drawings. Maurice Sendak, the wonderful illustrator of many children's books and fairy tales writes of things that influenced his own drawing:

People imagine that I was aware of Palmer and Blake and English graphics and German fairy tales when I was a kid. That came later. All I had then were popular influences—comic books, junk books, Gold Diggers movies, monster films, King Kong, Fantasia. *I remember a Mickey Mouse mask that came on a big box of cornflakes. What a fantastic mask! Such a big, bright, vivid, gorgeous hunk of face! And that's what a kid in Brooklyn knew at the time.*[7]

If the two-eyed profile was the subject of children's spontaneous drawing in 1882, and superheroes (4-2) lead the lineup some hundred years later, it is evident that specific sets of subject matter are unique to

FIGURE 4-2
Boy (age 6)
The Superheros (pencil and crayon)
9 x 12"
Superheroes appear in the drawings of children as young as four, and like six-year-old David's they are made up of figures drawn with an innately derived approach to drawing bodies, limbs, and heads. But the characters of Spiderman with his web, the Hulk (in fashionable green), and Superman with his cape are straight from the models of the culture.

specific times and cultures. What are some of the other images found in the spontaneous drawings of American children and of children in other Western countries? No list would be complete without space rockets and other space vehicles; monsters and dinosaurs; fashion figures; anthropomorphic creatures from Mickey Mouse to cute little bugs and animals (4-3) that talk and act in human ways; battles of space and air and under water; sports heroes; rock stars and rock groups (4-4, 4-5); complex machines; and fantasy worlds. We know that a hundred years ago none of these images existed and that a hundred years from now they will have disappeared, but because they are so much a part of the fabric of our culture it is sometimes difficult to realize that there are cultures in some parts of the world in which children's drawings contain few if any of the images we take for granted in the drawings of American children (4-6 and 4-7).

FIGURE 4-3
Jackie Sue (age 3)
Mickey Mouse (colored pencil)
8½ x 11"
In America, media influences begin early. At age three, Jackie Sue drew little figures she named Mickey Mouse—recognizable mainly by the big round ears.

FIGURE 4-4
Steven (age 8)
KISS (colored marker)
8" and 9" figures
Particular groups of musicians hold a fascination for young people. This is only a small part of eight-year-old Steven's depictions of the group known as "KISS."

(4-4)

FIGURE 4-5
Andy S. (age 11)
KISS (pencil) 8½ x 14"
Andy S.'s prodigious output of drawings include so many renditions of this one rock group as to be mind-boggling, and each one shows the members in different attitudes and states of animation. It seems to be the essence of the group that Andy sought to capture rather than the mere appearance, as Steven does.

(4-5)

FIGURE 4-6
These figures are typical of those found in the drawings of children in the United States.

(4-7)

FIGURE 4-7
The figures drawn by children in the Middle East today differ greatly from United States figures. They are not as complex, nor do they show the action, the character, or the humor of the latter.

Muscles & movements: drawing people & action

The difference between learning to depict all kinds of action or almost no action at all seems to be related to the extent to which children's drawings imitate the figures they see in illustrations in the media. Showing lots of extreme action is basically a cultural phenomenon, wherein images from the culture provide the models.

In a national survey conducted during 1974–1975 it was found that less than 20 percent of nine-year-olds and 39 percent of thirteen-year-olds in the United States could draw figures that appeared to be running,[8] yet we consistently find children as young as five or six who are able to depict figures that run, leap, fly, and move in astounding ways. These are children who model their drawings after the actions of characters seen in illustrations, in comics, and on television (4-8, 4-9, 4-10, 4-11).

While the ability to depict movement allows the child to

FIGURE 4-8
Boy (age 6)
Avengers (pencil) 8½ x 11"
It appears that this first-grader's careful observation of comic-book characters has contributed a good deal to his drawing development. On a single page he has drawn sixteen different superheroes, some of whom appear to have been borrowed while others are of his own invention. Notice the great variety of actions that the boy is able to depict, a fact certainly attributable to the moving, running, leaping, and flying figures he has seen in the comic books that he here emulates in this "cover" drawing.

FIGURE 4-9
Mike S. (age 10)
Killers (pencil) 8½ x 11"
In the multisectioned humorous depiction of the team that made it to the Super Bowl—in the stands—the influence of television is evident. The pan from *close-up* to *long shot* showing parts of figures and overlapping action shots produces a very different image than do figures that are influenced mainly by comic books. Perhaps because the action of the camera is more obvious in its rapid changes of view and position, the lesson of composition has been learned well in these frames.

(4-8)

(4-9)

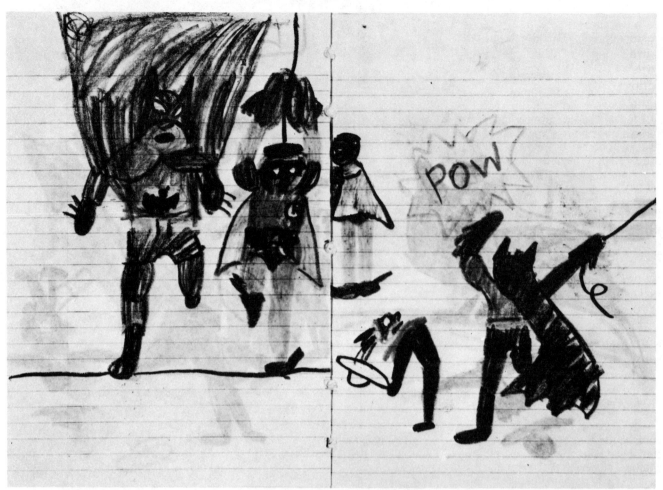

FIGURE 4-10
Taylor (age 7)
Pow (colored crayon) 10½ x 15"
All of the conventions of the Batman adventures seem to have been absorbed by seven-year-old Taylor, as seen on these two pages of his own Batman adventure. Batman, cape flying behind him, races with Robin to catch the masked bandit. As they race toward us on the first page, one leg is seen in a foreshortened view, which is reversed as we see Batman from the rear on the second page. Many adults are unable to achieve this kind of foreshortening in their drawings, nor could Taylor do so without the influence of comics.

FIGURE 4-11
Boy (grade 6)
A Satire (pencil) 4¼ x 4¾"
Younger children identify their superheroes by their clothes, their gestures, or their deeds. When you grow older you know that they couldn't possibly perform all of those deeds or move in the way they do without muscles. In this humorous depiction of a superhero, even these are a bit exaggerated.

bestow the characters who act out his symbolic reality-forming with the power to perform those actions, the manner in which figures are drawn gives evidence of the very nature of the characters themselves. The muscles of the comic's superheroes represent the powers that the heroes possess (4-11). The long flowing tresses and the curvaceous form of the heroine represent her feminine charms and beauty (2-23).

A visit to a fifth-grade class not long ago, revealed more than one aspiring comic-book artist. One boy in particular had hit upon a formula for showing action and movement with a minimum of drawing and a maximum of imagination. His action filled adventure strips were peopled with amorphously shaped villains and his superhero Super Pickle. In order to make Super Pickle run, the boy had only to draw him at an angle with stick legs and arms

bent in the proper attitudes; to fly he was placed in a horizontal position. By a simple manipulation of this single ovoid form, Super Pickle could perform all manner of feats.

The students in this class were being exposed to a series of carefully devised lessons in drawing the figure, including the showing of well-selected examples of masterly figures ranging from Michelangelo to Burne Hogarth,[9] the artist who drew *Tarzan* for many years. These images were taken from various sources and photographed on overhead transparencies so that after viewing the projected image, the students were able to use the 8½ x 11" transparencies at their desks as they would use reproductions. These and resources such as anatomy books were enthusiastically and excitedly devoured by students who were able to use these images to

improve, or in some cases, to develop their own drawings of figures.

A few weeks later another visit revealed the students immersed in their drawings, working on action and musculature and facial expression. One drawing stood out from the rest; the figure stood, flexing articulate muscles and wearing a menacing scowl on the accurately drawn face. The artist turned and was recognized as the author of the Super Pickle sagas. We said, "Hey, Jon—whatever happened to Super Pickle?" His answer: "Oh I don't draw *him* anymore. I mean, what can you do with a pickle?"

Students will most certainly turn to the media for their models. As parents and teachers we can make sure that the models they use are the very best ones available—the Michelangelos, the Burne Hogarths—rather than a stereotypical Super Pickle.

A bird's-eye view: depicting space

Baselines and free-floating figures, fixed locations, tilted planes, and an absence of overlap characterize the "naturally" developing ways that children depict objects in space. And many children are quite satisfied to show objects in these ways. Other children, however, draw in the manner of movie cameras moving above, below, and around objects; they zoom from long distances to extreme close-ups; scenes are drawn in

rapid succession as they dart from one view to another. The creators of movies, television programs, and comics have learned that they can create fuller, more complex, more believable, and especially more exciting images if they continually alter the viewer's implied location in space with respect to the objects they show. These children have made the same discovery. Movie and TV cameras and the comic-strip

and comic-book artists who have been influenced by cinematography have taught them how. One young boy, after having been shown how to make streets and buildings recede into the distance, exclaimed, "Wow, that's real power!"; and such is the real power of the graphic experience. For children who want to know "how," the ability to move objects in drawing is a power equal to psychokinesis.

FIGURE 4-12
Girl (third grade)
Space Visitor (pencil)
individual frame size 4¼ x 4¾"
This space odyssey tells, in the simplest drawings, the story of a space creature who lands on another planet, perhaps Earth, plucks a twig from a tree, and returns with it to his own planet. What is amazing is this third-grader's ability to zoom from a distance shot to a medium view to a close-up, back to a full shot of the spaceship, to medium shots for the action, and finally to a long shot of the ship returning home. The media lead to graphic accomplishments of which the child herself may not be fully aware.

FIGURE 4-13
Andy S. (age 11)
Bird's-eye View (pencil) 8½ x 14"
Andy S. can draw cars and motorcycles, spaceships and planes from nearly every imaginable point of view. This car is seen from above as if the viewer were either high up in the stands watching a race or in a helicopter hovering in the air.

FIGURE 4-14
Tony (age 8)
Starwars (pencil) 4 x 6"
Tony's ability to involve the "power" of perspective is no fluke; he does so in virtually everything that he draws, whether cities or houses or spaceships. Because of the profusion of space vehicles available in the media, children, especially young boys with a voracious appetite for such things, are able to use perspective and dimensionality in ways that boys of an earlier generation could not.

(4-13)

(4-14)

FIGURE 4-15
Tony (age 8)
Cityscape (ballpoint pen) 4 x 6"
This unusual depiction of space—almost as though one were looking at this cityscape from a third-floor window and across the street—is more unusual still because it was drawn by an eight-year-old. Television, photographs, and drawings have certainly served as his models, but Tony's ability to draw from a remembered image and to make the images his own is truly astounding.

Help or hindrance: pros & cons of copying

We have written of well-known and outstanding artists who copied from the work of others extensively as children. And yet, some children who copy will be able to produce, in the end, nothing but the most mundane copies. Why should this be so? Let us examine some of the outcomes of copying, the positive aspects first.

• Children gain confidence from the ability to produce drawings that have a style, technique, and accuracy far beyond those in drawings in which the child's natural resources alone come into play.
• Children are able to achieve mastery through copying—a mastery of the conventional ways of drawing. Such a mastery is necessary before the artist is able to go beyond the conventional to the creative.
• Copying enhances and facilitates perception of details because the more advanced

work from which the child copies necessarily contains more detail, which may otherwise have gone unnoticed.

Thus copying provides important information and a number of skills that contribute to development in art. But of course copying doesn't provide all that is needed for artistic development; the results of children's copying may even be detrimental to that development.

• Because the child may be incapable of devising new points of view, movement, or variations of the copied objects, the copy often becomes a frozen and inflexible schema which the child is unable to employ in ways other than that of the original image.
• The easily achieved slick results of copying may become so attractive to the child that his own more individual productions appear to him pale and

crude in comparison. This may result in an unhealthy reliance on copying with no attempt to go beyond the copied image.
• Since some of the images chosen to be copied by children tend to be among the most stereotyped to be found in the culture—the Snoopys and the smiley faces—they are least likely to contribute to the development of a taste for fine drawings and drawing techniques.

Should children, then, be allowed to copy? Since modeling-after is both unavoidable and inevitable as well as a necessity for skill development, the determined child will always seek out the necessary models for his productions. The child who would adhere to copying as a crutch should be guided out of this deadend. This can be done by encouraging activities that lead to exciting invention rather than mere conventions.

From A to Z: assembling an encyclopedia of images

Children cannot produce drawings without the necessary information about the objects, places, actions, and processes that they wish to draw. As they grow older, children develop a need to draw with greater accuracy and complexity. The reason is both personal and cultural; the child's maturational patterns and his personal desires as well as the culture dictate that he draw with higher and higher degrees of realism. Many children who lack the resources or the resourcefulness to find the necessary information just at the time when they become increasingly more critical and more demanding of their work cease to draw, and thus cease to utilize this important source of self-knowledge. In order for children to continue to draw, the information they require should be available and accessible.

Sometimes children discover their own sources. Often the source of information about the things children wish to draw will be photographs and illustrations, from fashion magazines and newspaper ads, magazines about cars and motorcycles, or comic books. Children should be provided with a variety of images from which to draw; a good selection of images may provide not only more information than a single image but different points of view as well. To this end children should be encouraged and assisted in the location, selection, and collection of images that will supply the necessary information and ideas for their own drawings. The collected images—preferably photographs and drawings, paintings, and illustrations by the very best artists—can be kept in an expanding file folder and located

where the child may easily refer to them whenever the need arises.

The important point is that it is not necessarily unchildlike, unoriginal, or undesirable for children to draw from the images of other artists or from photographs. Child art as well as adult art may come from outside—from other art—just as much as or more than from novel ideas generated from within. What artists and children do is to take existing cultural images and extend them, alter them, recombine them, place them in new contexts, and use them in new ways. Creativity is seldom achieved through the production of the utterly new but rather through taking those things which belong to the culture and using them in individual ways, resulting in images that are often novel and unique.

From convention to invention

Of all of the work that we have examined of young people, there is no better illustration of the amazing transition from that which is merely derivative—in this case, of the comic-book convention—to that which is truly inventive than fifteen-year-old John's story of *Gemini*.[10] John's

sources are not accidental or undiscriminating nor are the resulting images exact copies. According to John, his hero is "like [in] *Battlestar Gallactica;* like Buck Rogers; like Spider-man." John thinks that most other comic-book characters are all the same—"it is just the cos-

tumes that change." Just as the plot of his complex cosmic tale is an amalgamation of myth and fairy tale and all of the tales of adventure and space, of quest and villainy, of romance and combat and jeopardy that have ever been told, so his drawings combine all of what John

has seen and drawn and remembered. He has only to lay out before him a vast store of images—most of which now exist in his mind's eye, some of which still exist in the form of photographic or graphic images, and all of which he can call into play when a new image is needed. He has borrowed and extended and combined just as generations of artists have done before him. Years of drawing from and critical examination of the work of comic-book artists has also enabled John to discriminate between what is good—"There aren't very many of the good artists left; it's getting down to the ones who aren't very good—who don't even try to be good"—and what is not. He aspires to be among the "good" artists and continually strives to improve his own drawings. Young people like John have gone beyond admiration and emulation— "That's great, I'll do one just like it"—to discrimination and invention—"I can do better than that!" And he can! And they can (4-16 and 4-17)!

FIGURE 4-16
John (age 15)
(pen and ink)

FIGURE 4-17
John (age 15)
(Pen and Ink)
These drawings represent John's ability to narrate in a single frame, to convey graphically the feelings of power and force and of helplessness against those powers, to produce an exciting and eloquent image through the use of line and masses of dark and light; and they demonstrate his own unique manner of using design and decoration. These many well be comic-book conventions and formulae but the formation is John's own.

chapter five

More & more: expanding drawing vocabularies

When Leif was four years and two months old he drew his first airplane. Another two or three planes were drawn before bedtime on that Friday evening. Perhaps it was the airplanes proficiently drawn by his eight-year-old brother that inspired Leif's drawings, but the pleasure and excitement of his new accomplishment was unmistakable, and his father offered him a 9 x 12" pad of newsprint and told him that he could draw more airplanes in the morning. And draw he did. Between that Friday night and the following Sunday evening, just forty-eight hours, Leif made drawings of 164 airplanes or partial airplanes. Almost every plane was drawn on its own sheet of newsprint, and these sheets attest to a little boy's amazing struggle to master, to his own satisfaction, the drawing of a single object (5-1–5-6). Only forty-five of his planes could be considered complete. These contained a fuselage, two or more wings, wheels, at least one tail, and a propeller. A few planes also had a pilot. These completed airplanes Leif surely must have considered his successes. There were many more failures. Twenty-two sheets contained completed fuselages with one or two wheels, a single wing, or wheels and a wing. By studying these drawings it is possible to guess why Leif aborted his mission; often the placement was wrong, or there was room on the page for one wing but not two. But Leif's lack of control led him into even more serious difficulties. Twenty-six of the pages contain complete fuselages and nothing more. Apparently Leif decided that they were either too fat or too long, had undesirable bumps, or for some other reason did not merit becoming full-fledged planes. Another sixty-four sheets contain fuselages that were not even completed. They, too, appear misshapen, ill-placed, or otherwise out of control. Finally

(5-2)

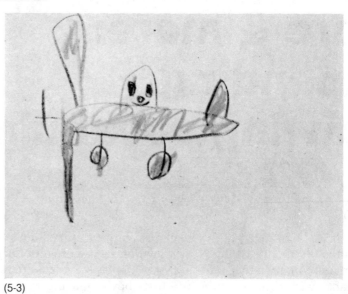
(5-3)

(5-4)

FIGURE 5-1
Leif (age 4)
Airplanes (colored crayon) 9 x 12"
Most of Leif's 45 completed airplanes
look like this—complete with the
basic fuselage, wings, wheels, tail,
and propellor.

FIGURE 5-2
Leif (age 4)
Airplanes (colored crayon) 9 x 12"
A few of the planes contained extra
wings and tails and the suggestion of
a pilot in the cockpit.

FIGURE 5-3
Leif (age 4)
Airplanes (colored crayon) 9 x 12"
Even fewer of Leif's planes became
almost tadpole planes with the head
of the pilot in the cockpit above the
leglike wheels.

FIGURE 5-4
Leif (age 4)
Airplanes (colored crayon) 9 x 12"
Of the 22 planes that were substan-
tially completed, this appears to have
been placed in such a way that there
was room on the page to place one
wing satisfactorily but not two, and
thus was abandoned in midflight.

(5-6)

FIGURE 5-5
Leif (age 4)
Airplanes (colored crayon) 9 x 12"
This fuselage appears to have been
abandoned because it was too broad.

FIGURE 5-6
Leif (age 4)
Airplanes (colored crayon) 9 x 12"
This one is too thin. In many of his
164 attempts it is possible to see
Leif's struggle to draw airplanes ex-
actly the way he wished them to be.

there were five sheets con-
taining undecipherable
scribbles. Perhaps airplanes
were begun and scribbled over.

In the pages recording Leif's
struggles to draw airplanes it is
possible not only to see the
drive to achieve satisfactory
graphic control of an image, but
also to speculate about the rea-
sons success was not achieved.
At first Leif couldn't always get
the initial placement right, and
even when he did, lines often
went awry. In the course of a
few weeks, however, they came
out "right" almost every time.
By then, through continous
practice, Leif had gained the
skill for which he had worked so
hard.

Whether or not Leif will be
an artist remains to be seen, but
the path that he was following

at the tender age of four was the
same one followed by Picasso
and other artists. The sketches
made by Picasso at ages nine
and ten reveal page upon page
of pigeons, and shortly thereaf-
ter, hundreds of humans drawn
from the front, the back, and
the side.[1]

And then there is Anthony.[2] A
few months ago we received a
letter detailing his latest proj-
ects—a new publication with
four other artists, *SComix*, pub-
lished at the University of
Southern California, where he
was a student, and plans for the
production of his own comic
book, a science fiction novel,
two magazine stories, an inde-
pendent movie, and a
newspaper comic strip—with
the added declaration, "If I'm
lucky, I'll finish them all by

Christmas, or explode!" At the
age of fourteen Anthony had
been filling page after page of
notebook after notebook with
literally thousands of figures,
figures that flew and moved in
incredible ways, sometimes as
many as forty to a page. An-
thony was practicing, drawing
figures from the front, the back,
and the sides, portraying arms
and legs at every angle and seen
in every degree of foreshorten-
ing, playing with the nuances of
the figure and its action as a
musician plays with the notes of
a scale, constantly honing, per-
fecting, and refining his drawing
skills (5-7).

Anthony's goal was the per-
fection of the human figure,
Leif's was to perfect his air-
plane. For Picasso and other
artists and for children who

Table 1:

Material Tested	ORIGINAL COLOR	COLOR IN ACID	COLOR IN BASE
#4 Cabbage	Purple Blue	Red Yellow	Green Blue
Brom thymol Blue			

FIGURE 5-7
Anthony (circa age 14)
Chemistry Lesson (ballpoint pen)
8½ x 11"
On what appears to have been the page of a chemistry worksheet, Anthony has created a world where strange, toadlike vehicles, spaceships, and other conveyances move among an assortment of astronauts, superheroes, robots, and all manner of odd creatures that jump and fly and soar and leap in a wonderfully rich tableau. Although some may dismiss such efforts as mere "doodles," graphic play of this kind is most important to the development of drawing skills.

wish to draw more and better, the goal is sometimes the perfection of a single object, sometimes of many. In order to accommodate a developing process of reality-making in drawing, it is necessary to acquire correspondingly increasing drawing skills both in the number of things that can be drawn and the accuracy and variation with which those drawings are executed.

Anthony's and Leif's process of skill development was self-motivated. Like most children who already draw well, they needed no special encouragement. The desire to make increasingly better drawings and to master the skill that it requires is generally all that is required to stoke the fires of determination; and the success in working graphic wonders further fuels the child's accelerating momentum.

Not every child will spend countless hours perfecting her entrechats at the practice bar or her scales at the piano or her figures or airplanes or anything else. Nor do we believe it to be necessary. There are ways of increasing almost all children's drawing skills, however, that are enjoyable and rewarding. Rather than focusing on the refinement of a single object or even a few objects, the exercises we are about to suggest involve the expansion of graphic vocabularies by increasing the number of objects that children can draw.

Games to extend the number & variety of things to draw

Most children draw only a few dozen things at most. Granted, these things do change over time. Abilities to draw new objects are acquired and old ways and old things are discarded. Yet compared to children's verbal vocabularies, which may contain as many as 2,600 words by the time the child reaches the age of six, their graphic vocabularies are minuscule. Of course children don't need to match graphic vocabularies with verbal ones, image for word. Because children do not communicate, in their drawings, in the same way as they do in words, and the receiver of their graphic communications is often only themselves, it therefore becomes unnecessary to continually say, graphically, new things in new ways—thus unfortunately keeping graphic vocabularies at a minimum. When graphic vocabularies remain small, then the possibilities for reality-building in drawing are markedly diminished. This series of graphic games may help to develop drawing skills.

The essence of these graphic-vocabulary-expanding games is to suggest to children that they draw as many of something as they can, or that they draw something in as many ways as they can. Once children have gone as far as they can on their own, then adults may suggest other possibilities and variations.

As we present the games and their variations, we will illustrate various exercises with the graphic responses of a brother and sister—Lana, age eight, and Oak, age ten,—in order to show the extent to which the child's graphic skills can be developed through these exercises.

how many kinds of people can you draw?

This game can be played by children of almost any age. You might begin by asking the child or children, "What different kinds of people can you think of?" Of course you can join in the response too, just to ensure that a wide range of possibilities are suggested. And what are the possibilities?

Boys, girls, old people, babies, tall people, short people, thin people, heavy ones, pretty and plain ones, monsters and outer-space people, astronauts, deep-sea divers, racing drivers, taxi drivers, kings and queens, knights and ladies, dwarfs, fairies, trolls, and giants; acrobats, dancers, soldiers, artists, wrestlers, models, teachers, old-fashioned people, future people; big-headed people, short-legged people, long-armed people, big-nosed people, two-headed people, ten-eyed people; square people, round people, crooked ones, straight ones, bent, flat, and curved ones; funny people, strange people, and on and on.

Once some of the possibilities have been suggested by you and the children it is time to begin drawing. Let each child exhaust his or her first array of characters and then come up with some more possibilities. If the child seems to have no more verbal or graphic options, then you may wish to begin suggesting. Our list is a starting place, and you can make it much longer. Usually a mere suggestion brings an image to the child's mind, and that vision soon becomes a graphic reality.

Variations. Each of the types of people can be drawn with several variations, and some with an almost infinite number. Imagine what some children might do with "How many kinds of monsters can you draw?" or "How many kinds of 'outer-space creatures' can you draw?" or "imaginary" or "future" people; and so forth.

The People game may also center on features of people. For example, how many hair styles, costumes, noses, mouths, eyes, hands, feet, and so on can you draw. Activities such as these are precisely the sort that artists themselves sometimes engage in. In a sketch for *Guernica*, Picasso surrounded a drawing of a bull with nine highly inventive drawings of eyes. In all of the sketches and prints associated with *Guernica*, Picasso drew nearly 100 different kinds of eyes.[3]

FIGURES 5-8
Lana (age 8)
How Many People? (pencil) 12 x 18"
In Lana's spontaneous drawings she draws characters—the cowgirl, the princess, the little girl. But when she was set upon the task of drawing lots of different kinds of people, she also began to experiment with the exaggeration of features, to do enormous sizes and minute sizes. She does the person with the world's longest fingernails, arms, and nose, "biggest ears," "most popped-out eyes." And as she drew she told little stories about many of the characters, identified her characters with people she knew, and even discovered that she could draw upside-down people.

FIGURE 5-9
Oak (age 10)
Oak's Characters (pencil) 12 x 18"
Oak began by drawing people but they were soon joined by assorted animals, birds, and creatures, and like his younger sister Lana, he too, exaggerated features and verbally narrated the actions and encounters of some of his characters. In this playful game it is certain that Oak has drawn characters and actions that he has not previously attempted, and by doing so and succeeding, he may have been encouraged to try even more.

how many kinds of animals can you draw?

When children who only scribble are asked to draw a particular animal—a giraffe, a snake, a dog—they draw more regular scribbles than they do when working without direction. In other words, the *Draw the Animal* game may have a beneficial effect even before children are able to draw animals.[4]

The game might begin in a variety of ways: "If we were to go to a circus, what kinds of animals might we see?" "Let's name the biggest animals we can think of" or "the smallest," "the cuddliest," "pets," "the most frightening," "farm animals," "dogs," "fish," "birds," and so forth.

Some children may be able to draw a favorite animal. Boys often can name and draw a surprisingly large number of

FIGURE 5-10
Lana (age 8)
How Many Animals? (pencil) 12 x 18"
Lana's menagerie consists of many of the animals you would expect a child to draw—elephant, lion, cat, crocodile, giraffe, octopus—each with distinct but somewhat generalized features. But as was the case with almost everything else that Lana undertook, her sense of humor and playfulness pervaded the drawings. Elephant's trunk, crocodile's tail, and giraffe's neck alike are stretched and extended and writhe snakelike about the page.

dinosaurs; but it will be easier for those children who have already drawn an animal or animals to draw animals. Younger children simply adapt the drawing of the human and add a horizontal body or sometimes a larger body and a greater number of legs.

For children who have never drawn an animal and cannot adapt another figure to their own satisfaction, perhaps the problem lies in a lack of information. In that case it is important to find as many animal pictures as possible, drawings or photographs, and to point out for the child the various unique characteristics of each animal—the giraffe's long neck, the camel's hump, the deer's antlers, the elephant's tusks and trunk, his large round body and big ears; the short legs and large head of the hippopotamus; and the surprising array of shapes and sizes of dogs, fish, birds, insects, and so

on. Without proper information nobody can draw satisfactorily. Children not only need information about ways to depict the characteristics of people or animals or whatever it is they wish to draw, but they also need to be taught how and where to find the necessary information in pictures or from actual objects. And, most important, they need to learn that it is appropriate to do so.

how many things can you draw?

People and animals are certainly not the only candidates for the *How Many Can You Draw?* game. Natural phenomena, plants, and manmade objects also provide rich possibilities. Here are some of those possibilities: houses, buildings, shoes, cars, planes, spaceships, ships, flowers, trees, toys, chairs. Ask the children to help you to extend the list.

FIGURE 5-11
Lana (age 8)
How many chairs? (pencil) 14 x 17"
Months before we had decided to ask Lana to help us by playing some of the drawing games in this chapter, we were aware that she was having difficulty drawing chairs. The simple foreshortened bench that we had demonstrated for her then was one of the first to be drawn on this page of chairs. But Lana shortly began to draw people chairs, and noting our delight, continued to practice not only her graphic skills but her fantasy skills as well. This drawing includes a "clown" chair, a "frog" chair, a chair drinking water, a "puppy dog" chair, a "king's chair—he's sad because he lost all his money," a "father" chair, a "mother" chair and a "brother" chair, as well as a "cat" chair, a "knitting" chair, and a "painting" chair. Had the paper not run out it seems that Lana could have continued to create chairs endlessly.

FIGURE 5-12
Oak (age 10)
How Many Vehicles? (pencil) 14 x 17"
While Lana was drawing her chairs, Oak was drawing as many cars as he could. Children are often able to expand their graphic vocabularies by drawing as many varieties of objects as they are able to imagine, each of which will present a slightly different graphic problem and solutions that the child may never have otherwise attempted. The various angles—drawn at our suggestion—show Oak's ability to draw things from the back, side, front, and from above three-dimensionally.

Games to show & increase expression in drawings

Children seldom use more than the turn of a line to show the emotions of their characters—upturned mouths for happy, down for sad. Other ways of expressing emotions, whether they entail facial expression or the language of the entire body, rarely appear in children's drawings. Yet often at the merest suggestion or description or even by demonstration, children are able to depict not only a range of emotions, but a variety of moods.

facial & bodily expression

Have the children draw a face as they usually do, one that is neither happy nor sad. Then have them draw it again, this time making it look very happy or very sad, surprised, angry, pleased, thoughtful, tired, bored, frightened, and so forth. The faces can be drawn on a regular sheet of paper, or on a sheet that has been divided into sections, or on a long narrow sheet, so that they line up in a row. The child may want to label each expression—or a different game may be played, with the child drawing the expressions while a friend, classmate, sibling, or adult guesses what they are. The latter game might necessitate a clearer or more exaggerated depiction if another is to guess the emotion or mood that is expressed. Certainly the older the child the greater the range of expressions; younger children should be able to master the more obvious expressions.

FIGURE 5-13
L'ana (age 8)
Facial Expressions (pencil) 12 x 18"
Lana first folded her paper into six sections and then proceeded to draw a face in repose. As the model assumed the various facial expressions, Lana drew—from left to right, top to bottom—*angry*, eyes narrowed, eyebrows knit, mouth twisted; *frightened*, eyes wide, mouth in an "O"; *unhappy*, eyes turned down, tears streaming and mouth in an inverted "U"; *pleased*, a moderately smiling mouth and widened eyes; and *very happy*, mouth broadly smiling, showing teeth, eyes narrowed, and what appears to be dimples.

FIGURES 5-14 and 5-15
Lana (age 8)
Very Angry (pencil) 7½ x 10"
Oak (age 10)
Utterly Dejected (pencil) 7½ x 10"
Lana and Oak were trying to draw the ways in which the entire body may express an emotion or a mood. Lana's attempt to depict a stamping foot led her to bend the knee of her figure sharply while still employing her usual "sausage" curves on the arms. We don't know to what extent it was deliberate, but Oak's figure is so dejected that even the chair slumps.

For those children who find this game difficult, here are two variations:

• Supply children with mirrors and have them create the facial expressions with their own faces, then draw them.
• Have another child or an adult create the facial expression from which the children can draw.

Certainly there are times when the entire body expresses an emotion or a mood. For "very angry," for example, the children may recall or you might read the story of Rumpelstiltskin, which in its many versions ends in a way similar to this:

"Who told you that! Who told you that!" shrieked the little man; and in his rage stamped his right foot into the ground so deep that he sank up to his waist. Then, in his passion, he seized his left leg with both hands, and tore himself asunder.[5]

Here, too, you can introduce the idea that line and color—heavy jagged lines, black or purple—can help to depict emotions in drawings. Here is a partial list—you and the children with whom you play these games should certainly be able to add

(5-14)

many more: unhappy, puzzled, proud, tired, excited, very amused. It is often helpful to invoke verbal metaphor and imagery—proud as a peacock (how does a peacock strut?); happy as a lark (one can actually appear to fly or soar); he laughed so hard he almost burst. The child might act out some of these expressions and draw the way their bodies feel to them, or again they might draw as others act them out.

using an entire picture to express mood

In the last section we mentioned the way line or color might express a particular mood or emotion. Often when children are given descriptions of a scene or a situation in which a mood is expressed, they instinctively employ lines and shapes in ways that convey the particular feel-

(5-15)

ing. The words with which a mood is described are often very helpful. Language abounds with descriptive examples—the angry sea (see storms at sea painted by Hokusai, Winslow Homer)[6]; majestic mountains (Cézanne)[7]—as does literature and poetry. Any of these might be employed to help children to visualize, imagine, and express. This description of a storm encourages the expression of the force and violence of the storm with dark, jagged lines, diagonality, and crashing and overlapping.[8]

The storm was terrifying. The black sky was streaked with lightning, rain came in torrents, trees fell, branches and other objects flew through the air. Small streams became wide rivers carrying everything in their path. People and animals were frightened and sought shelter and safety. Many other frightening things happened. Can you imagine how the storm looked?

Draw a picture of the terrible storm. Try to make your picture show the <u>feeling of the storm</u>, not just how it looked but how it felt.

This might also bring to mind images of the tornado in The Wizard of Oz.
Here are other examples for many of which descriptions (either verbal or visual) may be found in literature and poetry and art.

• A foggy day ("The Fog," by Carl Sandburg)[9]
• a calm peaceful place (Rousseau—*Sleeping Gypsy*)[10]
• a hustling, bustling, noisy city (Boccioni—*The City Rises*)[11]

This description details and recounts events that led to a particular kind of feeling.

The people of the village have been held captive for many days by the invading army. Now the invaders have fled, chased away by the friendly forces. The people are overjoyed. They race into the streets, dance and cheer. It is a happy, wonderful time. They find many ways of expressing their joy. Can you see the celebration in your mind's eye?

Draw a picture of the people in the village at this joyous time. Try to make your picture show the <u>feeling of joyfulness</u>, not just how things looked but how they <u>felt</u>.

After reading a poem or a story have children try to depict the way the characters would react.

• Hansel and Gretel reunited after the witch was burned up in the oven
• Fay Wray as King Kong climbed to the top of the Empire State Building

(5-16)

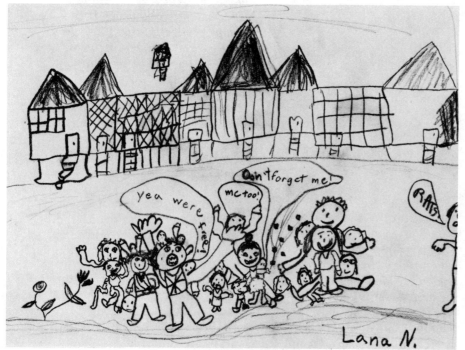

(5-17)

FIGURE 5-16
(Artist Unknown)
The Storm (pencil) 8½ x 11"
This child has included many of the expressive elements of the terrifying storm in the drawing. Lightning streaks across the sky; trees fall— even a telephone booth; hats and other objects fly through the air; streams turned rivers flow down the street carrying even people in their path. The man seeking shelter appears to be bucking the force of the wind while the rain falls in torrents. All of this is drawn with fast, jagged strokes of the pencil that help to convey a feeling of agitation while faces register terror.

FIGURE 5-17
Lana (age 8)
Liberated Village I (pencil) 9 x 11"
The feeling Lana was asked to express in her drawing, after hearing the description of the liberated village, was one of joyfulness. Elation, joy, and happiness are shown not only in facial expressions but in the triumphant raised arms of the villagers. The suggestion to place one figure behind another in order to show a crowd of people was followed repeatedly by Lana with great enjoyment at this discovery. A close study of the villagers reveals Lana's own story-making abilities in the person of specific characters—a crooked old man at the left, a child in the center who is crying because she has lost her mother in the excitement, and, of course, the expelled invader, who says, "Rats."

FIGURE 5-18
Oak (age 10)
Liberated Village II (pencil) 9 x 12"
Oak's concern with the story of the liberated village was less with the villagers themselves than with the way in which they had been held captive. Oak spent a good deal of time drawing this enormous counterweighted bamboo cage. Since Oak and Lana both drew at the same table it is clear to see where Lana's thatched huts on stilts came from. It is also interesting that both children felt the need to supplement the visual with verbal labels.

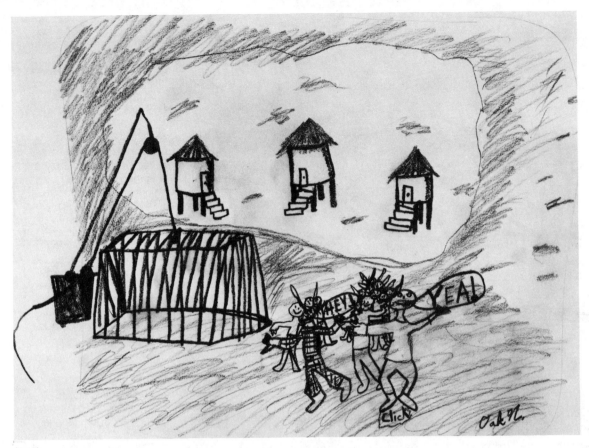

(5-18)

Increasing
the skill
to depict motion

We discussed in Chapter 3 the difficulties encountered by children in trying to show people and animals in motion. Because the key to showing movement in humans lies primarily in drawing arms and legs bent at the elbows and the knees, the child's innate propensity to keep limbs simple and undifferentiated often raises a powerful obstacle to depicting action. Children may be helped to overcome this obstacle through the simplest of exercises.

College students who had not drawn since they were in elementary school and who could not draw a figure running were shown the various ways in which the figure could be made to appear to be moving very quickly. Parts of the figure were drawn on the board and points were assigned to each for the degree to which they depicted action. The torso was shown to be leaning forward at a 45-degree angle; the forward leg thrust out high and with the

knee bent only a little or not at all; the other leg bent backward at a sharp angle; arms swung at sides with elbows bent; and finally the figure was shown raised off the ground and horizontal lines were added to indicate how fast the figure was running (5-19). A figure shown running in this manner was worth a number of points for each part depicted; a total number of points was the agreed-upon standard. Immediately after these parts were shown

(5-19)

FIGURE 5-19
The standard by which groups of college students measured their own *running* figures.

FIGURE 5-20
Lana (age 8)
Horses in Action (pencil) 6 x 18"
Lana drew her first horse standing (right). It was then suggested that she try to make her horse run and rear and buck. That accomplished, Lana decided that it would be fun to draw a horse-person and another standing on its front feet. These two Lana worked out on the spot. Once children are encouraged to perform graphic feats that they would never otherwise have attempted, you may be amazed at the heights they are able to reach in developing graphic skills.

FIGURE 5-21
Oak (age 10)
Figure in Action (pencil) 6 x 18"
Oak's drawing was to be of a person moving across the page. Curiously, like Lana's, the action moves from right to left. The figure starts to walk, trips over a rock, falls flat on his face, struggles to get up (erasures also show Oak's struggle to get this position just right), and finally runs on his way. Oak was able to depict these actions through assuming the positions himself and trying to "feel" the way the action would look.

FIGURE 5-22
Leif (age 11)
Diving Figures (pencil) 12 x 18"
If Leif had to choose between drawing and swimming, it would be a difficult decision to make. In this drawing of figures diving, Leif manages to combine both loves, and through his drawing he is able to work out the mechanics of the dive, which he was trying to master both on paper and on the diving board. On this particular day, he returned home from practice on the 10-meter board and continued to feel the ways in which the body moves as he symbolically recreated the perfection of the dive.

and for at least ten weeks thereafter every student in the class was able to reach and in most cases to exceed (with touches of their own) the required number of points for a figure running at high speed. This same exercise could easily be used with young children

Some younger children, however, are not yet able to differentiate, to locate elbows and knees and thus to bend them. Philip couldn't get his figures "runned" (Chapter 3) even though he knew that bending the knees was the secret. Like many youngsters, he accomplished the effect of running in a way satisfactory to him by merely separating the legs in scissor fashion. As this solution is usually embraced by the younger children, then simply to assist the child to this end should be your goal at this point. When bending limbs is out of the question, try the scissor solution; show the child the figure—as she typically draws it—but with legs spread in a running position (see Philip's

"runned" figures in his dialogue in Chapter 8—8-17).

Animals, too, can be made to move by simply orienting their bodies in various ways and by bending the legs a little or a lot depending upon the desired degree of action.

drawing figures in action

When the child is able to depict action to her own satisfaction it is time to start action games.

Action games may be derived from some of the earlier *How Many Can You Draw?* exercises. It might be fun to take all of the characters that a child can think of (5-8 and 5-9) and to put them into some active position—running, jumping, standing on their heads, standing on their hands, kicking a football, dancing, and so forth.

Another game is the *Animation* game. The object is to take a single figure through a series of actions or steps involved in an action such as might be

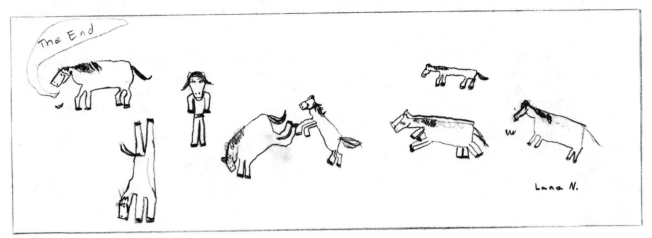

(5-20)

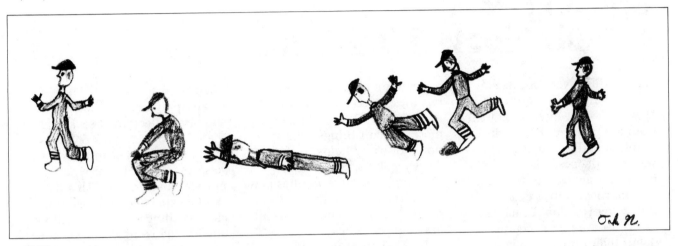

(5-21)

(5-22)

drawn to produce an animated film (5-20 and 5-21). Before starting this activity, there are books about animation to which you might refer that describe how to create the semblance of movement with a simple flip book.[12] After the child is able to show the steps from the simple walk; run; jump to the more complex actions of dancing or doing a somersault or even diving (5-22), you might try a flip book, which requires many more figures and more subtle actions. Remember that it is always best to have the child generate the ideas rather than the adult make all the suggestions.

Drawing from actual objects & images

We found five-year-old Brandy in the Metropolitan Museum in New York City, intently drawing from a portrait of Benjamin Franklin and producing his own very fine likeness. Satisfied with his first drawing, he moved on to a marble sculpture—*The Bather,* by Houdon. Brandy's drawings are more accurate in detail than drawings by most five-year-olds because he was drawing from works of art to which he was able to refer repeatedly in order to get things just the way he wanted them. Drawing from observation is a marvelous way for children to expand their drawing skills. Drawing from observation can be done at home or at school as well as in exciting places such as museums or on field trips.

at home & in school

Many children who draw extensively can be seen drawing pictures of their friends and especially of their teachers, of desks and chairs, and whatever other object or image catches their fancy. Not only does the child get a good deal of satisfaction from knowing that she has the ability to capture a likeness of a pet, an object, or a person, but these successes give her the incentive to draw more and more difficult things. Observational drawing helps to expand drawing skills, too, because *drawing by looking* supplies new visual information that is incorporated into the child's current drawing programs.

In order to be sure that detail is noted as the child begins to draw from observation, a verbal description may be helpful. You might want to point out such things as roundness or squareness, contrast of large and small, light and dark, the large overall shape as well as small details. Or it might be exciting and useful to have the child describe the object before it is drawn or as she draws it. Remember that the younger child is still working on a *simple* and *undifferentiated* program so should not be expected to include many details, even though they may be directly in front of her and in spite of her knowledge of them.

And what other kinds of things are candidates for observational drawing? Everything! Dolls; the dollhouse; chairs; toy cars, trucks, planes, and spaceships; a bowl of fruit; the kitchen pots and pans, and small appliances; a shoe or shoes; a collection of seashells; the telephone; a stack of books; a table with lots of things on it; scissors; a pencil sharpener; musical instruments. This list can be expanded endlessly including things inside as well as outside the window, or you can go outside and have the child draw things at close range:

• a flower (see paintings by Georgia O'Keefe)[13]
• a leaf
• a squirrel
• a branch of a tree
• a fire hydrant
• a discarded tin can

in settings

Brandy drew at the Metropolitan. Teachers often take children to museums and ask them to draw, but usually not until they are safely back within the confines of the schoolroom. But think how exciting it would be to be able to draw in the company of artists and of works of art! Almost any setting, though, ordinary or extraordinary, can become an exciting place in which to expand drawing vocabularies by tackling the

FIGURE 5-23
Brandy (age 5)
Ben Franklin (black marker) 8½ x 11"
Brandy studiously made this drawing
as he sat in front of a portrait of
Franklin in New York's Metropolitan
Museum. With a few strokes of the
marker Brandy was able to capture a
likeness of old Ben as well as the
feeling of the decorative frame.

FIGURE 5-24
Brandy (age 5)
Houdon's Bather (black marker)
8½ x 11"
Brandy graduated from portraits to
depictions of sculpture in this rendi-
tion of a bather by Houdon. Notice
the carefully counted fingers and
toes. The Metropolitan's stamp in the
lower corner of both drawings added
an air of authenticity to the fact that
Brandy, the artist, was in good
company.

(5-23)

(5-24)

Lana N.

(5-25)

FIGURE 5-25
Lana (age 8)
Plants (pencil) 9 x 12"
We chose Lana to participate in these drawing games precisely because her drawings were representative of the drawings of most eight-year-olds, because she enjoyed drawing and was willing and anxious to try anything. She had not customarily drawn from observation. In drawing the five plants that sit on a table in front of her living-room window, she was challenged to look for details, to pretend that her eyes were a camera's lens, to show the differences in the pots and the leaves and to note the way in which the light from the window created dark and light areas. Lana's drawing shows the way in which the drawing from actual objects encourages close, careful, sensitive perceptions.

FIGURE 5-26
Lana (age 8)
My Dolls (pencil) 9 x 13"
Lana has drawn her dolls lined up on a pillow on her bed, but it is obvious that her concern was less for the setting than for capturing the individual characters and characteristics of each doll. Lana was pleased with the result, as well she might be; she is learning to attend to detail and to individual differences as she draws more and more those things that comprise her *common reality*.

5-26)

by Lana

problems of *overlap* and *points of view,* showing *distance* and *dimensionality.*

When drawings are made in settings such as playgrounds, parks, ball fields, or even at home and in the classroom, many of the innate graphic characteristics (Chapter 3) such as simplification, showing objects from the most characteristic view, and avoidance of overlap may be overcome because of the altered point of view and the uniqueness of the situation.

Before children begin to draw, you might point out the way in which those things that are further away appear to be smaller and higher while those things that are nearer to the viewer appear to be larger and will be lower on the page; and how the things that are closer overlap those in the background.

Slowly, with caution

A word of caution needs to be inserted here. Many children, certainly younger ones, may be unable to draw any but the most direct point of view; high angles and bird's-eye views may be difficult and frustrating. It is our aim to expand and extend the child's drawing vocabulary and ability to depict so that she may want to continue to draw. Pushing the child beyond her ability to the point of frustration will most often produce the opposite effect—she may lose all confidence and interest and even cease to draw at all. It is unwise to attempt to have children draw things that are beyond their ability. Approach all of these activities with caution—proceed from simple to complex, watch the child for signs that you have begun to tread on thin ice, and be ready to retreat. Should this occur it is best to find something with which the child is more comfortable and which is less demanding—perhaps repeat a game with which she enjoyed success—and begin again. The cautious practice and the variation of these exercises may lead not only to mastery but to innovation and invention as well.

chapter six

And what happens next? telling stories through drawing

Once upon a time there was a man. The end.[1]

This first story, told by a two-year-old, has some interesting similarities to the first figure drawn by a child. We might even call it a tadpole story, because, like the tadpole figure, it possesses a head and tail [legs] only: a beginning and an end. There are other parallels between the systems of symbols by which children seek to express themselves, to communicate, and to gain knowledge about the world—speech and music and play, as well as drawing

and telling stories. Storytelling, like drawing and play, enables the child to create for himself model situations of past, present, and future possibilities of the four realities. Like drawing, too, storytelling has cultural roots; if there were not tradition of myth and fable and fairy tale, if mothers did not read stories to children, if there were no Mother Goose or Dr. Seuss, if no story, oral or written, existed in the culture, children would not tell stories. But there have been and there are stories; mothers tell stories to children and children tell stories as well. Story takers who repeatedly request

stories from children have been able to find many gems in these oral stories,[2] but because we have come so far from the oral tradition of the singer of tales, of the elder from whom oral tales were passed from generation to generation, unless there is a willing listener, stories will most likely go untold. A story that is drawn reflects the graphic tradition of narrative found on walls of Egyptian temples and on Greek vases, as well as contemporary conventions of television and comics, but would be told, nevertheless, because listener and teller are often one and the same.

101

Spontaneous story drawings

There is a narrative dimension to nearly all of children's make-believe play. The rectangular block that "stands for" the racing car goes *vroom, vroom* over the track and under the tunnel; the doll becomes ill and needs to be ministered to by Mommy, the doctor, Daddy. To the child's story drawings as well there is often a beginning, middle, and an end; more specifically, for the sometime shorthand symbols that appear on the page there is both past and future.

The very earliest scribbles, as we have demonstrated, become a pretext for the child's flights of fancy. The adult's "What is this?" can send the child off into stories that are sometimes wonderful, exciting, and fantastic. Older children will embroider extraordinary tales about simple drawings. The drawing she had made of her house motivated one first-grader to tell a story about her sister and herself and the way they often slipped into one another's rooms when their parents were asleep. Although some children are content to draw things—cars and planes and spaceships, horses and princesses and gymnasts—more often the cars are in the Indianapolis 500 and the planes are part of elaborate battles, and spaceships land on strange planets, peopled by strange creatures. Horses are ridden by the princesses or by cowboys and cowgirls, and gymnasts take part in the Olympics. Through extensive studies of children's spontaneous drawings—those drawings that are done by themselves for themselves as opposed to those that are done in school, for adults, or for the purposes of others rather than for their own purposes—it has become increasingly evident that children use these drawings for the primary purpose of narrating.[3] As we have seen also in children's play, the narrative allows the child to create sometimes complete, sometimes fragmentary "as if" models of reality or realities. It is through these stories that the child can explore and thus come to understand more fully life's dramas and processes. The myth, the fable, and the fairy tale serve as models for the child's own reality-testing. Bruno Bettelheim believes that the significance of these narrative forms is determined by the degree to which the view presented by them conforms to our own needs and desires.[4] For him it is the fairy tale in which all situations are simplified, where the figures are clearly drawn and the characters typical, where details and shadings are eliminated—there is only black and white, good and evil—which becomes a means for the child to understand himself and the world with which he must cope. The fairy tale is like a mirror in which the child sees reflected some aspects of another world through which he may better understand and come to solutions in dealing with life's mysteries. We believe that the child, in his own stories, is creating situations that are suited entirely to his own needs and desires, that deal directly, though symbolically, with his own immediate concerns. Brian Sutton-Smith, who has made numerous studies of children's verbal stories, characterizes them as "caricatures," much "like adult soap operas," devised by "persons caught in situations of stress and ambiguity."

For children, as for adults, there is early wonderment as to how one can possibly deal with villiany and deprivation, and whether or not these can be overcome by one's own skill or with the help of benign strangers.[5]

The visual narrative, then, serves as a means by which the child may use graphic symbols—those that leave a tangible record—whose very tangibility allows an infinite flexibility permitting him to invent and reinvent, supplement and delete, order and reorder realities through the mere addition and subtraction of lines and forms. Words must be set down in a particular order if they are to communicate; drawings, on the other hand, are not bound by the dictates of grammar.

In addition, there appears to be a point in the child's development at which he can show, in his drawings, dimensions of meaning for which he cannot yet supply the words or even perhaps yet fully understand.

Drawing, then, becomes a natural vehicle for the narrative; the narrative, in turn, promotes greater quantities of drawings, as well as the need to create figures and objects with more and more complexity, action,

(6-1)

FIGURE 6-1
Boy (grade 1)
I Beter [sic] *Jump* (black marker)
individual frame size 4¼ x 4¾"
A perfect example of overcoming a
threat through one's own devices is
this narrative by a first-grade boy. In
the first frame a little man confronts a
strange locomotivelike vehicle (we are
told, however, that it is a "super-
cycle"). He wonders, "What is this?"
In frame 2 the supercycle comes
closer—we can tell because it is now
larger and the person smaller—and
"it's going to crash into me." At this
point either some miracle will save the
man or he will have to take matters
into his own hands. He acts—with a
tremendous leap he clears the super-
cycle, with the declaration "I beter
[sic] jump!!" and the danger is aver-
ted. In the final frame we return to
normal, the man smiles and says,

"Good, it didint [sic] hit me." It is
certainly reason to smile, and to be
proud to know that we can fend for
ourselves when the necessity arises.
This is the rehearsal and practice,
through drawing, of a little boy's car-
ing for himself.

FIGURE 6-2
Boy (grade 5)
Superpig (black marker)
individual frame size 4¼ x 4¾"
In this humorous narrative the forces
of evil are overcome by the fortuitous
intervention of a benevolent super
anti-hero, Superpig. This satire of all
superhero sagas begins with the fig-
ure of a boy leaning nonchalantly
against a street sign "just hanging
around." His stance and the presence
of the yo-yo attest to the fact that the
boy is unaware of the danger, in the
form of a "giant claw," that lurks in

wait and, in the second frame, comes
and picks him up to carry him off. In
the next frame we see the villains in
the form of a robot at a control panel
and his "master," a huge, bloated
Humpty-dumpty figure, televised on a
screen. All seems to be lost until who
should appear but— "It's Superpig!"
who flies off over the rooftops with the
boy safely in his grasp. At times when
the odds seem to be overwhelming it
is nice to know that we may count on
"a little help from our friends."
This narrative is remarkable not only
for its Orwellian "Big Brother is watch-
ing" character but for the ability of the
artist to play with dramatically shifting
points of view in which the viewer is
at once spectator and participant. It
is almost as though the character on
the screen has brought the viewer into
the story and has addressed us as he
asks, "Have you caught the earthling?"

(6-2)

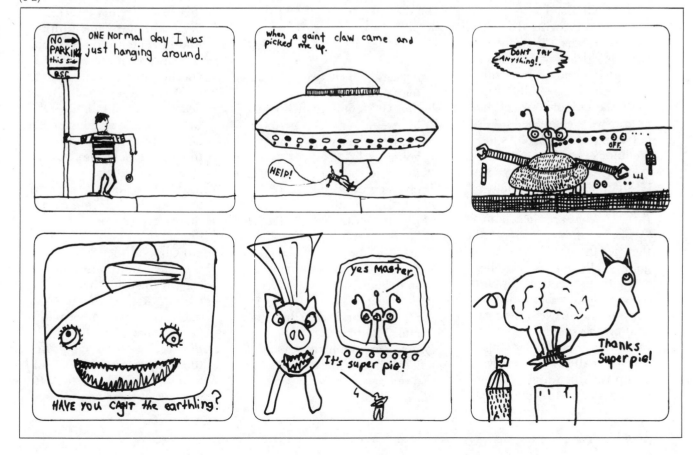

and detail. The little first-grader who was drawing a story about King Kong was having difficulty showing how big his character was. He found that he could either fill the entire page with the one figure or make him appear bigger than people, taller than buildings, thus creating a need to draw those other elements as well.

It is important to the child's need to narrate, to understand, and to test life's problems and processes, to help him not only to draw skillfully but to be able to use the medium of the story skillfully as well.

Encouraging drawing sequences & story plots

It was probably because Philip's younger brother, Michael, had at the age of four already conceived three imaginary friends that their mother despaired that Philip, almost six years old, had "no imagination." Although his fantasies were more conventional than Michael's, Philip was nonetheless able to generate fantastic stories once he was aware of their potential in his own drawing.

The first drawing that Philip showed us was a typical five-year-old's drawing, the figures very little removed from the first figure in the child's repertoire, the tadpole. Two of these figures were contained in a sort of boxlike shape. Philip's incredulous response to the request to "tell the story" was, "It's not a story; it's a picture." But further questions: "Who are they?" "What are their names?" "What are they in?" "How did they get there?" "Where are they going?" elicited ready replies, and although both Philip and we were aware that at least some of the answers were generated on the spot, there was the revelation that the drawing was—it really was—a story. Philip was then invited to draw a story. This first story was drawn enthusiastically but not without some degree of prompting.

Spiderman appeared as the hero of the adventure amidst questions— "What does Spiderman look like?" "He has no mouth; he has a spider on the back of him." "What can he do?" "Swing on his web."

When Philip was satisfied with his picture of Spiderman the dialogue proceeded in this way:

Adult: OK, tell me what Spiderman is doing.
Philip: He's going to swing on his web.
Adult: And then what is he going to do?
Philip: And then he's going to go on the ground.
Adult: Unh, hunh.
Philip: Here's the rope—like his hand's grabbin' …
Adult: And then what's he going to do? Is he going after somebody?
Philip: Yeah!
Adult: Yeah, and who's he going after? Bad guy?
Philip: Yup, the little person.
Adult: What's the little person's name?
Philip: Mad!

Adult: Man?
Philip: No, Mad.
Adult: How do we know he's mad?
Philip: Because Spiderman is chasing him. [Philip is beginning to get into the story.] Spiderman is chasing *two* bad guys.
Adult: Two bad guys? Oh, this story is getting very exciting (to Philip's mother)—oh, isn't this story getting exciting?
Philip, (gaining momentum): And now he put out his foot and hit one of the bad guys and he said, "Ouch."
Adult: I would say "ouch" if Spiderman kicked me, too. Oh, wow! Is the web gonna catch one of those guys? 'Cause there's the web—he's got the web going out there.
Philip: Here's where he's going to shoot the web (indicating that it comes from his fingertips).
Adult: Oh, and then what?
Philip: He caught one and he caught the other bad guy.
Adult: Oh! Both of them? All at once? Oh, that Spiderman, he's wonderful!
Philip, (really encouraged): And then Superman came … and Superman flied and took the gun out of their hand.

Adult: And took the gun out of their hand! That's great! Then what—are they going to take them off to——

Philip: They took ... they threw them in jail.

Adult: Oh, that's a good story. I like that story!

Philip insisted that his mother hear the entire story from the beginning as he delightedly pointed out and recited each detail right up to the place where he had written (with a little help on the spelling) E-N-D (6-3).

Subsequent stories on the same day were told with little prompting although with a good deal of appreciative acknowledgment of Philip's accomplishment by the adults present.

The second story, following the safe model of familiar superheroes, involved Batman and Robin (6-4), two crooks (they had "robbed a bank"), and the police whom Batman had summoned on his CB radio. One crook was hooked by the Bat rope and hauled to jail by Batman. The police who had been summoned on the CB radio got the second crook and threw him into another jail—complicating both the plot and the picture.

In response to a request for a whole different story, Philip drew (with appropriate sound effects) the Incredible Hulk (6-5). As before, the story was based on the powers of the hero and followed a plot typical of that superhero. The Incredible Hulk, as could be expected, picked up the bad guy and threw him— "far." When the Hulk sat down "so he could relax" he turned into David Banner. The one deviation from his other stories was that the bad guy, instead of being thrown in jail, was shot (by the police—neither the Hulk nor David Banner has ever been known to shoot anybody) and buried under a sign saying "BAD GUY."

FIGURE 6-3
Philip (age 5)
A Spiderman Story (pencil) 8½ x 11"
This is Philip's first drawn story. To the left is Spiderman minus the mouth—the picture that Philip used as reference for this figure appeared on his brother's tee shirt, and indeed he had "no mouth." Spiderman's arms are raised and he shoots a web from the hand on the right, and it falls and entangles the two "bad guys" below. On the upper right is Superman who happens along after "Spidey" has already done all the work and tied up the little person "Mad" and his partner. Superman helps to disarm the bad guys and they both haul the culprits off to the jail (lower right).

105

(6-4)

The final story that Philip drew that afternoon featured a hero of his own invention, "Big Man" (6-6). When asked if the hero had super powers, Philip replied, "You'll see; they're in the story."

At this point Philip was not as much concerned with the quality of the drawing as he was with the invention of the story. It was as though his first stories had been the tentative strokes of an uncertain swimmer. In this story, Philip was sure of his ability to tell a story, a story narrated from beginning to end (without any of the prompting

(6-5)

FIGURE 6-6
Philip (age 5)
Big Man (pencil) 8½ x 11"
This story is of Philip's own invention—no borrowed heroes here. Big Man looms larger than anybody else on the page and he needs help from no outside source to catch all the bad guys—there are three of them. He shoots a laser down his arm and ropes from his belt, kicks with his big feet, has a bomb in his ear and some secret weapon in his tummy. And that—announced Philip—"is the E-N-D". But Philip was so pleased with this story that he didn't want it to end, so he added a sun in the upper right-hand corner and gave the story, in addition to the-good-guys-always-win ending, a fairy-tale ending—"And the sun came out and they lived happy ever after."

of the earlier attempts) as he rapidly drew the few lines that were to represent all of the action. Although the story necessarily contained similarities to the previous three—there are always bad guys, aren't there, and stealing money for Philip was the ultimate evil—this was definitely Philip's own and if his superhero was to have super powers, they were to be many and as different from those of Spiderman and Superman and Batman as he could imagine. He shot a laser "down his hand," and ropes out of his belt; he had a bomb in his ear (they were large ears) to blow up the bad guy, and "something in his tummy that went out." Philip was so pleased with his story that as he recounted it to his mother he added—spelling and printing "END"—"and the sun came out and they all lived happy ever after."

Philip had discovered powers he didn't know he possessed, powers as great as any superhero's: the power not only to tell a story but to create characters whom he could direct to do whatever he wished them to do. At the same time he was learning to deal with villainy and deprivation and ways to overcome them. Although he was relying, in the first stories, on the help of benign strangers (or friends) to overcome difficulties—Spiderman had Superman; Batman and Robin, the Incredible Hulk, and David Banner all relied upon the police; only his own creation "Big Man" single-handedly took care of the bad guys—and there were at least three in this last story.

A few days later we were given a book that Philip had made. He had been working on it all weekend and when he was satisfied that it was finished, he presented it to his mother. The earlier stories he had drawn for us were each done on a single page, with all of the action occurring in one frame. In this one each page served as an indi-

(6-7A)

(6-7B)

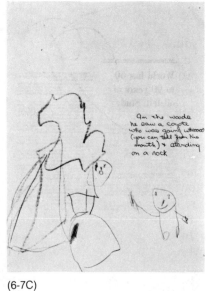

(6-7C)

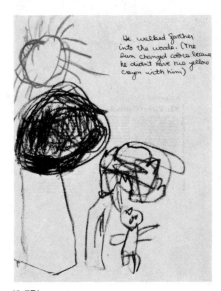

(6-7D)

(6-7E)

FIGURE 6-7 (A, B, C, D, E, F, G)
Philip (age 5)
Petey's Story (pencil and crayon)
7 pages 8½ x 11"
Petey's Story was drawn by Philip over a weekend. He announced to his mother that he was going to draw a story, armed himself with available scrap paper—it had printing on one side—and a few crayons, and settled down for a ride in the car. His story took seven sheets of paper, which he then asked to be stapled together to form a "book." (His mother wrote the story on the pages just as Philip told it.) The figures are very rudimentary, but the story, although simple, is complete with a beginning, a middle, and an end; and while Philip's earlier stories all dealt with villainy, "Petey's Story" is one that seems to relate more to the concerns of a five-year-old who is afraid of the dark.

(6-7F)

(6-7G)

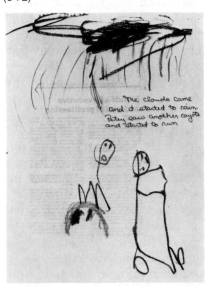

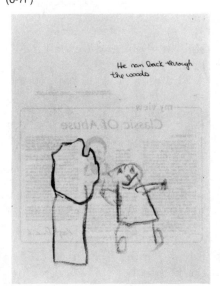

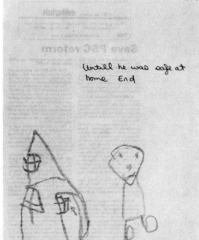

vidual frame, and the story no longer dealt with superheroes but with a small boy named Petey (6-7A–G). He told the story to his mother this way:

• A little boy named Petey was walking down a path. The sun was shining and there is a rainbow with many colors. There are lights on in the house.
• Petey walked into the woods.
• In the woods he saw a coyote who was going "Whoooo" ["You can tell because his mouth is like this"— an O] and standing on a rock.
• He walked farther into the woods [he has drawn many more trees to indicate deep woods].
• The clouds came and it started to rain. Petey saw another coyote and he started to run.
• He ran back through the woods.
• Until he was safe at home.

As we have already noted, the drawing of the story allows the child the flexibility of arranging and rearranging elements and characters and often allows the child to depict aspects of meaning about which he may not yet be able to verbalize. A young child, for example, might, through the simple act of placing a flower closer and closer to the sun, be able to indicate growth, and by drawing the sun moving across the sky, show the passage of time. We also believe that drawing allows children to add elements to their stories that might otherwise remain unexpressed. For Philip, Halloween precipitated stories about witches and haunted houses and black cats and ghosts and disembodied faces. This was not unusual in itself; what was interesting was that the sound effects which had begun early

on in Philip's *Hulk* story and had become an important element in his book about Petey meeting the coyote—it was the "whoooo" of the coyote as much as the storm and the darkness that frightened the boy—show up in the recounting of his Halloween stories: "And the cat goes 'meeeow,' and the ghost goes 'woooooooo,' and the witch goes 'heh, heh, heh.'" We find that older children also incorporate sound effects in their stories, borrowing the convention from the comic book and adding them in a "balloon" along with the stars and X's and curlicues typical of this genre.

Philip continued to use his newfound powers of narration. Because Philip was able to tell original stories, his kindergarten teacher, who for the purpose of teaching her class to read, lettered, on lined sheets, sentences that the children dictated and then illustrated, allowed him to dictate and illustrate a complete story. This setting apart from the rest of the class further reinforced his pride in his accomplishment. It is important to note that Philip, who was not a spontaneous narrator, as we find to be the case with many young children, was nonetheless able to use this ability after only a single day's play at storytelling. He certainly continued to draw with adults and to receive encouragement and reinforcement. Without all of this, however, he might never have found or used the ability to tell stories in his drawings.

Other children have only to see the narratives of others and they are off and running on narrative flights of their own. When Andy was in the second grade, for example, he was asked if he would like to draw a book of his own, as his older friend Bobby

had done (*Goldman* 1-4 and 2-24). Andy responded by producing not one book but several. *The Legend of the Theem and the Red Glob* (1-5, 6-8, 6-9, 6-10) contains a full fifty-figure-packed pages of battles in a remarkable space odyssey.

Still others continually create stories that exist in a single frame. These stories are sometimes complete, but they are most often merely pieces of stories that may have their beginnings and their ends proceed in any number of directions (6-11).

FIGURE 6-8
Andy (age 7)
Theem and the Red Glob—page 7 (colored marker) 9 x 12"
"He is unfreezing the *Red Glob* now. The King is watching. That is a car on their planet with five wheels, like a space buggy, but for them it is a car." Andy found the inspiration for his 50-page adventure of the Theem not only in his older friend Bobby's 16-page comic book, *Goldman*, but in generations of children who have created generations of superheroes of their own.

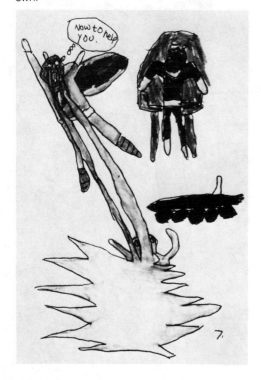

FIGURE 6-9
Andy (age 7)
Theem—page 30 (colored marker)
9 x 12"
"The Raden is back in his hideout. These are Robots." Each of the fifty pages of Andy's Theem adventure is filled with action and excitement as characters zoom, fly from one planet to another, freeze and unfreeze each other, with generous doses of humor thrown in.

FIGURE 6-10
Andy (age 7)
Theem—page 33 (unfinished) (pencil)
9 x 12"
"The battle is on. The *Red Glob* is making a giant monster. He can fight by himself but one of his powers is to make different shapes and characters." We wonder if Andy has ever heard of a self-fulfilling prophesy because, of course, one of Andy's powers, one he uses with great skill, is to make different shapes and characters—and stories as well.

FIGURE 6-11
Jason (age 5)
Plane Crash (wax crayon) 8½ x 11"
In much of children's story drawings the entire action of a narrative is played out in a single frame. This is only one of several airport and airplane drawings done by five-year-old Jason. Here a Delta airplane crashes into some flowers. The most amazing feature of this drawing is not the drawing of the airplane itself but the effect of the crash on the poor defenseless flowers, which have been given facial features on which to record their various expressions of shock as each looks toward the plummeting plane. "The faceless one is hiding," Jason says. Many other of Jason's stories examine the cause-and-effect theme, too. In one such story, described by his mother; "The bird is sitting on her nest in the barn, she flies out the window ... up the chute, lands on the other barn, goes over the roof and throws a ball down which lands on the sheep's back, bounces on his head, and bounces out of the picture." This sort of playful exploration is usually pursued by older children, and reminds one of the machinations of Rube Goldberg.

(6-11)

Making myths:
the themes
of story drawings

If the myths of our ancestors consisted of folktales narrated by an elder or by a "Singer of Tales"[6] in some far-off European village, our own twentieth-century folktales assume the form of television commercials and magazine and newspaper ads and comics.[7] And whether the enemy to be overcome is a rival king or a frightening beast or a dirty shirt collar and whether the beautiful princess invokes magic or merely a better brand of mouthwash in order to win her heart's desire, the themes correspond. Children's story drawings, too, employ the same themes; they are about villainy, as are Philip's stories (6-3–6-6), where there was always a "bad guy" to be dealt with; or they are about deprivation, as in Bobby's *Goldman* (2-24), where there was first a need for money and then for restitution and finally for revenge; or they are about both. Within and beyond these broader themes of *villainy* and *lack*,[8] we find in children's story drawings themes dealing with *origins*, such as the origin of *Goldman* or other superheroes or an origin may be the birth of a character like Dirk's *Dubser* (2-9) or the germination of a seed or the arrival of matter from outer space. *Growth* (6-12 and 6-13) is shown in the development of flowers or plants or trees, of animals and people as well; and *transformation* in ways natural—as a chrysalis to a butterfly—and unnatural—as a frog to a prince or a Dr. Jekyll to a Mr. Hyde. *Quest* appears in the children's narratives as a space odyssey (6-14), a climb to the top of a mountain (6-15), or a search for adventure; *trials* appear as tests of strength, of

(6-12)

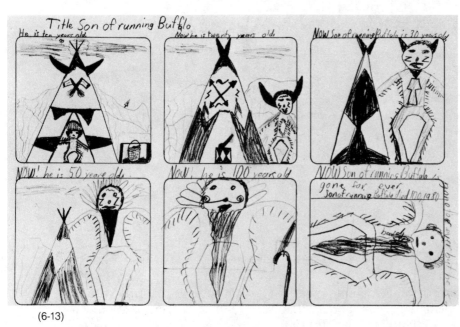

(6-13)

(6-14)

FIGURE 6-12
Girl (age 9)
The Seed (pencil) individual frame size 4¼ x 4¾"
The growth in this narrative by a South Australian girl begins with the origin—the planting of a seed that takes root and grows simultaneously above and below the ground, with the help of sun and rain, to a flourishing flowering plant. Perhaps the playing out of this persistent theme is a means by which a child can better understand her own growth and the growth about her.

FIGURE 6-13
Boy (age 7)
Son of Running Buffalo (pencil) individual frame size 4¼ x 4¾"
This humorous and beautifully drawn story by a Zuni boy is of growth and aging (and finally death). The bandy-legged "Son of Running Buffalo" is seen at ages 10 and 20, at 30 and 50, and finally at 100, and he is "gone for ever."

FIGURE 6-14
Boy (age 8)
Link-up in Space (pencil) individual frame size 4¼ x 4¾"
An interesting variation on one of the most popular themes seen in boys' story drawings is the space adventure drawn by an eight-year-old Navajo boy. It is shown first in a close-up and then from farther and farther off in space. In this odyssey, after the successful link-up with a satellite seen in a well-drawn three-dimensional view, the spaceship departs, then explodes. The zapper at the end is a common characteristic of children's story drawings.

112

(6-15)

FIGURE 6-15
Girl (age 11)
I Did It (pencil) individual frame size
4¼ x 4¾"
The climb to the top is graphically shown in this clever drawing in which the height to which the climber goes is illustrated (in the third frame) by simply depicting a foot, a leg, and the end of the length of rope. We do not need any more information; she has climbed right out of the frame. As she finally struggles to the top, we are quickly reminded that *the bigger they are* (the prouder or the more self-satisfied) *the harder they fall*, a message that is clear—with even the humor of the marvelous backward tumble of a fall.

FIGURE 6-16
Girl (grade 4)
Fighting Like Cats and Dogs (pencil) individual frame size 4¼ x 4¾"
This cat-and-dog fight reminds us of "The Gingham Dog and the Calico Cat", even to the ferocious battle indicated by the fury of the lines in the scribbled cloud of dust that surrounds the two in frame 3. But instead of eating each other up, the two antagonists shake hands and smile happily at the end as we see conflict (in the first three frames) and its resolution and the resulting satisfaction with the peacemaking ending (in the final three frames).

(6-16)

courage, and of perseverance and as *contests* ranging from individual *conflicts* (6-16) to huge battles and sports events (6-17). Most often themes of *good and evil/crime and punishment* prevail. Crimes that are committed are punished, the culprit caught, and justice served in stories as simple as Philip's or as complex as Bobby's *Goldman*. *Creation* covers subjects as diverse as building a house and baking a cake (6-18), often fol-

lowed by *death and destruction*—of objects, people, plants, and animals; they are blown up, swallowed, broken, and eaten (6-19). Other topics include *failure* (6-20) and *success*—triumphs, rewards, recognition, and achievement; the fulfillment of wishes is best accomplished symbolically in children's story drawings, as are *cause and effect* (6-21). Often children merely depict the *natural processes* of seasonal change,

volcanic eruptions, and the triumph of nature over man (6-22)[9]; and *daily rhythms*—the everyday experiences of awakening, going to school, going out to play, and going to sleep (6-23).

Story drawings best serve children as means by which to actively explore the dynamic nature of the four realities—to look at the world and to ponder its anomalies, to master its processes and rhythms, to con-

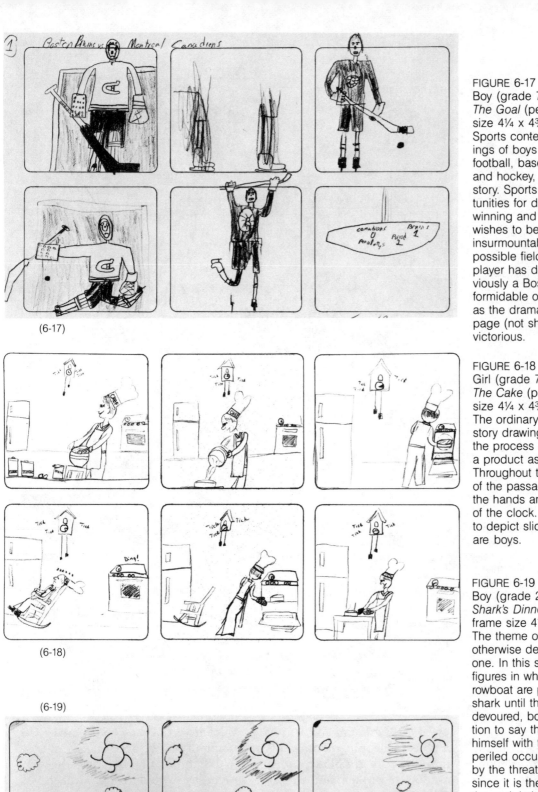

(6-17)

(6-18)

(6-19)

FIGURE 6-17
Boy (grade 7)
The Goal (pencil) individual frame
size 4¼ x 4¾"
Sports contests appear in the draw-
ings of boys around the world—
football, baseball, soccer, basketball,
and hockey, as in this well-drawn
story. Sports allow endless oppor-
tunities for depicting the success of
winning and the fulfillment of a boy's
wishes to be the best, to triumph over
insurmountable odds, to score an im-
possible field goal, as this Boston
player has done (the artist is ob-
viously a Boston fan) against a
formidable opponent, Montreal, and
as the drama continues on the next
page (not shown here) to emerge
victorious.

FIGURE 6-18
Girl (grade 7)
The Cake (pencil) individual frame
size 4¼ x 4¾"
The ordinary slice-of-life theme of this
story drawing shows also the steps in
the process of creation—in this case
a product as mundane as a cake.
Throughout the process we are aware
of the passage of time as we watch
the hands and almost hear the ticking
of the clock. Girls are far more likely
to depict slice-of-life incidents than
are boys.

FIGURE 6-19
Boy (grade 2)
Shark's Dinner (pencil) individual
frame size 4¼ x 4¾"
The theme of being gobbled up or
otherwise destroyed is a common
one. In this story drawing two small
figures in what appears to be a small
rowboat are pursued by an enormous
shark until they are overtaken and
devoured, boat and all. It is a tempta-
tion to say that the child identified
himself with the small, exposed, im-
periled occupants of the boat faced
by the threatening force; and yet,
since it is the shark that wins out in
the end, is it not possible that the
small boy is trying on the cloak of that
powerful force that looms so large in
the final frame that the sun itself be-
comes a mere speck in the sky?

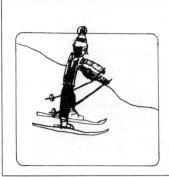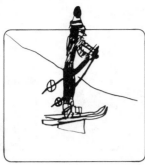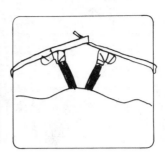

(6-20)

FIGURE 6-20
Girl (grade 5)
Oops! (pencil) individual frame size
4¼ x 4¾"
The drawings in this story are simple,
clear, and to the point. The skier
takes off on her skis (we can translate
the smile as either confident or deter-
mined), makes a jump, and lands skis
up in the snow. The grim figure is then
hauled off on a sled, her feet wrap-
ped in bandages, as she grimaces
and looks sideways out of the frame
as if to say, "Boy, am I dumb!" The
attitude that we find most remarkable
in these story drawings is the child's
ability to accept failure, at least sym-
bolically, with a good deal of humor,
to rehearse facing the knocks that
fate hands out.

FIGURE 6-21
Girl (age 12)
Caterpillar Filler (pencil and colored
marker) individual frame size
4¼ x 4¾"
The notion of cause and effect—if I
do this, then that will happen—is an
integral part of most of children's story
drawings. This South Australian girl
plays with the idea and allows what
happens as a result of the minimal
action of a caterpillar eating a leaf to
become the entire theme of her draw-
ing. As we follow frame by frame, the
caterpillar approaches the leaf and
nibbles on it. The more it nibbles, the
larger the caterpillar grows. The larger
the caterpillar grows, the smaller the
leaf becomes, until the caterpillar fills
the last frame and the leaf is gone.

(6-21)

115

FIGURE 6-22
Boy (grade 5)
The Sixth Year (pencil) individual frame size 4¼ x 4¾"
For many years art and literature have dealt with the triumph and the superiority of nature over man. Hermann Hesse's 1910 story "The City" ends much like the story by this fifth-grader, which seems to have accelerated the process of erosion and decay so that an entire landscape—building, mountains, and all—becomes leveled in only six years.

sider one's origins and anticipate one's future, to know oneself, and to make decisions about right and wrong behavior.

Although we find children who are natural narrators, children's stories rarely exist with the kind of completeness and correctness found in adult stories, visual or verbal, or in those cited in this chapter. Although virtually all children's drawings have a narrative dimension, these narratives are most often found to exist in fragmented form. Kelly's drawings (1-3), for example, are mainly of elaborate settings in which stories and actions that take place may be as many and varied as she can imagine, but which remain in her own imagination. Michael L's eighteenth-century characters (1-7) appear to exist without setting or story, both of which Michael could readily supply when asked; while still other young artists like Anthony may draw hundreds of episodes of figures in action without sup-

plying a setting (5-7). Many children who do draw stories complete with setting, character, and action often do so in a single frame, as in Dirk's battle of the *Dubser* (2-9); beginning, middle, and end of these stories may exist and be known only to the creator. Because we knew that these stories existed—children are most anxious to share them with interested listeners—we wished to see how they would evolve when children were provided with a familiar format in which they might easily draw setting, character, action, and plot with a beginning, a middle, and an end. The story drawings illustrated here are the result of our providing children with a sheet of paper divided into six frames (they might use as few or as many as they needed) and asking the following:

• Have you ever drawn pictures to tell stories?
• Have you ever drawn adven-

FIGURE 6-23
Girl (grade 3)
Come in out of the Rain (pencil)
individual frame size 4¼ x 4¾"
A large percentage of children's story
drawings involve the simple depiction
of such everyday events as these. The
little girl in the story is jumping rope
when it starts to rain. The artist shows
that she knows enough to come in out
of the rain and the story ends with the
child going home and finally going to
bed. What is most interesting in this
drawing is first the sun, which remains
shining steadfastly from its ac-
customed corner in spite of the rain,
and second the child's depiction of
hands only in places where they are
necessary to hold the jump rope—the
rope is held with two hands in the first
two frames and folded in the one
hand in the third.

tures that you, or heroes, or
animals might have?
• Have you ever drawn adven-
tures that could not happen?
• Have you ever drawn stories
about strange creatures in
strange worlds?
• Have you ever drawn stories of
battles or machines; of plants
and insects?
• Have you drawn stories about
sports or vacations or holiday
celebrations?
• Have you drawn stories about
everyday things that happen to
people?
• Please draw a story using
boxes to show what happens
first in your story, what happens
next, and how things finally
turn out.[10]

making story drawings happen

Just as important as a visual/
graphic vocabulary is the gram-
mar of the story drawings. The
model is usually assumed by
the child from the stories he is
told or read, from the first *Once
upon a time* ... to the later more
complex and complicated plots
of television and movies and
comics. We have also said that
the narrative exists in some
form, however fragmented, in
most children's drawings. Be-
cause we believe that the more
control the child has of this me-
dium, the more control he has
of his *self,* we offer these sugges-

tions for making story drawings
happen. These may be done
with an individual child or with
groups of children.

• Suggest stories to the child as
we have done above. (Because
this particular set of instruc-
tions was developed for
purposes of collecting children's
story drawings around the
world it is purposely without
focus.)
• Suggest a specific story or
story line, or a favorite charac-
ter about which to draw a story.
• Suggest that the child invent
his own character or superhero.
• Suggest a theme and supply
the child with paper that has
been cut horizontally, forming a
long, narrow sheet.
• Simply supply the child with
paper upon which frames have
been drawn (or the child may
draw his own, or trace around a
template, or fold paper into
sixths, eighths).
• Set a child or children loose
with a long roll of paper.

Children drawing with chil-
dren and children drawing with
adults often produce some
startling results. Some of these
drawings are shown in
Chapter 8.
Any one of these methods
may set into motion the child's
storytelling potentialities that
are just waiting to happen. The
richness of the story drawings in
this chapter and throughout the
book tell the tale.

chapter seven

Could it be? encouraging imagination & fantasy in drawing

Machines come to life; strange and wonderful worlds appear, peopled with strange creatures that possess marvelous powers; ordinary people assume extraordinary forms and animals evolve with multiple heads and a curious assortment of wings and limbs. What worlds are these? These are everyday occurrences in the world or worlds of the child's rich and vivid imagination. The youngest child often invents imaginary friends and her fancy may run wild and unfettered. At times these are private worlds, but often they are shared with other children in what is called *sociodramatic*

play. Jerome Singer, a psychologist who, with his wife, Dorothy Singer, has done a good deal of work in the realm of children's play and imagination, has written of his own early experiences with fantasy. In these reminiscences he tells how, as he grew older and ceased to engage in make-believe play with other children, the fantasy characters of that play found their way more and more into his spontaneous drawings and doodles at home and on the pages of notebooks at school.[1] Beyond the obvious pleasure and excitement that the child derives from these inventions,

fantasy is the main ingredient in her fashioning of the four realities in her story drawings. If, for example, the child could draw but did not understand the story form, or if she could draw and understood the story form but could not imagine characters or situations, then there could be no story drawings; or story drawings, if they did exist, would simply be lifeless copies of stories seen or heard and would not relate to a child's own realities, as with Philip (6-7) whose first stories of superheroes and derring-do were replaced by a story of a child's own fears.

Further fantastic functions: fantasy & imagination

We have put a good deal of emphasis upon the reality-fashioning function of fantasy, but it may also be important to the child's development, well-being, and happiness that she develop an active imagination. The Singers have observed that the child who has an active imagination is more likely to actively explore her physical environment; that imaginative children smile more than unimaginative children; that they exercise more self-control and are better able to wait patiently and to entertain themselves. Perhaps the most surprising observation made by the Singers is that imaginative children are more able to discriminate between make-believe and reality.[2] Paradoxical as it seems, the children who are most involved in constructing their own private versions of reality know the most about the everyday, or common reality. It may be that this knowledge derives from the imaginative child's exploration of the similarities and differences of worlds that are imagined and worlds that are perceived.

It is frequently asked, "Can the child be harmed by too much fantasy?" We must respond that we simply do not believe this to be so. According to Richard de Mille, children who learn to use their imaginations most are also the ones who are best adjusted, because the mastery of imaginary situations is good practice for the mastery of everyday situations. Most of the evidence points to the fact that instead of a means of *escaping* reality, as some people fear, fantasy becomes the means by which children *create* reality.

encouraging imagination

In any group of children it is possible to find those who easily engage in fantasy and others who seldom do. The book of imagination games *Put Your Mother on the Ceiling*, by Richard de Mille, to whom we owe a debt of gratitude for many of our own imagination games described here, begins with the dedication, "To Tony who started off with a levitation machine and Cecil who said, 'That's crazy! You can't walk through a tree trunk.'" These two attitudes toward fantasy certainly describe the two poles of the imagination spectrum. It is possible, however, that if adults will make the effort to use fantasy for and with children, to engage in activities designed to encourage fantasy and imagination, then unformed imaginations will develop and grow and already formed imaginations will be expanded.

Although we find that generally children who produce many spontaneous drawings also have vivid imaginations, a good many children whose imaginations are extremely active seldom draw. Some children may act out their fantasies; others express them through music or other symbol systems; but we think that it is the combination of drawing and imagining that together enables them both to flourish. When images are projected only in the mind's eye, fantastic and as vivid as they may be, they quickly vanish. When that image is set down in drawing, though, it is made permanent, perceivable and recognizable for both the conceiver and for other observers as well. Although we are all capable of seeing in our mind's eye what a Peter Rabbit or an Alice might look like, it was the setting down in drawing of the images by Beatrix Potter and John Tenniel that have made those particular images a permanent part of our memories of those story characters—Peter sneaking into Mr. MacGregor's garden is a real garden variety rabbit rather than the cartoon figure another artist might have drawn, and Alice, with her somewhat scraggly hair, her white pinafore, her striped stockings, and her dainty Mary Janes, is and has been for generations of children the real Alice.

In addition to amplifying the images of the imagination, drawing often stimulates the imagination as well; a line, a chance mark, a doodle may call into play all sorts of fantastic drawn images.

Imagination games: word to image to drawing

In order to bring together the powerful combination of drawing and imagining we wish to suggest imagination games in which an adult and a single child or a pair of children, an older and a younger child or even children of the same age, may engage.[3] These games consist of the description of an object or event to be imagined and drawn; or they require the imagination to perform extraordinary feats, with the resulting images drawn. Until children become accustomed to playing the imagination-drawing game, we suggest that the games be short and simple, as these will be easier to play. Those that are more complex necessarily require more concentration, imagery, and imagination. You will know by the child's response—when the images on the page seem almost to run away and to delight and amuse—that she is ready to move from a simple to a more complex game.

Richard de Mille emphasized a step-by-step mastery of the imagination, and his own fine book points to the best way to help the child to gain this mastery. Our own imagination games are designed to be used primarily for the expansion of the imagination in drawing, but the same cautions apply.

We hope that the games that we suggest lead to lots of other games that you and the child will devise together. In playing these games, the secret is for the leader or reader to pause at each slash (/) in order to give the child time to picture each new image in her mind or to elicit spontaneous responses, whether graphic or verbal.

big & little people

This game might be played by any child who is able to draw people with bodies. Here it is important to note that many young children are able to do so even before they show bodies in their spontaneous drawings. The game involves imagining both the features of characters and size and postion relationships among characters. Little characters standing on top of and clinging to a big character opens the door to later games that play with much more imaginative characters and juxtapostions.

The game:

Think of a very big man. Think of his belly. / Have his belly get bigger and bigger. / Have his arms and his legs, feet and hands get very big. / <u>Now draw the big man</u>. Think of a little man. / Have him be only as tall as the big man's foot. / <u>Draw the little man no taller than the big man's foot</u>. Think of another little man. / Have him jump high in the air. / Have him land on the big man's foot. / Have him jump higher than the big man's head. / Have him land on the big man's head. / <u>Draw the little person standing on the big man's head</u>. Think of another little man. / Have him jump on one arm of the big man. / <u>Draw the little man standing on the big man's arm</u>. Think of lots of little men. / Have them jumping all around the big man. / Have one jump inside his belly. / <u>Draw the little man in the big man's belly</u>. <u>Now draw some other little men jumping around the big man</u>.

Variations. Other variations of this game may be played by substituting for the big and little men such things as cats, dinosaurs, horses, dogs, and other animals, cars (with little cars driving over and around a big car), monsters and houses and trees (have the trees jump around and grow out of the house).

things stacked on top of other things

This game can be played with any number of things that are stacked. The one we have chosen to use is the animal stack-up. We will illustrate two of several variations, and suggest others.

Each one of the games in this chapter may be played in a number of ways. *Big and Little People* was given in the simplest format in which few images are invoked before the child draws. In *Stack-up*, there are more imagining activities sandwiched between drawings, but you may choose to save the drawing activity until all of the imagining

FIGURE 7-1
David (age 7)
Big and Little People (black marker)
12 x 18"
Seven-and-a-half-year-old David was ready to draw. It was easy to see this by the animation in his face and the way his hand almost imperceptibly traced the envisioned form of the drawing on the page. David's big man had a big belly indeed, so big that his shirt had to gape open in order to span his entire girth. The little man who jumps higher than the big man's head and finally lands upon the head of the larger man does so with the aid of both a helicopter hat on his head and springs attached to his feet. The little man who jumps onto the arm of the bigger man stands balanced on a wristwatch (right of the drawing); but it was only when David unleashed "lots of little men" that the fun really began. Superman and other strange little men jump and fly and even surfboard about the page; they stand on one another's heads and hide in pockets—big little men, medium-sized little men and small little men. Finally one of the smaller little men burrows beneath the earth.

It is most important, as you try these games, that the attitude and involvement of the child or children be monitored. Is the child anxious to go on or is she frustrated or unable to complete a suggested drawing? Is she able to go beyond the game or is she quite ready to stop at any given point? David was not only able and willing to go beyond the game but anxious as well. It is his extra personal touches that make the drawing more than a simple exercise.

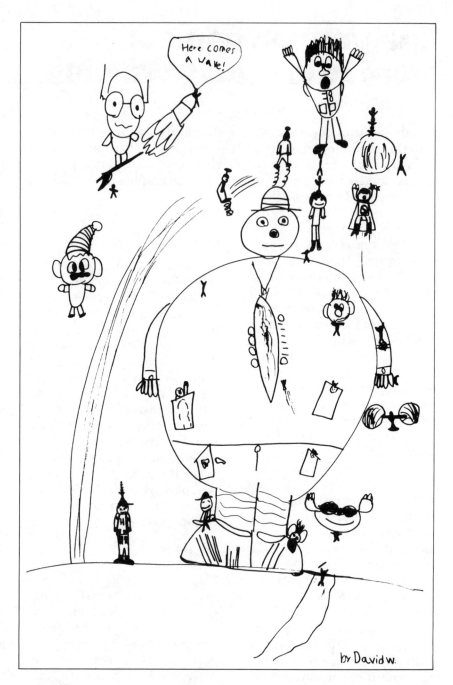

has been completed; or since each of the imaginative descriptions to follow is simpler at the beginning than at the end, you might decide to cut short any description that you sense might overwhelm the child if the game is carried on to its conclusion. Simply stop at a convenient place and invite the child to draw. Whatever the chosen format, however, it is important to wait until the child

has signaled that she is ready to go on—by verbal assent, by a smile or other facial expression, or by a nod of the head—before moving from one idea to another.

Since in the imagining portion so many ideas are presented one after the other, the drawing portion becomes a test of the child's memory. Don't be concerned if the child forgets to include some of the parts in the

drawing. Remember also that to include all the parts might take a much longer time than the child is willing to devote to drawing. It is important to realize, too, that the child may not have the skills to draw many of the things that she is able to imagine easily. Of course, if the child wishes to be reminded of some of the forgotten parts you should certainly oblige.

animal stack-up

In this game some of the animals may be difficult for the child to draw. If the child is unable to draw one or more of the animals, you might substitute animals that are easier to draw or you might offer some assistance. We have found that most children, however, are ready to tackle the animals in the game. Remember, too, that animals can be added to the stack-up as you perceive that the child is capable of more or of more difficult depiction.

Game I.

This game is called <u>Stack-up</u>. Think of an elephant. / Make him come really close. / Have him move just far enough away that you can see him easily from the side. / <u>Now draw the elephant</u>.

The elephant needs a friend. / Think of a horse. / Have the horse run up to the elephant. / Have the horse's nose touch the elephant's trunk. / Have the horse run around the elephant. / Now have the horse make an enormous leap and land on the elephant's back. / Have the horse rear up on his hind legs. / Have the horse's front legs come back down on the elephant's back. / <u>Draw the horse standing on the elephant's back</u>.

Think of a dog. / Have the dog grow really big. / Make the dog really small. / Make him regular sized. / Have him do a backward somersault in the air. / Have him do another somersault and land on the horse's back. / Have the dog stand on his two front feet on the horse's back. / Have him lie down on the horse's back. / Have him stand up. / <u>Draw the dog on the horse's back</u>.

Think of a rooster. / Have the rooster spread his wings. / Have the rooster fly around the ele-

phant, the horse, and the dog. / Have the rooster land on the dog's head. / Have the rooster stretch his neck and crow. / <u>Draw the rooster standing on the dog's head</u>.

Have a very tiny flea fly out of the sky and land on the rooster's head. / <u>Draw the flea on the rooster's head</u>.

Note: As you read the foregoing instructions you might ask additional questions that will be helpful in assisting the child to imagine or to stretch the imagination further. For instance, after a statement such as "Make the elephant come really close" you might ask "How close is it?" or "With the elephant so close to you, how much of it (or what part of it) do you see?"

Game II.

This game is called Stack-up. Think of an elephant. / Make him go far away. / Now make him come really close. / Have him turn and rise his trunk to trumpet for his friend. / Have another elephant join him. / Have both elephants move away so that they are very small. / Have one elephant jump onto the other elephant's back. / Have them come toward you. / Have still another elephant join the first two and jump on top of the others. / <u>Draw the elephants</u>. / Have a horse run up to the elephant on the bottom. / Have the elephant pick up the horse in his trunk and place the horse on the stack. / Have another horse come galloping from very far away. / Have him leap on top of the first horse. / Draw the horses standing on top of the elephants. / Have some roosters come strutting along. / How many are there? / <u>Draw them stacked up on the animal stack</u>.

Variations. The stacking of one thing atop another can furnish endless enjoyment, just as we continue to delight in the image of the stack-up of the donkey, the dog, the cat, and the rooster in Grimm's tale about the musicians of Bremen. And with the *Stack-up* game there are endless possibilities. The more adept the child becomes at playing the game, the more ridiculous the ensuing games might be. Planets might balance on a monster's upturned Pinocchio-like nose and automobiles atop butterflies, or parts of the body may be jumbled and stacked in strange ways. The more improbable the combination, the better.

A *One-Thing-Inside-Another* game might also be played. This game begins with a tiny animal or insect drawn small in the center of a rectangular or square sheet of paper. Then a slightly larger animal is imagined and drawn around the first until the page is filled with one animal inside another. The game might move from insect to turtle, to fish, to horse, to dinosaur, and just for fun, end with a lady—a variation on the one who swallowed everything from a fly to a horse. (Ours is *not* dead, of course!)

the house that jack built

Every child knows this nursery rhyme. We have turned it into a simple game where one thing can be drawn inside another. Often, though, the expected result is subverted by the child, as we shall see in many of the illustrations for these games, but because imagination is really the name of the game, anything

FIGURE 7-2
David (age 7)
Stack-up (black marker) 6 x 18"
David's "stack-up" began with Game I
but it became evident very shortly that
instead of expanding David's active
imagination, the game was serving as
a restriction. It had been obvious in
some of the other drawings that David
had done (8-1–8-7) that he did his
best imaginary drawing when he was
given a suggestion and then allowed
free rein to expand in any direction he
wished. After the flea had landed
squarely on the rooster's head we told
David that lots of other animals had
all come along and had stacked up
one on top of another on the head of
the flea. David's animals include a
donkey, a lion, two birds (one stand-
ing on one leg only), another elephant
dressed in a tutu (also balanced on
one leg—a little more difficult for the
elephant than for the bird) and an owl
on the limb of a tree which peeks
from the right top edge of the draw-
ing. It is easy to see how much more
freely and whimsically David drew this
latter menagerie.

FIGURE 7-3
Lana (age 8)
Lana's Stack-up (pencil) 6 x 18"
Given this long sheet of paper and
the task of drawing three elephants
one on top of the other (with no sense
of what would be coming next) Lana
proceeded to draw her elephants at
the top of the page, so that they
appeared to be lying on their backs,
one under the other. After the first two
elephants had been drawn, we inter-
ceded to suggest that there would be
many more animals in the stack-up so
she might want to leave the elephants
on their backs. We knew that Lana,
who delighted in depicting such flip-
flops, would have no trouble with
somehow setting the third elephant on
the feet of the second, a problem
solved without missing a beat of her
rapidly moving pencil. It seemed, in
fact, that this move freed her to at-
tempt some more daring depictions
such as the second horse bucking on
the back of the first, the dog in the
ballet skirt poised on the horse's tail,
the second dog's nose balanced on
the rear leg of the first, the three
roosters in various precarious posi-
tions, and finally Lana herself, with
flexed muscles, holding up the entire
stack.

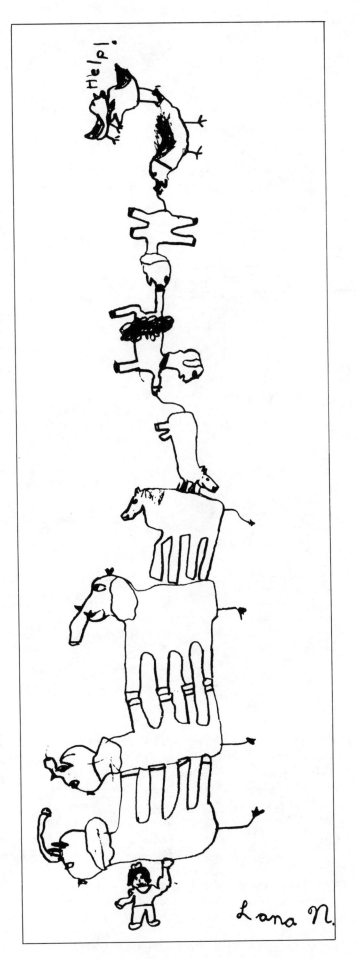

(7-4)

(7-5)

FIGURES 7-4 and 7-5
Lana (age 8)
And Lana Swallowed Them All
(pencil) 12 x 18"
Oak (age 10)
One-Thing-Inside-Another (pencil)
14 x 17"
Both Oak and Lana were told to start
this game with a very small animal.
Oak's was a buzzing bumble bee;
Lana's a speck that was a flea. They
were then asked, "And what do you
think swallowed the flea [bumble
bee]?" As they drew enthusiastically
and one thing swallowed another, the
same query was repeated each time
until there was room for no more.
Lana appears to have had a large
appetite. Lana herself was pictured.
She swallowed a large cat and sev-
eral small ones; the cat swallowed a
fish; the fish swallowed a bird; the
bird swallowed a bumble bee which
swallowed a snail which swallowed
the flea.
Oak's final swallower was a whale that
swallowed a shark that swallowed an
eel that swallowed a fish, a frog, and
the bumble bee. Oak, the older,
seemed more bound by logical cate-
gories. Suggestions can always be
made before or during the course of
the drawing in order to add more
interest, excitement, and imaginary
play to these drawings.

goes; and the child often has
better ideas than we adults.

You can start either by sim-
ply reciting the nursery rhyme
and asking the child to draw the
events as they occur in the
rhyme, or in this way:

*Imagine that you have made a
wrong turn in the road and you
see in front of you a very strange
house. / Look around and see the
land of Mother Goose; the house
you see is the* House That Jack
Built. / *Draw the house so that
you can see what is happening
inside*. / *Find a sack of malt in-
side the house. Draw the sack of
malt*. / *Have a rat gnaw through
the sack and eat the malt. / Draw
the rat that ate the malt. / Have a
huge cat with big yellow eyes and*
*sharp claws run after the rat. /
Have the cat catch the rat. /
Draw the cat that caught the rat.
/ Have a big playful dog come
running along. / Have him chase
the cat. / Draw the dog that wor-
ried the cat. / Have a great
spotted cow take the dog and toss
him up into the air. / Draw the
cow with the crumpled horn as
she tosses the dog. / Have a*

maiden with the cow. / *Draw the
maiden (all forlorn) as she milks
the cow.* / *Have a man come over
and kiss the maiden.* / *Draw the
man (all tattered and torn) as he
kisses the maiden.* / *Have a priest
perform the marriage ceremony
for the man and the maiden.* /
*Draw the priest (all shaven and
shorn) as he marries the happy
couple.* / *Have a cock crow.* /
*Draw the cock crowing to wake
the priest.* / *Have a farmer sowing
the corn in the field.* / *Draw the
farmer as he sows the corn that
fed the cock.*

When the picture is completed
the child may want to recite the
nursery rhyme. This is the farmer
sowing the corn ... that ate the
malt that lay in the house that
Jack built.

Variations. A variation of this
game might be to have the rat
eat the malt. / Have the cat eat
the rat. / Have the dog eat the
cat. / Have the cow eat the
dog—and have the child draw
each animal inside of the other.

In this case the animals would
get larger and larger, so the rat
would have to be pictured quite
small in order for the cow to
finally fit on the page. Con-
versely, in the *House* game, the
house would have to be drawn
quite large in order for the other
animals and characters to all fit
inside. These instructions could
easily be given at the start of
the game without giving away
the surprise of the unfolding
story.

Another variation would be to
have all of the characters and
animals pile one on top of an-
other as in the *Stack-up* game.

fabulous creatures

Some of the wildest inventions
are to be seen in depictions of
creatures that never existed—
dragons, griffins, unicorns, har-
pies, mermaids, monsters.
Drawing imaginary creatures
imposes few constraints on

young artists, because the draw-
ings do not represent anything
that has ever existed; therefore
they need not look like anything
in particular. But even imagin-
ary creatures usually begin with
the known. This recipe for in-
venting imaginary animals from
actual animals was written by
Leonardo da Vinci.

*If you wish to make an animal
imagined by you appear natu-
ral—let us say a dragon—then
take for its head that of a hound,
with the eyes of a cat, the ears of
a porcupine, the nose of a
greyhound, the brow of a lion,
the temples of an old cock, the
neck of a water tortoise.*[4]

To this recipe Leonardo
might have added the wings of a
bat, the spots of a leopard, and
the claws of a sloth. And why
not three heads and twelve
limbs? This imaginary creature
game consists of a recipe much
like that of Leonardo.

*This game is called The Chang-
ing Dinosaur.* Think of a huge

FIGURE 7-6
Lana (age 8)
"Cook a Doell Do" [sic] (pencil)
12 x 13"
Lana's house is hardly large enough
to hold all of the strange goings-on of
"The House That Jack Built," so much
of it takes place around the house. A
particularly interesting segment shows
the man (who somehow resembles a
dog) as he purses his lips to kiss the
maiden who was supposed to look
forlorn but who seems instead on the
verge of giving the presumptuous
suitor an elbow in the ribs. Her hands
are busy, though, as they reach out,
snakelike, to milk the cow. As with the
other games, practice is given in
imagining and in drawing people, ani-
mals, and situations, as well as in
telling stories in drawings.

FIGURE 7-7
David (age 7)
Fabulous Creature (pencil) 14 x 17"
David's creature has the body of an
armadillo, with two legs of a zebra
and two of an elephant and two
heads as well. The heads are fish
heads complete with turtle necks,
bull's horns, and lizard's tongues.
David added the wings of an eagle
and the tail of a rabbit from which a
snake's rattler emerges. This drawing
was made in response to Leonardo's
description; the combination and
choice of elements, with the excep-
tion of the neck of the tortoise, are
David's own.

*dinosaur. / Have him raise his
head way up high. / Have him
lower his head way down to the
ground. / Have the dinosaur turn
around. / Have him move his tail
back and forth. / Have the dino-
saur look angry. / Have the
dinosaur run away. / Have him
come back, really close. / Put
some big black spots on the dino-
saur. / Have him sprout
enormous bat wings. / Have him
fly above your head. / Have him
land and look you in the eye. /
Have him grow three new heads. /
Have all his heads smile. / Give
him ten new legs. / Have some
lollipops stick out of the dino-
saur's back. / Have flowers grow
out of his heads and tail. /
Frighten the dinosaur and chase
him away. / Have him come back. /
Now draw the dinosaur with as
many of his changes as you can
think of. As you draw you may
change him some more if you
wish.*

Variations. The *Changing Crea-
ture* game might begin with
almost any type of animal—a
cat, dog, turtle, bird, alligator.

Similar games might begin with
things such as cars, dolls,
houses, chairs, light bulbs, trees,
and flowers. As quickly as possi-
ble try to get the child to
describe to you how things
might change. You could both
draw from the child's
descriptions.

Another way in which fea-
tures from one animal can
easily become those of another
is to have the child imagine
that, for example, all of the ani-
mals in the stack-up tumble to
the ground and a great mix-up
occurs—heads and ears and feet
and bodies and tails are all
changed one for the other until
none is recognizable. Or there
might be a firecracker in the
middle of a barnyard to produce
the same results.

Space visitors.[5] This game re-
quires the reader or narrator to
use some gestures, pointing, as
the game proceeds, to the vari-
ous features of the face indicated
in parentheses. These should not
be read or said but simply
shown one at a time as they

appear in the story. You might
even show the actions of the
space visitors as they explore
the strange new planet. Chil-
dren will be amused that the
new planet on which the crea-
tures from space land is in
reality the human head. The ex-
ercise is fun and helps the child
to see ordinary things in an ex-
traordinary way.

*Let us imagine that you are a
creature from outer space. / You
are very small. / You and another
space creature have discovered a
new planet. / You land on top of a
mountain covered with a thick,
dark forest (head) / Get out of the
spaceship. / Each head in op-
posite directions. / Push aside the
trees (hair) and find a clearing. /
Slide down a smooth slide that
ends in a loop-the-loop (ear). /
Start walking toward each other
across a high ridge (cheek bone). /
Each one comes to a big lake
surrounded by tall grass (eyes/eye-
lashes). / Peer through the grass
(eyelashes). / See yourself in the
lake (eye). / Walk to a line of trees
(eyebrows). / Sit down and rest.*

FIGURE 7-8
Lana (age 8)
Space Visitors Narrative (pencil)
12 x 18"
Lana's decision to show the journey of the space visitors in separate frames resulted in this eight-part narrative. In the first frame two space creatures are seen inside a space ship; in the second frame the creatures are seen peering through the trees of the mountain forest. In the next frames they proceed to loop-the-loop around ears, peer into lake/eyes, slide down noses, become frightened by a tongue monster inside a huge, cave-like mouth, and finally blast off. Children do not always do what we adults expect—if we think that a head that has been described as a planet will be shown as a head with all of it's parts in their proper places, we are often surprised. Lana's depiction of the planet in the final frame shows all of the parts of the story, as seen in the first frames, but certainly not in any facial order.

FIGURE 7-9
Oak (age 10)
Space Visitors (pencil) 7 x 9"
In spite of the fact that Oak knew that the new planet that the space visitors landed on was really the head, he was more intrigued by the imagery of the mountains, lakes, and loop-the-loops. Superimposed on the head/planet is the mountain; the eyes are lakes with a stand of trees for eyebrows; the nose becomes a child's playground slide with nostril caves from which emanate streams of air, and a real (though miniature) monster is seen from the mouth of the mouth/cave. A dotted line outlines the path of the space visitors from the X at which they landed to the departing spaceship.

(7-9)

(7-8)

129

FIGURE 7-10
David (age 7)
Mountain Planet with Orifices (black marker) 12 x 18"
Of the three illustrations we have shown here of the space visitors, David's is the most surprising. The fact that the new planet was actually the human head was only an incidental detail to David's conception. His mountain is a great, tall, most unheadlike structure that appears to be more cyclopsian than human. The orifices that dominate the structure are the single "lake" close to the wooded top of the "mountain"; below that appear two small caves and lower still the large mouth/cave complete with monster. The space creatures appear at each site and flight lines trace their hasty retreat from the last fright of the monster in the cave back to their space ship and its fiery flight for home.

Look up and see your friend coming toward you. Find a long slide (nose). / Take a great long ride. / Fall down at the bottom. / Look into two dark caves (nostrils). / Feel the wind. / Try to stand up. / Get blown away! / Tumble down to the entrance of a much larger cave (mouth). / Feel the icicles that hang from the roof and the floor of the cave (teeth). / Look inside. / See a monster darting out at you from the cave (tongue)! / Have the monster become very large. / Have the *monster get very small. / Have the monster run away. / Fly back to the spaceship with your partner. / Fly back home. / All right now, draw your adventures.*

You could create imaginary landscapes in any number of places—the hand or the foot—or you could have the creatures fall into a bowl of fruit—slide down a banana / climb a bunch of grapes—or like Gulliver grow very large in our own world so that everything would appear to be tiny and toylike—people like ants.

the jelly bean factory

This game incorporates many of the ideas we find in children's spontaneous drawings of machines that make things. Children are concerned not only with the way things look but

with what makes them tick. Some children spend their time taking things apart to find their inner secrets; others, like Andy S. (2-15–2-17), spend the same time drawing their own conception of what makes things work. It could be any kind of factory but we chose a jellybean factory because it has many possibilities for showing hundreds and hundreds of jelly beans in every color and size.

Let us imagine that we have a factory. / Make it a big factory. / Have all kinds of machinery in the factory. / Have all the machines have wheels that go round and round. / Have the machines have pulleys and belts that make the machinery go. / What else can machines do? / Make them do that.

Have the factory make jelly beans. / Turn all the jelly beans red. / Turn them blue. / Turn them another color. / What color are they now? / Turn them every color of the rainbow. / Have the jelly beans on a belt that travels from one machine to another. / Where do the jelly beans go now?/ Make them go there. / What else can the machine do? / Draw it!

the house full of rooms

This game requires the child to imagine that she is much like a movie camera that first takes a long shot, gradually moves in for a close-up and a wide-angle shot, and pans through a series of medium shots of the rooms of a house. The parts of this game are not difficult to imagine, but is is unlikely that children will be able to remember all the

complex things to be found in the house when they begin to draw. A large sheet of paper is suggested for this game.

This game is called The House Full of Rooms. Think of a little house far away in the distance. / Have the house come closer and closer. / Now have the house grow larger and larger. / Put three roofs on the house. / Make the roofs very tall and pointed. / Take away the front of the house so that you can see all of the rooms. / Give the house hundreds of rooms. / Have lots of rooms on top of other rooms. / Make some of the rooms very large and other rooms as tiny as closets. / Look inside one of the big rooms. / Put beautiful large paintings on the walls of the room. / Put a table in the middle of the room. / Have a cow stand on the table. / Look at all the rooms in the house again. / Make stairs going from the top to the bottom of the rooms. / Have

FIGURE 7-11
David (age 7)
Jelly Bean Factory (pencil) 14 x 17"
David needed very little encouragement to produce this complex drawing of a jelly bean factory. His depiction of the way jelly beans must be made is made more enjoyable by David's own unique brand of humor. Sugar and color are added by pincerlike arms that appear to constitute the main workings of the machine, while the jobs of the men are merely to pull levers ("pull ... to stop; push to go"), stand about and direct on the floor, or stand above in a booth that looks like one in which broadcasters appear at sports events and presidential conventions. Our vote for the best job of the lot goes to the man who shouts "Good work!" as he is held aloft (apparently to survey the operation) by a mechanical hand on a pulley below the oven. Of them all, the only one who seems to do any work is the figure who leans out of the truck on the lower right as he takes boxes of jelly beans off the conveyor belt and loads them into the truck. But they all get paid; at least, they punch a time clock, seen just below the hanging figure.

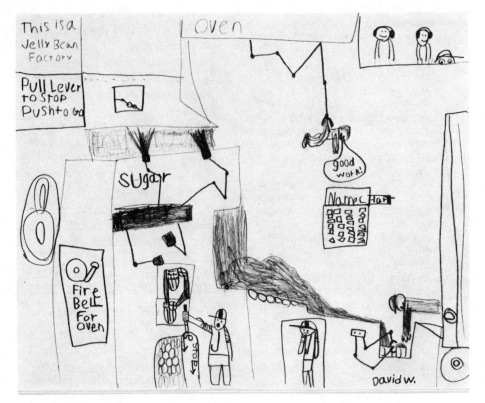

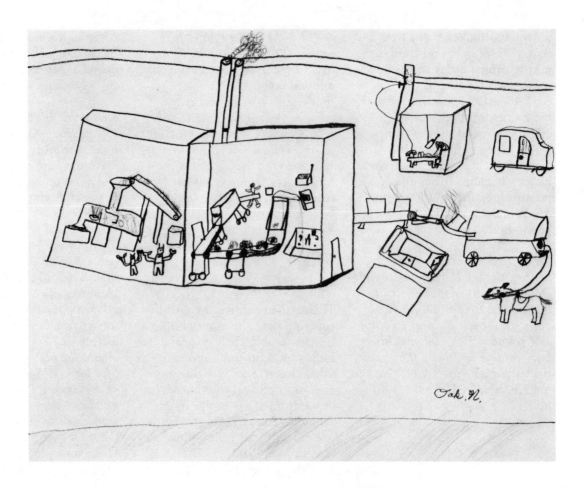

FIGURE 7-12
Oak (age 10)
Jelly Bean Factory (pencil) 14 x 17"
Oak might have been perfectly content to limit his jelly bean factory to the building in the center of the page and one simple machine, but the continual queries of "And where do the jelly beans go then?" "Who runs the machines?" "How do they get the orders?" "How are they shipped?" (here the question which was followed by "By covered wagon or what?" is answered with the appearance of a covered wagon complete with horse in the "parking lot" next to the parked car and below the truck), which brought about this fairly complete operation and a much richer drawing. Just as skill development is increased, so imagination skills are encouraged through gentle nudging and prodding and a little humor.

people walking up and down the stairs. / In one of the rooms have people sleeping in their beds. / In another room have some people enjoying a party. / Have all the people at the party turn into all kinds of animals. / Have the animals wear funny hats and clothes. / In another room have people swing from ropes hanging from the ceiling. / Have another room piled full of broken tables and chairs. / <u>Draw the house with its three roofs, all its big and little rooms, atop one another, stairs, people, party and animals, furniture, and anything else you would like to put into the house</u>.

Variations. There are dozens of exciting variations of this X-ray view game. Here are a few:
• a mountain sliced to expose tunnels, caverns filled with cities, cars running through the caverns, fires, invading armies;
• a huge ocean liner with an X-ray view of cabins, cargo, swimming pools, parties;
• an aircraft carrier with planes and helicopters above and below decks, sailors, pilots, engine rooms;
• a series of views of the insides of a mechanical man;
• animals hibernating underground;
• the inner workings of a plant that manufactures automobiles, or airplanes, toys, dolls, or bionic people;
• the interior of an enormous clock, computer, radio;
• trips to the center of the earth, or inside a whale.

These imagination games began with absurd situations and progressed to imaginary creatures, imaginary landscapes, and imaginary worlds. We have

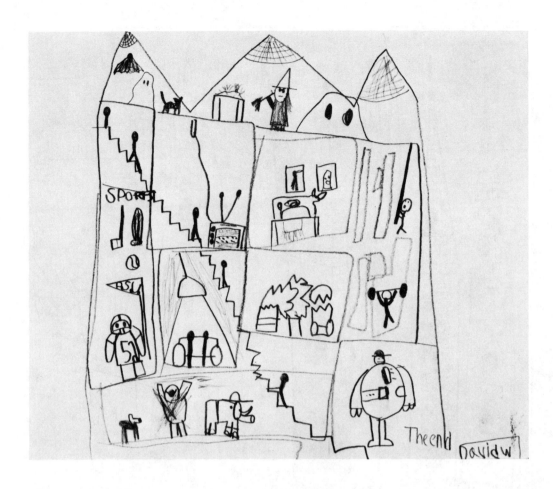

FIGURE 7-13
David (age 7)
House Full of Rooms (pencils)
14 x 17"

This game really appealed to David, perhaps because of the opportunity it offered to depict all sorts of nonsensical situations. He could hardly wait for the completion of the verbal description before applying his pencil to paper. His eyes gleaming, and smiling in anticipation of the images that he had already generated and was anxious to record, David quickly gave form to the outline of the house, three roofs and all, followed in rapid succession by the room divisions and the long staircase. He had no trouble remembering the contents of the rooms—paintings on the wall and the cow standing on the table; people turning into all kinds of animals and swinging from ropes; broken furniture—then proceeded onto his own agenda. He added a football player, a person lifting barbells, a fat man, a television set, and, in the attic, ghosts, witches, and black cats.

referred to nursery rhymes and fairy tales. Inspiration may also come from science fiction or from such imaginary worlds as Lewis Carroll's *Alice in Wonderland* or *Through the Looking Glass* or Tolkien's *Middle Earth*[6] or C. S. Lewis's *Narnia*.[7] In searching for models for more games adults may explore worlds that they have never entered or that they may have forgotten, worlds that are rich and exciting and that will inspire all sorts of fascinating games you and the child may devise.

Even more important, however, is the child's own generation of imaginary creatures and landscapes, imaginary situations and worlds of her own, to encourage her to produce imaginary drawings without benefit of the games or to spon-

taneously engage in the playing of the games with other children.

We wish to reiterate that these games are merely models and beginnings. There are many more fantastic descriptions to be found in fiction and in art that we do not have room to mention, but the richest and most fantastic journeys into the world of the imagination come from children themselves. Many of the ideas listed here, in fact, derive from the things that we see in children's spontaneous drawings. In the end, it is the child who teaches the adult not only what to see but how to see it. We are privileged to be allowed into these magic worlds and to use the vision to show other children the path that may lead to fantastic worlds of their own.

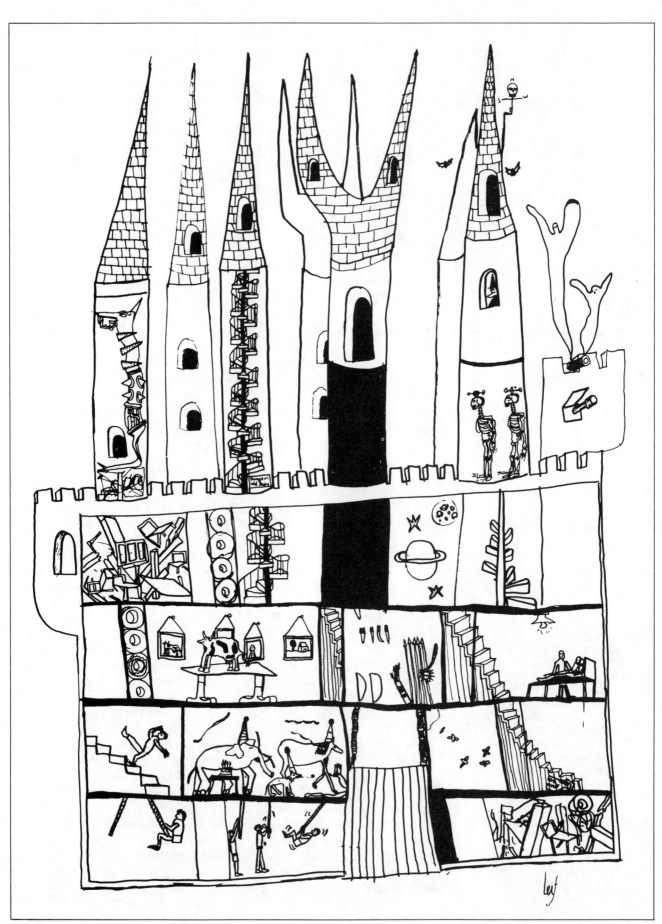

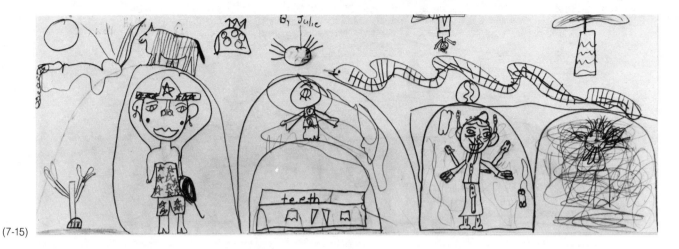

(7-15)

FIGURE 7-14
Leif (age 11)

Castle Full of Rooms (black marker)
Leif's house full of rooms became a castle complete with seven turrets. The thing that best characterizes Leif's drawing is the progression in many cases from idea to image to concept and to variations on a theme, until he is satisfied with the result. Because he is older than David, Leif is less concerned with the idea of getting the images down on paper than he is with getting them exactly the way he wishes them to be. Like David, he has added some whimsical touches of his own—rooms full of automobile tires; the solar system; bows, arrows, and spears; skeletons, ghosts, moths, and a mechanical dragon. In the lower left corner room of the castle a man swings on a rope, but not very successfully; the men in the room to the right seem to perform this same feat in three steps and the swinging man does so with ease and the aid of lines of motion. The lowest right hand room contains the broken furniture but the second attempt (the room at the upper left of the castle below the turrets) is more satisfactory. Perhaps the most interesting of Leif's progressions involved his attempts to draw a staircase. On the left we see a staircase with a man who appears to

be falling over backward. On the right another, more complex staircase ascends through two levels. Above that is what appears to be a modern sculpture but is in actuality an aborted spiral staircase; Leif considered this a failure. The model for this staircase was one that Leif climbed every day for the weeks that he visited with us and the one that he resolutely sat down with pad and paper to conquer. After he had it drawn to his satisfaction from observation, he returned to his castle drawing and added two exquisite spiral staircases, one on top of the other. While David's house was completed in a matter of minutes, Leif worked on his drawing on and off for the better part of a week. Although it is not always possible, necessary, or desirable to allow that amount of time for drawing, when the child and the situation seem to call for such attention, it may sometimes be profitable to do so.

FIGURES 7-15 and 7-16
Girl (grade 3)
(pencil) 6 x 18"
Girl (grade 3)
(pencil) 6 x 18"
These wonderfully rich drawings were made by third-graders as part of a class response to this fantasy game

that we devised and administered. We narrated each part, pausing to ask questions, to receive as many responses as possible (all of which were correct assumptions, of course), and to wait until the required elements were drawn.

Once upon a time there was a hill—oops—not just one hill but lots of hills—and, oh, were they strange! They had the strangest shapes you could ever imagine. Some of them looked like _____, others like _____ (make suggestions of your own—ice-cream cones, alligator tails).

At the very end of the hill was something most valued, something that people have always wanted. It was _____ or some _____.

A group of explorers and adventurers (what do you think *they* looked like?) decided to climb up and down and over and across the strange hills to reach the treasure. To help them the explorers took _____ and _____. Can you show them traveling all the way across the hills?

During the journey they were attacked by _____ and _____. What did they do?

Did they finally reach the treasure? What happened when they finally got there?

(7-16)

chapter eight

What did you draw? engaging in drawing conversations with children

Alex and her mother, Joan, are busily engaged in verbal dialogue. Alex babbles, "da da da da," to which Joan responds, "ma-ma, ma-ma." As the sequence is repeated again and again, Alex laughs delightedly. She wriggles her toes and frequently arranges her mouth in readiness to form the sound of "mmm." Finally, one morning Alex calls from her crib, "Ma ma ma." Although she may not yet have made a connection between the person of her mother and the "ma-ma" sounds, Alex has learned the new sounds through their continual dialogue, as she will the next sounds and the next.[1] This interaction is necessary to the child's development of language. The child who only listens to language does not learn to speak. A boy with normal hearing, whose parents were deaf mutes, heard language only through a daily diet of television and failed to develop verbal speech. There had been no interaction; one doesn't talk to a television set, nor can the set answer back. The boy did learn to communicate, however, through the interaction that he did experience—the sign language of his parents.[2]

Since the mother begins her dialogue with the child at birth, a dialogue made up of coos and sounds, of words, of questions, it would be a rare instance in verbal language in which interaction did not occur. It is unusual, however, for children to "speak" through drawings to adults who "answer back" with drawings of their own. In Chapter 3 we offered suggestions for interacting verbally with the young child in order to assist in the passage through early drawing development. Because we believe that children can benefit tremendously from graphic as well as verbal interaction, we will now introduce a model for graphic interaction through the presentation of a series of drawing conversations between adults and children as young as five and among children of various ages.

137

The graphic dialogue

In verbal dialogue first one person speaks, then the other, in a rapid exchange of ideas ranging from highly serious to playful interchanges. The drawing dialogue is also an interchange—I draw and then you draw—and, although always a serious business to those who participate, graphic interaction has many characteristics in common with the best and most spontaneous play. The participants enter into play willingly; they may tacitly agree to a few simple rules such as taking turns (although they remain free both to make and to break rules in the context of the play), and sometimes they may also agree to a general theme for the play.

As in play, once a drawing dialogue has begun there is no adult and child—merely two players. There is an excitement, a flow of ideas, a sensitive and willing response to unexpected cues suggested by the other or to the serendipitous occurrences in one's own drawings. Sometimes one leads, sometimes the other. There is a total absorption. Graphic play at its best is like being somewhere else—living within the bounds of a sheet of paper, in the world created there, to master or be mastered, good guy or bad, in real (if symbolic) events. Because these dialogues are free, playful, stimulating, and fun (for children and adults alike) they may be the very best way to expand the child's narrative abilities, drawing skills, and his inclination toward invention and fantasy. Through drawing dialogues and conversations in the company of adults, children have the opportunity to create, preview, rehearse, and test in symbolic

form the very patterns of past, present, and future realities.

The basic element of the narrative is telling or showing what happens and what happens next. This element becomes even more exciting when it becomes a series of getting into and getting out of difficult situations. When two play this drawing game, move and countermove often follow in quick succession. This was certainly the case with some of the drawings we did with David.

We had known for some time of David and of the fact that he had been drawing intently since he was two-and-a-half years old, although we had previously had little contact either with David or with the large body of drawings that his parents had been carefully saving for nearly four years. So neither David nor we were quite sure what would happen when we met to look at his drawings and to talk about his work. It was obvious that the development of David's graphic abilities was greater than the average just-six-year-old, because of the prodigious amount of drawing that he had done; but in order to determine how far his development went and to see how it could be expanded we embarked upon a graphic journey. (It should be noted that B. has a great deal of experience at games of this sort. He can draw quickly and easily using programs that are very little removed from the child's own, picking up on some of the cues presented by the child's own drawing, and when he engages in this form of play, he involves himself completely in the world that he is creating. But we think that almost any-

one who is willing to do so can play the game with children.)

"the flying cat"

Drawing upon the knowledge of children's fantasy narratives and keeping in mind adventures in which something happens and then another thing happens, the principles of cause and effect, and the theme of opposition—the "game"—began.

David agreed to play the game. He wasn't quite sure of the rules or even what sort of game it would be, but he loved to draw and was anxious to share his drawings.

David was to start with anything he wished to draw. He had been drawing stories about dinosaurs but what he drew now was an animal with four legs, a bushy tail, two little pointed ears, and stripes, not a dinosaur at all, but a cat (8-1).

B. began to draw then, describing as he did: "Oh, this will have—it looks like three ears—and a big mouth [making growling sounds] and a long tail [emulating as he drew the same kind of dinosaurlike figure that David had been drawing moments before] and with this arm he is reaching out—almost touching the cat—and, oh yes, he has teeth, big teeth—and now it's your turn."

With a smile and gleeful sound of recognition—the rules and the game suddenly becoming clear—David bent over the page and above the dinosaur drew a space ship, a figure inside and, with a rapid series of dots, a projectile or projectiles of some kind aimed directly at the tail of the creature.

Although B. had decided to

FIGURE 8-1
David (age 5) and B., an adult
The Flying Cat (marker) 8½ x 11"

be the "baddie" he couldn't resist adding a graphic description or two to the distress of his own creature. He added lines (with appropriate sound effects) to show that the rocket ship had landed a direct hit on the creature's tail and added smoke billowing up from the injured part reaching to the rocket ship.

David quickly added a tank with its gun blasting away at the rear of the already assaulted creature.

B. countered with another creature—"Our tank's going to be in trouble"—a strange creature "with short legs and this long arm reaching out to get the tank's gun and the other to get the rocket ship."

Well, if B. could make up creatures that didn't really exist so could David. His flying creature was related to dinosaur-birds that he had drawn earlier, but this one had several novel elements, including a doglike head with eyes that could send

out destructive rays to the long-armed monster as well as to the first creature, who had still not been adequately done away with (at least not to David's satisfaction).

Taking both sides at once, B. then drew a rocket ship—very much like David's, only with the addition of wings and five guns, which dropped bombs directly into the toothy creature's eye.

David's next invention was a pair of tentaclelike guns "that can bend like an octopus and shoot lasers" simultaneously at B.'s rocket ship and each of the two monsters. Meanwhile a protruding rock that had originally been the perch of the dinosaur-dog-bird became a gun emplacement for a little man, who also helped to blast the monsters.

At that point B. decided to "get that cat out of there" and redrew it—so that it was still David's cat—in a safe spot on the page, adding wings as he did so and showing with circles

and an arrow the cat's path to the upper right-hand corner of the page.

David was puzzled at first, and wondered if those were feathers on the back of the cat. "Yes, they are wings," was the answer. Without hesitation David added wings to his own cat and as a parting shot had him zap the monster eye to eye.

Until the very end David's cat had been relying upon others to help him out of his predicament. Now the cat was providing his own defense.

"the trucker's trial"

Nearly a week passed between our first dialogue with David and the next, and much had happened both during the course of the "adventure of the flying cat" and in the interim to change the course of the second dialogue. David had increased in the number of things he could draw, was more daring in

what he would attempt, picked up cues from B.'s drawing—as B. had earlier from David's—and felt free to transform ordinary creatures into extraordinary ones and to endow them with exceptional powers.

This time David was ready for the game. He had had an entire day to anticipate and prepare; his mother had even participated in a drawing dialogue with him the night before. In the drawing she had met the assault of his creatures and monsters with steel walls, an idea which can be seen to have funded itself into David's present dialogue.

B.'s intent as he started the game was to embark on a fantastic voyage. (In preparation he had cut and joined four long narrow strips of paper.) David, however, had learned the form very quickly from the dialogue of the week before and was prepared for an encounter, and although he had earlier countered every one of B.'s moves without hesitation, this time he was more than prepared and often jumped in with his own ideas before the initial idea had even been completely set down. Often the dialogue seemed more like a duet, with David very much the leader. During the first game David had said very little, while this time his continual verbal assaults were as much a part of the dialogue as were his graphic ones.

B. asked David to begin by drawing a car or a truck or a "big-wheel" such as the one which had appeared in one of the drawings he had shown us from the previous week's work. He drew a truck.

B. was, at this point, intending to embark upon his voyage. He added a street and put in the middle of it a pile of "what?"—

waiting for David to finish the thought.

David's mind, however, had raced ahead to the predicament his truck was in and, leaving B. with his question unanswered, catapulted the driver out of the truck and into a spaceship.

Further attempts at a voyage were equally thwarted. Monsters and creatures were continually getting into the path of anyone or anything that might attempt a voyage of any sort either on land or on the sea or in the air. Tunnels turned into the mouths of poisonous snakes; and a "stretchy guy" who stretched himself from the top to the bottom of the page to become a fence prevented all movement or escape (one of several moves that seemed to have been directly influenced by a wall his mother had drawn the previous evening).

What follows are descriptions involving some of the verbal dialogue which added to the shared excitement of the adventure.

At one point B. is attempting to remove the poor put-upon hero (you remember he started out as the driver of David's truck who was later catapulted into a spaceship) from a new danger that has beset him—this time a shark that shoots out fire. B. starts to make the hero shrink in size so that he gets smaller and smaller and smaller until he becomes a mere speck and can escape past the very eyes of the shark. The intended journey remains in B.'s head as he continues to draw his incredible shrinking man, but David is still outthinking him. He says, "They have really big eyes"—B. keeps on with the shrinking. David counters, "They're really fast" but B. perseveres. "But he's just a speck and he's sneaking, sneaking,

FIGURE 8-2
David (age 5) and B., an adult
Trucker's Trials (colored marker) (each of six sections) 6· x 18"
David's truck travels along a road that ends in a barrier of some sort (set up by B.). David quickly catapults the driver from the truck into a spaceship in order to fly over the barrier.

FIGURE 8-3
B. has our hero falling from the spaceship but he won't get hurt as he falls into David's quickly constructed trampoline. But B. makes a hole in the trampoline and draws a huge fish waiting below for the unsuspecting hero. David easily eliminates this danger by dropping bombs into the hole and B.obliges by showing the fish being blasted and the hero making a narrow escape using his helicopter hat. He is not about to get too far without coming face to face with David's monster, but the hero is resourceful, and flying close to the monster's head, he takes out his magic ray gun, which David's monster blasts out of his hand. B. has him reach into his pocket to take out another magic ray gun with the other hand—which David's monster blasts out of his hand. Failing to make the monster succumb, the hero flies away over its head—only to come up against a "stretchy guy" who becomes a fence and prevents his getting any further, even though B.has him try and try.

FIGURE 8-4
To B.'s cries for help David responds by adding an escape tunnel through which B.flies the hero, only to be confronted by another of David's monsters. The hero sticks his head out of the tunnel and doesn't know what to do, so again David obliges by providing a tank to shoot the monster. But B.has the monster grab the tank while David counters with a spaceship that turns into a creature that grabs the monster.

(8-2)

(8-3)

(8-4)

141

sneaking"—as he adds dot after dot— "and he is past the shark!" "Not quite!" says David as he hurriedly adds an octopus.

At another time B.'s hero has found a way out of the tunnel-turned-snake and is about to prevail when David admonishes, "But his mouth is about closed," and B. is forced to open a doorway in the body of the snake.

David has the last word in this journey-cum-adventure when B. deposits the hero safely into his own bed—"And see the happy look on his face" (while he sleeps). David gleefully draws a wiggly line around the house. "Not too happy when he wakes up!" He has frozen the house in a solid block of ice. (Actually it was the snake's final shot. "He's not dead yet," was David's triumphant response.)

Two important aspects of this dialogue relate to David's flexibility. The first is his ability to transform one object into another or to change the nature of a particular animal. At one point in the narrative David finds that he needs a defense against B.'s monster, so he creates a rocket ship which immediately turns into a creature with long arms that reaches out and grabs the monster (these long arms are very much like those created by B. moments earlier). Sometimes things are not what they seem. Sharks turn out to be "not just plain sharks" but ones that "shoot out fire." An octopus is "not just a plain octopus" but has an antenna that emits laser rays.

The second aspect is David's ability to flexibly change sides—to be first on the side of the "goodies" and then the "baddies" and to easily switch from one to the other as the situation requires (as B. does continually).

Often B. would feel that the hero was trapped and ask, "What can I do—can you help?" and David would oblige by providing a way out—a tank to thwart the monster's attack, or an escape tunnel that fortuitously appears—"He didn't see the tunnel." He could even provide escape for the hero at the same time as he set up barriers. In the same move that the shark, "not just a plain one," shot fire at the hero, David set up a protective barrier between the fire and the man. And often his solutions, usually to problems he has created himself, are ingenious. Sometime late in the story when the poisonous snake sprouted spikes from its back that "were really time bombs" and began to burn the hero (and the friend with whom B. had recently endowed him), David conjured up a sink, turned on the faucet, and doused the fire.

"sam's barriers"

Ten-year-old Sam, demonstrated, as David had, that many dialogues have an "argumentative" flavor—in the best possible sense of the word. And as in the best arguments, the necessity to counter the thrusts of one's opponent leads to the further development and refinement of one's own ideas.

This dialogue (8-8) had begun (as had David's "trucker's trials") with a long strip of paper. B.'s character is confronted by one of Sam's "weird people" with a "weird long arm," and "You'd better not move or you'll get rays." But the character easily collects the rays from the ray gun in a "handy collector" box. Sam adds some "long, long, long grass" and then "what comes out of it is a snake" which "goes over the

FIGURE 8-5
"Hurray, I'm saved," B. has the hero proclaim, but is he really? "No," answers David as he draws ocean waves with the tails of four sharks coming into view. B. has one shark jump out of the water headed for the hapless hero. David at the same time provides both the fire breathing out of the shark's mouth and a barrier to protect the man from its flames. B. shrinks the hero until he becomes nothing but a speck and can sneak past the shark. But David has other ideas and plants an octopus in the path whose eyes follow the hero as he again grows in size and zaps him with laser beams. B. manages to have the hero escape into the mouth of the octopus and to lengthen one of the tentacles to provide yet another escape tunnel.

FIGURE 8-6
The escape tunnel ends in the toothy mouth of a poisonous snake, but B. is not beaten yet. He has the hero remove one of the teeth and use it as a knife that starts to blow up the snake. But according to David the snake is "not through yet" and its tail turns into yet another snake. The hero can only do his best to swim to safety inside the first, dying snake.

FIGURE 8-7
B. adds a friend for our hero (to supply help when needed?) and they swim together through the second snake and are about to reach safety when David counters that "his mouth is almost closed" so B. is forced to cut a doorway through the side of the snake. But once inside the two fearless friends are confronted by David's spikes that sprout on the body of the snake— "really time bombs"—and begin to burn our heroes. At this point, David, ever compassionate and ever inventive, draws a sink, turns on the faucet, and douses the fire. B. ensconces them in protective bubbles that turn into a space ship—"They both get into one and there! they've gotten away" but David will have none of it. *Nuhh, uhh* and a gun appears from the side of the snake to explode the ship. B. concedes that one friend died but the other one got away first by parachute and then, finding his helicopter-blade hat in his pocket, he flies away. David doesn't want the game to end and even as B. sets the hero safely down into his house and asleep in his bed, David insists that the snake "is still alive."

(8-5)

(8-6)

(8-7)

FIGURE 8-8
Sam (age 10) and B., an adult
Sam's Barriers (colored marker and
pen) 6 x 54"

weird person's head and what he does, he goes around the collector. He's called a clear snake; you can see right through him."

Sam's younger brother, Brent, who is drawing across the table, disagrees.

"This one is," retorts Sam. "Listen, Brent, this is my imagination, not yours."

B.'s character turns into plastic man and slithers along the top of the page, thus avoiding the snake. Sam is stumped, but he soon adds "a giant ant mound with a bunch of flying ants that get on his hand—walk all over him." B.'s response is to supply his character with even greater flexibility, sprouting five "anteater tongues" with which he sucks up the ants. (To which Sam's response is, "Yucky, yucky, yucky!")

Sam adds yet another anthill and a "spitting cobra" and a wall that "never stops." As B. attempts to get out of this predicament, Sam adds, "Hold it, you forgot about the wall, OK the wall never stops, you gotta get through the cobra and ants before you can go through the wall—if you have anything to go through the wall with." At this point the verbal assault runs alongside the visual barriers

and Sam reminds B. that he is a formidable opponent. "And also you're too full of ants so you can't eat 'em." Sam watches as B. draws. "What's that?"

"He seems to be getting smaller, doesn't he?"

"Yeah, but you know what? The ants are filling up these cracks." And then, aside, "I'm making it hard for you." But B.'s character becomes a "very small" atomic bomb that blasts the cobra "named Ralph" and heads toward the wall.

Sam is ready with his verbal barrage. "Now the ants—he's too full to eat 'em all. Remember, he can't get through the crack, cause the ants know what he looks like," and giggles with glee to think he may have stumped B. after all.

But B. is undaunted. Turned into a screw, his character screws an opening through the wall, emerges, encounters a mine field, and is blown to bits. The bits ricochet from wall to wall of Sam's shed full of TNT. B. is trying to get Sam to draw figures. He taunts, "The only way you can get this guy is to get somebody as smart as him to take him on: snakes aren't smart enough," and "I think you're going to have to create a

character that has at least the same powers that mine has, otherwise how can you take care of him?"

Sam accepts the challenge. "OK, I'll show you." He hedges still with hills and land mines and buildings but succumbs with a promise of "a motorcycle gang [in case B.'s character should surmount the other barriers] with guns and daggers and brass knuckles." He is finally cajoled into "putting his pencil where his mouth is." He draws a motorcycle. "There's the motorcycle."

"Where's the gang?" B. asks.

Giggle. "Inside the motorcycle—that's the motorcycle gang."

B. treatens to have his character make his getaway on the motorcycle. "I'm glad you left the motorcycle for him. Maybe he couldn't ride it if somebody was on it or something."

Sam tentatively starts to draw a motorcyclist with "shaggy hair, a big nose, and white eyes."

B., seeing that Sam has started his figure too high on the page, asks, "Is he standing behind it or is he on it?"

Sam encounters, "Oh, he's

(8-8)

real short so he's standing on it," and encouraged, draws another. "I'm not done yet," but laughing, "I told you I'm not good at making people, space people, yeah."

B. continues to playfully tease Sam. "Is he standing on his [the first guy's] motorcycle, too?"

Sam laughs, but, "That's not all, behind them is the Muppet gang. Nobody can go through them—Kermit the Frog and all those weirdos." There is a discussion involving Sam's brother, who is not sure that Sam can draw "all them," and B. again teases about men standing on top of motorcycles, but all's fair and "Come on," says Sam, "your

guy has two thousand tongues and eats ants."

And as Sam proceeds, B. gently encourages him. "I thought you couldn't do that, that's better than mine."

Accepting the praise, Sam answers, " 'Cause I'm using your pen." Encouraged, he adds more characters. "He's dancing," and "Miss Piggy—has a dress on," and "and then there's Cookie Monster." Sam has discovered that he really *can* draw people.

The story ends by the bits of B.'s character finally blasting out from the TNT-filled room and plastering themselves to the faces of Sam's gang. When a bit hits Miss Piggy the creature re-

composes, as if kissed by the fairy-tale princess. Sam finally decides the only way to take care of this creature is to create another like it. The final figure is his and it runs to encounter B.'s creature. Perhaps the important thing here is that Sam's figure is running. Not only is he drawing figures, now his figure runs—a first for Sam.

In the getting-into and getting-out-of-difficulty dialogues, each new countermove virtually demands new drawing skills of the players, but because the playing is so much fun the new skills develop almost effortlessly.

Actions and more actions

The drawing conversations presented thus far have been with boys. What do girls do in similar situations? This was the question that we asked ourselves as we began to draw with Holly. Holly who is eight years old, likes to draw—a fact to which the display on the family

refrigerator attests. Holly's drawings are those of a typical eight-year-old girl. She draws flowers and houses, single figures ("Daddy" adorns the refrigerator door), and colorful designs. There was no indication from the drawings that we saw that Holly had ever used any

storytelling or fantasy in her drawings and it was difficult to predict what would happen when she was introduced to the idea. A great many exciting things did happen, not just with Holly, but also with her five-year-old sister Lindsey and Lindsey's friend Jonathan, also

five. When the dialogue acquired "eavesdroppers," in fact, it became so exciting that the only way to convey the richness of this four-way conversation is to describe three drawings at once.

"holly's house and the things that happened around it"

B. asked Holly if she would like to draw something. Holly seemed eager to try although she appeared to be unsure of what was expected of her, and it was certain that she had no story in mind as she carefully drew a table and chair at the very bottom of the page (8-9).

Because there is really no story without characters and because he hoped that Holly would soon initiate some action, B. supplied a character, a boy standing beside the table, and it was Holly's turn. For each of B.'s moves, Holly would cautiously add a detail to the drawing—a hat to a figure; a dish of marshmallows on the table—but it would take several more turns before there was to be any action.

Meanwhile five-year-old Lindsey was busily drawing on her own paper on the other side of the table, with a watchful eye out for the activities of her sister and B., but it wasn't until B. enclosed table, figures, and all

within a frame and Holly added a roof that Lindsey, quickly recognizing the familiar "house" configuration, turned her own paper over and drew a house (8-10).

When Holly answered B.'s next query about what might live in the top of the house by suggesting a dog, B. said that he was "not very good at dogs." As he drew, Lindsey allowed that she could draw a dog but, "I'm not good at it either." She then proceeded to draw a dog in the same part of her house as B. was drawing his. When B. wondered if you might think his dog was a cat, Holly assured that there could be no mistaking its

FIGURE 8-9
Holly (age 8) and B., an adult
Holly's House (colored marker)
13½ x 17"

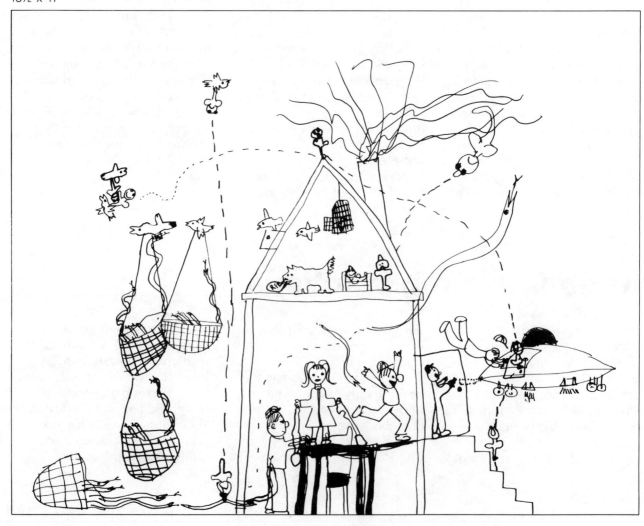

dogness by adding a balloon reading "RFF." So that her dog would resemble B.'s Lindsey then added a curlicue, like Holly's "RFF," coming from the mouth of her dog.

At this point, Lindsey's friend Jonathan had come in, joined the group at the table, and obligingly begun to draw. As B. urged Holly to be "silly" as she drew, Jonathan said that he would make a silly drawing.

Although Holly seemed to be enjoying her participation in the drawing, it wasn't until some time later that things were to begin to happen, but happen they did, and in rapid succession. Birds appeared; they

escaped from cages; they flew into the air carrying baskets; the baskets sprouted snakes (this was Holly's inspired addition); a snake crawled up and bit a bird; the bird dropped the basket of snakes; one snake slithered into the house and bit the boy standing at the table; the boy jumped, ran across the table and out the door, and came face to face with a spaceship complete with Martian.

It is necessary, though difficult, to keep track of what was happening on both sides of the table, because the conversation and interaction were to influence each of the three drawings. Jonathan talked incessantly, ex-

plaining his drawing and his marking, which were surely more kinesthetic than graphic. (Jonathan's drawing quickly became a mass of lines laid one atop another [3-7].) The staccato beat of his pencil and his chatter, however, were to add an infectious note of excitement to the proceedings. His animated questions such as, "What's happening to the snakes?" also triggered some more imaginative responses from Holly, or he would be heard arguing with Lindsey about the merits of a snake's biting somebody.

"They should!" said Jonathan.

"They shouldn't, Jonathan," admonished Lindsey.

FIGURE 8-10
Lindsey (age 5)
Lindsey's Dog House (colored marker) 13½ x 17"

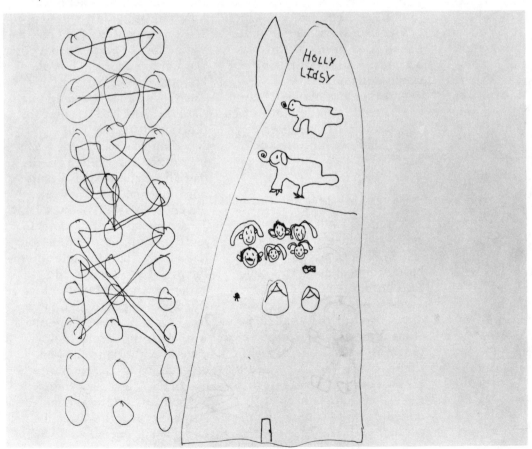

We believe, also, that it was Jonathan's enthusiasm about the "flying saw-saw" that had appeared in Holly's and B.'s drawing and his stated determination to add Martians to his own drawing that caused the appearance of Holly's Martian.

Ideas bounced from one side of the table to the other and fed three separate drawings. The flying saucer had inspired Jonathan to invent Martians and Holly absorbed the idea from him. Jonathan, in turn, wanted a "flying saw-saw" in his drawing, and as the Martian idea bounced back to him upon seeing Holly's man from Mars, he began to chant (because Jonathan's drawing skills are greatly outdistanced by his ability to fantasize, there was little on the paper that was recognizably Martian-like), "There's his nose; there's his mouth!" Lindsey joined in, "I'm going to make a Martian," thus completing the cycle.

The electric mood that sparked the completion of this story can best be conveyed by presenting the dialogue exactly as it occurred.

Jonathan is still talking excitedly about his Martian who, he now says, "has no nose."

B. continues to narrate, as he has done throughout the session in order to keep the story going, "This gets more and more complicated; the Martian has fallen [after having leaped through the air]—what's he fallen on?"

Holly is now primed to expect bizzare situations and is completely involved in the action. She answers brightly, "A snake."

B. asks, "And what does a Martian do when it's fallen on a snake?"

Jonathan pipes up, "It gets bitted!"

The snake makes a truly enormous leap.

"Oh, what a picture!" Lindsey marvels. She has abandoned her own drawing and is now intently watching the action.

B. continues, "And the poor Martian that was on it——"

Jonathan (gleefully) "——got bit!"

B. "He really didn't."

Jonathan (determined) "He should've!"

B. goes on, "He was flying in the air, up into the smoke, he still has an unhappy look on his face—as you can imagine——"

Holly interrupts, "He has a bump on his head." This is a detail she had added earlier and wants to be sure that B. does not leave out.

Lindsey (eagerly) "He got bitten."

B. "so there he is flying away from the snakes …"

Jonathan is explaining that the Martian in *his* picture was bitten by a snake (if no one else would oblige).

And then B.'s Martian "says he's so terribly tired, finds a bed and, closing his eyes, goes to sleep. Shall we have that be the end?"

Holly agrees.

"the lion and the bats"

The story of Holly's house had ended but the excitement lingered on. Another story was begun immediately. This time the plan was that Holly, Lindsey, and B., at least, would draw together. Jonathan, unsure of his drawing abilities, declined to join in at first but, as we shall see, was finally enticed by his own curiosity and imagination to participate in the unfolding adventure on the paper across the table.

It was another example of the residual effect of "Holly's

House" that the drawing that Jonathan began on his own was to start with a bird carrying snakes in a basket. Jonathan says that his "bird is going to be in trouble—this is a copperhead snake and he's going to bite him." He is still determined that somebody will be bitten by a snake one way or another.

Jonathan makes a biting sound. "Oh, poor, poor bird."

It is hard to concentrate on one's own story with Jonathan being so impellingly vocal. "Supersnake to the rescue!" he shouts, and then, as the snakes attack the house, "Charge!"

"The Lion and the Bats," being drawn by Holly, Lindsey, and B., also contained suggestions of the earlier effort (8-11). Lindsey began by drawing a house; Holly's first suggestion that a snake lived there, however, was gently sidestepped. The birdcage that Holly had invented for the earlier production was enlarged for the lion she had just drawn. She perhaps was certain that B. would free the lion as he had the bird (he did). And it is here that Jonathan was lured into taking part in the story; after all, there had already been a snake story, and what imaginative five-year-old could resist a runaway lion? Jonathan was, by this time, intently examining the situation and already had the solution to the problem—a bat would swoop down and bite the lion. Of course! "I'm going to draw a bat!" Jonathan began to draw a wing and was surprised and pleased with the result—his other drawings, as we have noted, had been very complex scribbles with few recognizable elements. "Hey, I drawed a good wing." He is encouraged with praise from all.

"It's the best wing you've ever

FIGURE 8-11
Holly (age 8) Lindsey (age 5)
Jonathan (age 5) and B., an adult
Bats (colored marker) 13½ x 17"

made!" Holly marvels. He continues to draw. "He has a spear [it is actually a large front tooth … sound effects]—he's going to kill the lion." Truly encouraged by this time, Jonathan draws another bat swooping down on the lion—and still another bat, "good bats because the lion is bad … sharp teeth." He is really wound up now. He counts, "One, two, three, four, five—five bats."

B. determines that, in spite of the digressions, something has to be done about the poor lion. "Is he dead or is he just wounded?"

"He's wounded bad," Jonathan replies.

B. says that what happens is that the bats say to the lion (who wasn't a bad sort after all), "I'm sorry."

"They just wanted to keep him quiet," Jonathan pipes in.

B. says that the bats will carry him away to the hospital.

Jonathan says, "There's lots of bats" (enough to carry the lion). Jonathan is making baby bats now, all sizes of bats. "I'll count the bats—four, five, six, seven, eight, nine bats."

B. counts ten bats.

Holly thinks there are eleven but counts again. There are ten.

Lindsey adds a fire to the hospital "just to keep him warm."

"Okay," says B. "let's decide. Does the lion get better?"

All agree, and the story ends on a happy note.

Of the important aspects of the drawing conversation, "the ten bats of Jonathan" is of special interest. Jonathan is a bright, imaginative, and energetic five-year-old. His ability to tell stories and to fantasize is great, but Jonathan does not

customarily draw. A conversation with his mother revealed that, although his older sister, Amy, draws continually, Jonathan generally refuses to participate in any drawing activity. The fact that he consented to draw with us, became caught up in the excitement, and on his own, produced ten bats then becomes more significant.

Let us examine the circumstances of his bat production.

Jonathan had come to play with Lindsey and found her and Holly drawing at the table with a couple of unfamiliar adults. They all seemed to be enjoying themselves, so when he was invited to join in, he accepted. He readily became part of the group; his first declaration as he prepared to draw was, "I'll make a silly one [drawing]," and he found the making fun. As we have noted, Jonathan's participation was at first more verbal than pictorial; he was timid about drawing and often asked for help. When he was drawing his bird (the one that was carrying a basket of snakes)

he enlisted B.'s aid; and B. patiently drew for him, "like a circle, and then another circle on the head, and then a big beak and an eye—and then they have wings like that and other wings down there and sometimes they have feet going down below the wings." A short time later he was drawing "eight, nine [ten] bats."

Perhaps Jonathan's drawing ability will eventually catch up to his ability to narrate, to fantasize, to verbalize. It is possible that it will catch up quickly and that he will develop a more positive attitude toward his own drawings given the open acceptance of his limited ability that was present in the drawing dialogues—encouragement such as Holly's "It's the best wing you've ever made!"—and demonstrations like those of B.'s of simple ways in which to give form to his more complex fantasies.

It is important to note again that it was also the excitement of the interaction in the drawing session that served as the impetus for Jonathan's participation,

the way in which ideas bounced across the table and found their way into each of the several drawings produced that afternoon.

The first idea, that a drawing could tell a story, seemed natural to Jonathan, but Holly and Lindsey were also titillated by the notion (and we know that Holly continued to draw "silly" stories with her friend Amy after we had left). Snakes and Martians ricocheted from drawing to drawing and the bullets with which Jonathan was bombarding his "flying saw-saw" became, for Lindsey, a pattern of small circles with interconnecting lines on the side of her paper. Lindsey's ability to reproduce almost anything she saw drawn proved extraordinary and Jonathan's enthusiasm and imagination certainly added to the excitement of each drawing; if he was not contributing a part of the drawn story then he was animating the story verbally.

It is certain that learning of the most enjoyable kind was shared by all that afternoon.

Making machines

Many of the dialogues that we suggest derive from the spontaneous drawings of children. In these drawings we have seen elaborate machines shown in the process of manufacturing such things as ink, automobiles and human body parts ready to be assembled into bionic people. Whenever possible, it is advantageous to begin a dialogue with the ideas commonly used by children in spontaneous

drawing as in fantasy games such as the Jelly Bean Factory (Chapter 7).

A "machine making" dialogue might begin with a short discussion of machines, what they look like, and what the machine is to manufacture. Or it is possible just to begin with a machine, because the machines themselves sometimes "tell" their creators what sorts of things they might make. This is

precisely what happened in a dialogue held with six-year-old David.

"the peanut butter machine" (8-12)

David sat as we talked about machines and described a hay baler we had seen, a machine that picks up cut hay, bales it and ejects the bales through a chute to a trailer in the rear. This was a new game to him but he entered into it with as

FIGURE 8-12
David (age 5) and B., an adult
The Peanut Butter Machine (colored
marker) 12 x 12"

much enthusiasm and invention as he had the games of pure action.

B. suggested wheels.

David immediately drew a box with wheels and added two flywheels with a pulley to the box (indicating that he understood the nature of machines).

B. drew a pipe from which small pellets dropped into a bin.

David quickly extended the pipe from beneath the bin and carried it to another box-shaped area and on up the side of the page and back across the middle with a sweep to the upper left-hand corner, just above his starting point. He then proceeded to add the pellets going through his length of pipe (and might have continued filling the page except that B. decided that he wanted his turn).

B.'s controls were drawn on the second boxlike part that David had constructed and then more controls cropped up in other spots, while David obligingly added the men to handle the controls.

At this point B. stopped and asked, "What are we making?"

David thought (but not for long), picked up on the pellet shapes, and said, "They could be nuts"—and quickly, "We could be making peanut butter."

From there the machine took off almost on its own, David and B. working together to smash the peanuts—B.'s smasher, a wheat-grinding mechanism with grinding wheels, David's a device that resembled two plates that come together like cymbals.

Salt and sugar were added

through additional devices. The finished peanut butter was poured into jars that traveled on a conveyor belt across the bottom of the page, up the right-hand side, and across the top to a machine that placed the jars into boxes and finally loaded them onto a truck (David pictured a sort of forklift for this part of the operation).

Dialogues of this sort provide particularly rich opportunities for problem-solving because of the requirement to invent machine parts that could conceivably perform a particular process or that could convey a product from one section of the machine to another. Machine making is also an excellent means for developing ideas about cause and effect and processes.

Worldmaking

As we have already said, one way in which the child develops his ideas about the realities is through the creation of a coherent world, or at least a fair portion of a world. Such worlds sometimes take the form of a map; sometimes a panorama or terrain reveals the existence of worlds above the ground and of worlds below, and frequently both at once.

The conversation of the *Worldmaking* game may be quite different in tone from that of the *Getting into and Getting out of Difficulty* game. In the *Difficulty* game, one participant waits while the other either makes a move or counters one. The waiting is essential. In worldmaking, the drawing by two or more participants usually occurs simultaneously, although it is by

no means a matter of everyone for himself. There is in the *Worldmaking* game a continual consulting about what goes next to what, where things ought to be attached, the form things should take and what happens and what happens next.

"the solar-powered system" (8-13)

This drawing conversation had three participants, two ten-year-old boys, Sam and Bobby, and B., an adult. Earlier, Sam's mother had shown us a drawing by Sam and Bobby that appeared to us to be an X-ray view of the prow of a huge aircraft carrier with compartment upon compartment for sleeping, with tunnels and airshafts. We were corrected by Sam and Bobby, however, who told us that it was actually the inside of a moun-

tain. And so the contour of a mountain was the starting place for "the solar-powered system." B. started by drawing hilly contours near the top of the page in order to assure that much of the world would appear underground. Sam's line, continuing on the second half of the paper, described a deep ravine climbing to a steep cliff, assuring for his part that the world would appear above the ground as well.

As with most worlds, the world that developed is far too complex to be described easily. The idea for a world with solar power was Sam's. "You know how there is an energy crisis and all? Let's say this thing is solar powered." But it was Bobby who was responsible for most of the solar power collec-

FIGURE 8-13
Sam (age 10) Bobby N. (age 10) and
B., an adult
The Solar-Powered System (colored
marker and pen) 17 x 27"

tors, underground power substations, power lines and transformers, and vehicles whizzing through tunnels. Sam specialized in rocket ships, their elaborately detailed interiors, and cavernous underground warehouses for storing rocket parts. B. was the gadfly, adding elevators to Bobby's substations, helping Sam with some of his rocket ship components, and spending a good deal of time on the distant city seen floating in midair on the left-hand side of the drawing.

The world took on highly realistic characteristics and an implicit logic controlled its structure. It was Sam who decided that this was to be a working place and that people were to return to the city for sleeping purposes, but since they did need to eat, under-

ground caverns for growing food as well as restaurants were created. An air of seriousness characterized this drawing session until at the very end, when people began falling down shafts and were then obliged to climb all the way back to the top.

And what are some of the things learned from the conversation? There was a good deal of sharing of technical drawing information. Sam had already learned from Bobby the method of depicting things in three-dimensional form. Here, Sam and Bobby both learned that, in drawings, tunnels, shafts, and power lines can pass in front of and behind one another. They had previously thought of drawings as one dimensional and that an object, once encountered, could only be

circumvented, so that Bobby was disturbed when he discovered an elevator shaft in the path of his power lines. Only when he was reminded that the lines could go behind the shaft was he once again happily drawing. B. learned from Bobby the way to draw jets in a contemporary way and watched as Sam reproduced almost exactly the World War II planes that B. had drawn when he was Sam's and Bobby's age. "My father used to draw those real kookie planes." When B. was asked, "Where did you learn to draw that [the city]?" he explained that he had remembered the illustrations drawn by the Austrian artist, Schmögner, for a book called *The City*.[3] So Sam and Bobby learned, too, that it is permissible and acceptable to borrow ideas.

"just space"

As the solar-powered system was nearing completion Sam asked if next time "couldn't we do a drawing showing 'just space?'" The promise was made and a few days later "just space" was begun by Sam and B. (Bobby wasn't able to join in on this particular day.) Like the ones started by Holly and B., this drawing too became a "parent"; Sam's younger brother Brent and his friend Doug, seeing what was happening, made their own space drawing—one that grew to twice the size of Sam's and B.'s drawing.

At its inception, this exchange could not have been called a dialogue. Instead it involved two people each deeply engrossed in his own drawing, creating "good guys' battle ships—it's more like an aircraft carrier" and "bad guys' fighter ships" (8-14). Although Sam kept up a running commentary, describing his part of the action, neither artist displayed more than a mild curiosity about the activity of the other. Rather than any sort of dialogue, at this point it was more a "collective monologue."

As Sam worked on the right side and B. on the left, the page began to be covered with the elements that are necessary before a story can emerge, bringing, as it did so, the individual drawings closer together. Sam and B. used the created elements, good guys and bad, to cooperatively bring the story into being. The earlier concentrated silences became filled with talk about what will happen to what spaceship and what can and can't be done, until Sam interjects, "We've gotta stop talking." Between them Sam and B. had been verbally

working out the narrative possibilities; now Sam had indicated that it was time to start drawing again. And now they consult with one another as they draw:

B. Look, are these rockets going to be shot off down here?

Sam You can shoot some off and blow up these two ships.

B. Good idea. Good close range.

Sam (laughs) No, I think that's wasted missiles.

B. Well, I wasted one. Maybe it was a misfire but (sound effects of explosions).

Sam the fire reaches that one——

B. and it goes——

Sam (giggles) and then it reaches that one——

B. And then it goes—and then——

Sam This one escapes just in time.

It had become a true dialogue, graphic and verbal, and Sam ensured the coherence of the effort by "joining all the forces" in the drawing "like in World War II."

In the meantime, Sam's six-year-old brother, Brent, is drawing a story of his own on the other side of the table and has allotted one page each to "space" and "underwater" (8-15). The conversation often includes Brent and his story and Sam stops every once in a while to check out what is happening across the table. Brent's friend Doug has joined the activity and as the drawing expands, Brent's horizons expand as well; he adds a sheet of paper for "underground" and another for "undermountains" and even goes so far as to suggest that Sam and B. join their sheets

FIGURE 8-14
Sam (age 10) and B., an adult
Just Space (colored marker and pen)
17 x 27"

FIGURE 8-15
Brent R. (age 6) and Doug (age 8) and M., an adult
Just Space II (colored marker)
27 x 34"

with his. The conversation continues to pass from one side of the table to the other; fleets of ships that had been originated by Sam found their way into Brent's and Doug's drawing. Sam's "ooie, blooie" is softly echoed in an "ooie, blooie" from Brent's side of the table. And when Sam attempts to add a bit of destruction to his brother's drawing, Brent offers, "Hey Sam, you're so stupid; that's the good guys." Again the participation has proceeded from interest, to verbal suggestion, to graphic interjection.

When the game between Sam and B. ends and Sam declares, *We won* with a banner across the page, Brent quietly adds, *We're* winning so far—look at all these good guys."

A feature worth noting about the two drawings is the formations of spaceships—Sam's triangular formation on the right and B.'s curved linear formations on the left (8-14). When Brent saw how B.'s formations were appearing to get closer and closer, his response was "Stop"; they had come close enough! But there was another type of response to the formations; Brent and Doug gave indications of taking aesthetic pleasure from the formations and soon they had created their own formation that encompassed most of the lower right-hand quarter of their drawing (8-15).

(8-14)

(8-15)

FIGURE 8-16
Steven (age 8) and M., an adult
Football Bird (pencil) 13¾ x 33¾"

Eight-year-old Steven loved to draw. He drew football players, cut them out, and placed them on a football field. His drawings, especially those drawn in the post Super Bowl atmosphere, were minimally stories—a missed pass, a tackle, a touchdown that could not yet be projected to include a field goal.

Steven said he couldn't "tell" a story but he could draw another of his football vignettes. The story that was generated by Steven as he drew with M, however, was as far removed from this as it could be.

M: I don't know that much about football, so we'll just have to make up what happens on this very strange football field. OK? You start the drawing any way you want and then I'll draw—like a conversation.

It was not surprising that Steven drew one of his helmeted football players stiffly grasping a football. The figure was placed on the right-hand edge of

the page, so the story proceeds from right to left.

M: (Draws the same football player—checking with Steven to make sure all the details are correct) He's running so fast that he's off the ground—so you can see his cleats he's so far off the ground. (Proceeds to describe, as she draws, the way the figure is drawn to show the action of running) And something's going to happen—because he's running so fast.

Steven: (Intrigued) he's gonna trip!

M: He's not watching and there's something on the ground (explains that a careless fan has thrown a banana peel onto the field) OK, now you have to show what happens. (Steven's player becomes much more animated this time; his arms fly in the air as his foot makes contact with the banana peel and the ball flies out of his hand.)

M: (draws the player as he somersaults head over heels, arms spread wide, while Steven, getting into the action, makes suggestions) And now do you know what's going to happen to the football? (Steven guesses, but he can't possibly anticipate the en-

trance of a football-player bird "who has this football helmet on")

Steven: Oh! It's a make-believe story!

M: (draws the bird with huge wings and football pants as it grabs the ball in its huge claws. A second sheet of paper is added to the first to make more room for the action to unfold.) Now what are you going to do?

Steven: (getting into the spirit—after all, it *is* a make-believe story) I guess I'll make a tree. (Steven has the bird fly the ball to his nest in the tree. He draws the tree—with a lake beside it. Out of the side of the tree grows a branch and on the branch sits the bird's nest with four eggs in it.) A playful verbal exchange continues throughout the drawing activity. There is a discussion about what might happen if the bird sat on the football and hatched it. M. asks "what would come out—a little pig or a little football player?" Steven opts for a little football player. He is starting to get used to the idea of an adult with such strange notions.

M: Oh, oh, what is that?

Steven: It's a king cobra.

M: The king cobra can't get up the tree, can he? (Steven believes he can climb and he adds a few branches to the tree for good measure).

M: Now it's my turn. Well, you've left me with a lake—and a cobra—and a bird's nest—and a tree.

Steven: (Gleefully) And a bird with a football!

M: Wonders what will happen next and Steven, by now ready for anything, is full of helpful suggestions. He reminds her that the snake is after the eggs.

M: Well, there was this guy (and just to make sure the king cobra has no trouble getting to the nest) he left his ladder against the tree when he was picking apples. (The snake climbs the ladder and coils himself up in the nest)

And now what's going to happen?

Steven is happy to have his turn—this is getting interesting. He says that the bird is frightened by the snake so he flies away with the football and drops it in the lake.

M: But then he won't have it either!

Steven: But he has friends! (and sure enough, he draws a frog on a lily pad next to the lake—and he says "Rivet"—while the snake, not to be robbed of the football, follows the bird. Suddenly a shark appears in the lake. Steven explains that the lake was next to the ocean "and there was a storm and it broke the dam")

M: Now what's going to happen? (But Steven has relinquished the narrative for now, although he is quite willing to suggest ways in which the story might proceed and to bring the story up to date: "The frog saw the ball going down—and so did the shark") (The ball is drawn falling down and down and as it falls it goes faster and its gets longer and skinnier and it goes "kachoom" as it hits the shark "like a bullet" and the shark jumps out of the water and flips up and ... "Steven's turn!")

Steven: He got mad! (he redraws the shark—mad; the bird flies down and—with more than a little glee) it's your turn!

M: complains playfully that Steven always leaves her with these problems. (It is obvious at this point that Steven

can not only create problems but he is quite able to solve them. The game has gained importance, though, and it has become a matter of who can present whom with an insurmountable problem.) M. takes Steven's challenge to "draw one thing and then give it to me." She adds impact lines indicating that the bird and the shark have crashed. Steven has the bird narrowly avoid the snake as he does a backward somersault and he gets so dizzy—he sees stars—the helmet falls off and the bird "got his regular head back" and the bird drops the helmet—it really wasn't his—he took someone else's helmet ... he thought he could play a game of football and the football bounced back into the first page. And we'd better end this or it could go on forever. Actually, Steven is stumped.

M: And then there's this other guy and he's jumping up.

Steven: Intercepted!

M: He catches the ball as it comes down and runs for a touchdown.

Steven: And next time you start and I'll finish the story!

FIGURE 8-17
Philip (age 6) and M., an adult
The Race (colored marker) 11 x 27¼"
This dialogue between Philip and an adult took place three months after Philip's first stories (6-3–6-6). Before the dialogue began there had been a discussion of figures running (Chapter 3) so that what follows is a continuation of that exchange.

M: Start with a little boy and a little girl. Think about the story—do you know what they're going to be doing?

Philip: They're having a race (he adds a sign and asks the spelling of "start") S-T-A-R-T period!

M: Now there's a man ... and he's standing over here.

Philip: I know what you're going to do with the man. You're going to make him hold a gun and it goes "pow." (The drawing of the referee is very close to the best of Philip's own figures. He adds some black scribbles and a bit of red flame coming from the gun—to graphically indicate that it has been shot off to start the race.)

M: Here is the ground and there's this big rock.

Philip: quickly points out the error of that move. His runners were proceeding down the page rather than across the page. Because he was not yet ready for a profile view, his figures were shown as if seen from above. He then proceeds to redraw the ground line with the proper orientation.

Philip: Now here comes the biiiiig rock—they're already trippin'—ohh—the boy's gonna trip right to here—and the girl falls down, too.

M: Are they going to help each other to get up, or what?

Philip: They can get up their selves (but he looks again at his drawing) ... but not without they have arms (and Philip adds arms to his figures, but not until he has gotten down on the floor and demonstrated just how hard it would be for him to get back up without using his arms.)

M: The boy is running very fast.

Philip: Are you going to make the boy win?

M: Here is the girl.

Philip: She's way behind (but she is sad. Philip guesses she is sad because the boy has gotten so far ahead) but she isn't running. (The girl has hurt her knee.)

M: Do you think the boy will feel sorry and go back and help the girl?

Philip: Bring her a bandaid. (He draws the boy as he turns to go back to the girl. This figure is drawn perpendicular to the others—still from a bird's-eye view.)

The boy and girl are both running together and they are smiling and holding hands.

Philip is pleased with this turn of events (he adds a finish line—again asks for the spelling and writes "F-I-N-I-S-H" and places between the clasped hands of the girl and boy ... a trophy. They have both won the race.

In the drawing "Holly's House and the Things That Happened around It" we described how Martians and flying saucers flew from one drawing to another; in this session it was fleets of ships and aircraft drawn in a particular way that traversed the two drawings. Just as ideas feed other ideas, drawings feed other drawings, adding richness upon richness to one drawing and another. It is these things that make drawing dialogues with children so important a part of their drawing development.

Variations. Here is a list of ideas for dialogues, some of which we have already tried with children and others that we will try when we get the opportunity.

A Funny Person. One player draws a body part such as a head and the next player adds the next part and so on. The drawings may be serious or silly; usually they turn out to be silly. There is nothing that says that the figures in drawings can't have three heads and nine legs.
This game may be varied endlessly by starting with a part of a house, an animal, a car, a plant, a toy, etc.

Opposites. You draw the biggest thing you can think of and I will draw the smallest thing I can think of. I will draw the skinniest person in the world and you may draw the fattest. You draw the worst person in the world and I will draw the best. In this game one player may leave it to the other to decide what the opposite will be, or each player may specify what the other should draw. Either way learning takes place.
Changing Costumes. In this game one player draws a character dressed in a costume. The

other player draws the same character dressed in a different costume, and so on. The costumes seem to become more elaborate and outrageous as the game progresses.

The drawing conversations that we have described in this chapter help to illustrate most of what this book has been about:

• that children learn to draw more skillfully through practice
• that children may learn to draw images that are more varied and exciting and stimulating by adapting and recombining images that are modeled after those of others
• that drawings can tell complex stories—what happens and what happens next?
• that drawings may be "real" or fanciful; that one's imagination often leads to new and exciting insights and ideas
• that drawings may deal with major life themes and the four realities: the *common*—the reality that we all share in common; the *archeological*—the reality of the self; the *normative*—the reality of right and wrong; and the *prophetic*—what will be? What may the future reality hold?

• that entire worlds can be envisioned and created on a single sheet of paper.

FIGURE 8-18
Jeff and Chris (grade 5)
Scroll (black marker) 18" x 25'
This is only one small segment of a 25-foot scroll produced in one evening by two fifth-grade boys working side by side. Their fantastic world of humorous creatures plays with shapes and spaces between shapes as they continuously stretch, compress, and combine both ideas and images. Since both are at the same level of drawing development, growth occurs through the challenges presented through the continual interplay of images.

chapter nine

Individual differences

In this book we have charted the general nature and course of the child's innate and cultural development in drawing. We have shown the ways in which the child's internal biases and the influences of the culture, of graphic models from the media—television, comics, and cinema—interact to determine the nature of children's images. We have described the many spaces and places and modes in which individual children choose to create and to recreate their own visions and versions of the four realities—of the familiar, the self, of the shoulds and oughts, the future. The children whose drawings illustrate the book have one important thing in common—the pleasure and satisfaction that they derive from the act of drawing. The differences, on the other hand, as well as the individual graphic needs of these children, are as many as there are children themselves. These unique children range from those with average graphic abilities to those whom we would identify as artistically gifted. For some, drawing has become a magic door to knowledge about themselves and about the world, and for others, a magic carpet to other strange and wonderful worlds. Some children will obtain all the benefits that their abilities and exploration will allow, and then move on to other symbol systems—to fulfill themselves through music, drama, poetry or literature—while other children will continue to hone and perfect their skills and become adult artists in the tradition of a Maurice Sendak or a Pablo Picasso. In this chapter we will outline some of the specific differences found among the drawings of gifted, average, and slow learning boys and girls. An awareness of these differences should help adults to respond sensitively to children in terms of their individual requirements.

The artistically gifted

Artistic giftedness is not easily defined; indeed, it is not just one thing, nor does it subsume one standard set of characteristics. Nevertheless, as a group, the artistically gifted children that we have studied have possessed the following characteristics:

• Strong need to be intellectually stimulated, or a dread of intellectual boredom. The seeking of stimulation or the escape from boredom frequently leads to the need to create other realities through drawing.
• Awe at the magic of their own ability to give visual form both to the known and to the-until-then-unknown with pencil and paper.
• Ability to depict, with competency and accuracy, characters and characterizations, settings and actions, dimensionality, shading, and space—usually years ahead of most of their peers.
• Unusual visual memory that enables them to remember in vivid and accurate detail the contents of pictures and objects of their own daily perceptions.
• Early ability to masterfully mimic the styles, contents and techniques of the drawings,

paintings and illustrations of adult artists.
• Active imagination and the ability to combine fluently and inventively images and ideas from diverse sources and to synthesize them into new totalities.
• Preference (at times) for drawing and other symbolic activities to firsthand encounters with people and objects in the world.
• Extraordinary ability to solve graphic problems such as ways to depict objects in new positions, and from different points of view by extending and altering their current patterns of drawing.
• Personal agenda of skill development to which pages filled with endless variations of objects, positions, and actions give evidence.
• Early realization of their own artistic ability, often accompanied by the decision to be an artist.
• Strong sense of visual order and a sensitivity to the tensions of visual disorder.
• Unusual awareness of sensory qualities and the aesthetic outcomes of artistic techniques.

The most artistically gifted children possess almost all of

these characteristics. Less gifted but still unusual children possess some of them—sometimes to an exceeding degree. Some children may indeed be graphically gifted—in the depiction of objects, in rendering or in producing extraordinarily realistic reproductions—while lacking, for example, the visual memory or the ability to combine and incorporate images in new and imaginative ways.

And how should a parent or teacher work with an artistically gifted child? The program set forth in this book serves the gifted as well as the average and slow learning child. The gifted child will, of course, be able to accomplish the activities set forth at an earlier age and more easily than most. We suggest that after the age of nine or so children who are really advanced and interested in developing their drawing skills be given good instructional drawing books—those usually intended for adults and art students.[1] Finally, if it is possible, introduce the gifted child to an adult artist who is willing to share insights, ideas, and techniques, and to serve in other ways as a model and mentor.

The slow learner

Except for a few brain-damaged children who have been found to possess extraordinary graphic gifts,[2] most children who are generally slow to learn are also less advanced in their drawing development. Their drawings

typically contain fewer culturally influenced characteristics and are thus more strongly in the grip of the innately derived factors lined in Chapter 3. For these children a program of

drawing, sensitively conducted, can lead to general cognitive development as well as graphic development. Such a program might contain the following characteristics:

• Lots of specified drawing (i.e., "draw a person". "Where is the mouth?" "You forgot the hair." "Can you draw the fingers?"
• Simple narratives in which the adult assists with the "what happens, and what happens next." For example: "Draw a dog—where could the dog go?" or "Draw the house that the dog goes in." "Now put the dog in the house." "What could frighten the dog?" "What does the dog do then?" With this kind of careful guidance through a narrative as the child draws, the child practices such things as making relationships and previewing the possibilities, for example, of cause and effect.
• You and the child might carefully examine many illustrations and actual objects, pointing out their characteristics as you do.

Then invite the child to draw the objects, with patient reminders of the things that may have been omitted.

The slow-learning child's production of tangible visual symbols provides a unique opportunity for discussion between adult and child, leading to the expansion of the child's comprehension of the four realities.

Boys and girls

As nearly as we can determine the drawings of the very youngest boys and girls contain no differences. But as children grow older the drawings and drawing behaviors of boys and girls form distinct patterns. It is difficult to say whether or not these graphic differences are partially determined by genetic differences; it is, however, easy to point to cultural factors that encourage different kinds of drawings. In the United States, for example, boys' drawings contain a profusion of violence, of villainy, and vehicles; girls' drawings are full of benign animals, bugs, and blooms. The boys' drawings seem to stem from media action narratives, pictures, and memories of automobiles and other vehicles,

space-oriented science fiction, as well as the actual space program—still almost exclusively male domains.

Our observation of patterns of drawing behavior is that many more boys than girls are high producers of spontaneous drawings. These spontaneous drawings, as we have already said, have a strong narrative flavor—often serving to tell a story or at least a part of a story. Girls, too, narrate through their drawings. The cultural graphic narrative models such as comic books, however—even with female superheroes—are directed toward, consumed, and finally modeled by boys. In other words, it seems to us that male-oriented, highly stimulating, action-filled graphic

narratives encourage more boys than girls to produce drawings. It has been noted by Brian Sutton-Smith that boys' verbal stories, as well, are subject to more influence from television than are girls' stories.[3] Because boys are more influenced by the media, the realities that they reinvent are often richer, more complex, and more dynamic than are those of girls. We believe, however, that both boys and girls may expand their visions and versions of the realities through the graphic narrative and the graphic dialogue, and that in following the drawing programs we have outlined in this book they may increase their drawing vocabularies, their imaginations, and their abilities to narrate.

Notes

chapter one

1. The "collective monologue" was characterized by Piaget as a monologue during which another person is present but is expected neither to attend to nor to understand what is being said. Howard Gruber and J. Jacques Voneche, *The Essential Piaget* (New York: Basic Books, 1977), pp. 69, 70.

2. On Picasso's acquisition through drawing see John Berger, *The Success and Failure of Picasso* (Harmondsworth, Middlesex, Eng.: Penguin Books, 1965), p. 3.

3. We have talked about Kelly and Michael L. in Brent Wilson and Marjorie Wilson, "Visual Narrative and the Artistically Gifted," *The Gifted Child Quarterly* 20, no. 4: (Winter, 1976), 432–47; and in "Children's Story Drawings: Reinventing Worlds," *School Arts* 78, No. 8 (April 1979): 6–11. We have also written more about Kelly's drawing in "An Iconoclastic View of the Imagery Sources in the Drawings of Young People," *Art Education* 30, No. 1 (Jan. 1977): 5–12.

4. The Boston reminiscences are those of Marjorie Wilson.

5. C. S. Lewis's descriptions of his early drawing activities are found in *Surprised by Joy* (New York: Harcourt, Brace and World, 1955).

6. On Nadia see Lorna Selfe, *Nadia: A Case of Extraordinary Drawing Ability in an Autistic Child* (London: Academic Press, 1977).

7. School Zone, Inc. is located at P. O. Box 603, Corrales, N. M. 87048; (505) 898–6795.

8. On one such accumulation of a child's prized drawings see Sylvia Fein, *Heidi's Horse* (Pleasant Hill, Calif.: Exelrod Press, 1976).

9. See Maurice Sendak, *Where the Wild Things Are* (New York: Harper & Row, 1963).

10. Maurice Sendak speaks of his fantasy life in Justin Wintle and Emma Fisher, *The Pied Pipers: Interviews with the Influential Creators of Children's Literature* (London: Paddlington Press, 1974), p. 223.

chapter two

1. A description of Dirk's "Mr And and the Change Bugs" is found in our "Children's Story Drawings."

2. Hans and Shulamith Kreitler fully explore the four realities in Chapter 15, "Cognitive Orientation and Art," in *Psychology of the Arts* (Durham, N.C.: Duke University Press, 1972), pp. 325–58.

3. Piaget's statement is from "Some Aspects of Operations," in Maria W.

Piers, ed. *Play and Development* (New York: Norton, 1972), p. 27.

4. Erik Erikson's theories of play are set forth in *Toys and Reasons* (New York: Norton, 1977), p. 44.

5. Erikson speaks of ideal and evil roles in *Toys and Reasons*, p. 101.

6. Robert Ornstein presents this idea about the role of stories in his introduction to Idries Shah's writing on "The Sufis," in *The Nature of Human Consciousness* (San Francisco: W. H. Freeman, 1973), p. 274.

7. The Wilsons have written about Tami in "Reinventing Worlds."

8. Ornstein, *The Nature*, 1973, p. 274.

9. Mercer Mayer, *There's a Nightmare in My Closet* (New York: Dial, 1968).

chapter three

1. An account of Franz Cizek's discovery of child art is given by Wilhelm Viola, *Child Art and Franz Cizek* (Vienna: Austrian Junior Red Cross, 1936).

2. On uninfluenced tadpole figures see Dale B. Harris, "The Case Method in Art Education," in *Observation*, a report on preconference education research training program for descriptive research in art education, National Art Education Association (Jan., 1971): 29–49.

3. The tadpole person is discussed by Rudolf Arnheim in *Art and Visual Perception: The New Version* (Berkeley: University of California Press, 1974), ch. 4.

4. The innatist position is perhaps best exemplified by Rhoda Kellogg, *Analyzing Children's Art* (Palo Alto, Calif: Mayfield Publishing Co., 1970).

5. Viktor Lowenfeld declared, "Never let a child copy anything.... Don't impose your own images on a child." *Creative and Mental Growth*, 3rd ed. (New York: Macmillan, 1957), pp. 14–15.

6. Breyne Moskowitz discusses the child's process of language acquisition in "The Acquisition of Language," *Scientific American* 239, no. 5 (Nov. 1978): 92–108.

7. Even in Rhoda Kellogg's samples of cross-cultural drawings in which she purports to be illustrating the universal nature of children's drawings, it is possible to see distinct cultural differences. See the inside front cover of *Analyzing Children's Art*.

8. On what we have chosen to name the *simplicity principle*, see Arnheim, *Art and Visual Perception*, pp. 179–82.

9. Figures 3-1, 3-2; 3-4–3-6; 3-8–3-18; 3-20–3-26; 3-28–3-35; 3-37–3-39; and 3-42 have either been traced or drawn from original drawings of young children.

10. On perpendicularity see Jean Piaget and Bärbel Inhelder, *The Child's Conception of Space* (London: Routledge & Kegan Paul, 1956), ch. 13. Henry Schaefer-Simmern writes of the greatest contrast of the direction of lines in *The Unfolding of Artistic Activity* (Berkeley: University of California Press, 1948), p. 13.

11. On "To Each Its Own Space" see Jacqueline Goodnow, *Children Drawing* (Cambridge, Mass.: Harvard University Press, 1977), pp. 11, 34.

12. For illustrations and discussion on Filling-the-Format see Fein, *Heidi's Horse*, pp. 25–28. Also Goodnow, *Children Drawing*, p. 58.

13. Picasso's painting *Three Dancers* is reproduced in H. W. Janson, *History of Art* (Englewood Cliffs, N.J.: Prentice-Hall, 1963), colorplate 75.

14. On conservation and multiple application see Goodnow, *Children Drawing*, p. 141 and Arnheim, *Art and Visual Perception*, p. 177.

15. On intellectual realism see G.H. Luquet, *Le Dessin Enfantin* (Paris: Alcan, 1927).

16. For Lowenfeld's views on "disproportion" see *Creative and Mental Growth*, pp. 135–38.

17. Grandma Moses was a woman who in her eighties and nineties gained celebrity in the 1950s with her detailed but unschooled and unsophisticated childlike paintings of rural scenes.

18. On the importance of the interaction between mother and baby in the acquisition of language, see Jerome Bruner, "Learning the Mother Tongue," *Human Nature* 1, No. 9 (Sept. 1978): 42–49.

19. Kellogg has catalogued children's scribbles extensively (*Analyzing Children's Art*). Claire Golomb's work with children's scribble behaviors is more insightful: *Young Children's Sculpture and Drawing* (Cambridge, Mass.: Harvard University Press, 1974).

20. On romancing see Golomb, *Young Children's Sculpture*, p. 4.

21. Golomb notes that Rhoda Kellogg's own tabulation of preschool incidence of mandala and sun schema reports only 1.6 to 9.6 percent for the mandala "and an even more limited range of 2–4 percent for the sun-schema." In "Representation and Reality: The Origins and Determinants of Young Children's Drawings," paper presented at the Symposium for Research in Art: Representation and Metaphor. University of Illionis, Urbana-Champaign, October 1980.

22. On global man see Golomb, *Young Children's Sculpture*, pp. 14–24.

23. On Freeman's research see "How Young Children Try to Plan Drawings," George Butterworth, *The Child's Representation of the World*, (New York and London: Plenum Press, 1977), pp. 3–29.

24. On developing a body between the two parallel lines of the legs see Golomb, *Young Children's Sculpture*, p. 40.

25. On the all-embracing line see Goodnow, *Children Drawing*, p. 37.

chapter four

1. We are indebted to June McFee for first making us aware of the role of culture in children's art. McFee, June King. *Preparation for Art.* San Francisco: Wadsworth, 1961.

2. On the two-eyed profile see Marjorie Wilson and Brent Wilson, "The Case of the Disappearing Two-Eyed Profile: Or How Little Children Influence the Drawings of Little Children." Proceedings of the National Symposium for Research, University of Illinois, Urbana-Champaign, October 1980.

3. Figures in 4-1, 4-6, and 4-7 have been either traced or redrawn from the original.

4. For an account and reproductions of Picasso's early drawings see Juan-Eduardo Cirlot, *Picasso: Birth*

of a Genius (New York and Washington: Praeger, 1972).

5. On Beardsley's early drawing activity see Brigid Brophy, *Beardsley and His World* (New York: Harmony Books, 1976), p. 29.

6. On the early art activities of Millais see Raymond Watkinson, *Pre-Raphaelite Art and Design* (Greenwich, Conn.: New York Graphic Society, 1970), p. 44.

7. Maurice Sendak speaks of his early influences in Jonathan Cott, *Forever Young* (New York: Random House, 1977), p. 195.

8. On the running-person exercise see *Design and Drawing Skills*, Denver, Col.: National Assessment of Educational Progress, (June 1977), ch. 4.

9. On Burne Hogarth's fantastic figure drawings see Hogarth, *Dynamic Figure Drawing* (New York: Watson-Guptill Publications, 1970).

10. For more about the inventions of John Scott see Brent Wilson and Marjorie Wilson, "Beyond Marvelous: Conventions and Inventions in John Scott's *Gemini*" *School Arts* 80, No. 2 (Oct. 1980): 20–26.

chapter five

1. On Picasso's pigeons and persons see J.E. Cirlot, *Birth of a Genius*, 13; 197–205.

2. On Anthony see the Wilsons' "Iconoclastic View" and "Artistic Giftedness" and Howard Gardner, *Artful Scribbles* (New York: Basic Books, 1980), pp. 170, 171.

3. On Picasso's sketches for *Guernica* see Rudolf Arnheim, *Picasso's Guernica: The Genesis of a Painting* (Berkeley & Los Angeles: University of California Press, 1962).

4. Claire Golomb found that when scribblers were given a specific task they were able to draw more regular scribbles: "Representation and Reality."

5. David Hockney has illustrated this theme from Rumpelstiltskin in four frames in *Six Fairy Tales from the Brothers Grimm* (Petersburg Press, 1969); (New York: Abrams, 1976).

6. For a comparison of paintings of storms at sea by Winslow Homer and John Marin see John Canady,

Mainstreams of Modern Art (New York: Simon and Schuster, 1959), pp. 444, 445.

7. Paul Cezanne's *Mont Sainte-Victoire* is seen in H.H. Arnason, *History of Modern Art, Painting, Sculpture, Architecture* (New York: Abrams, 1968), colorplate 16.

8. The "Great Wave" can be seen in Hokusai (Prague: Artia), p. 108.

9. On "Fog" see Carl Sandburg, *Chicago Poems* (New York: Holt, 1916).

10. Rousseau's *Sleeping Gypsy* is seen in Arnason, *Modern Art*, colorplate 117.

11. Boccioni's *The City Rises* is seen in Arnason, *Modern Art*, colorplate 87.

12. On some animation techniques see, e.g., Yvonne Andersen, Make Your Own Animated Movies (Boston: Little, Brown, 1970). See also Eadward Muybridge, *The Human Figure in Motion* (New York: Dover, 1955) and *Animals in Motion* (New York: Dover, 1957).

13. One of Georgia O'Keefe's enormously enlarged flower paintings, *Black Iris*, may be seen in Arnason, *Modern Art*, plate 667.

chapter six

1. Brian Sutton-Smith explains the two-year-old's story as an acquisition of the terminal (beginning and end) markers in "A Sociolinguistic Approach to Ludic Action," *Handlungentheorien Interdisziplinar*, ed. Hans Lenk (Karlsruhe:, Universität Karlsruhe, 1977), pp. 239–50.

2. On storytakers, see Brian Sutton-Smith, *Folkstories of Children* (Philadelphia: University of Pennsylvania Press, 1980).

3. On visual narrative see Brent Wilson and Marjorie Wilson, *Reinventing Worlds*, *School Arts* 78, No. 8 (April 1979): 6–11.

4. On Bruno Bettelheim's view of fairy tales see *The Uses of Enchantment* (New York: Alfred A. Knopf, 1975).

5. Brian Sutton-Smith's characterization of children's verbal stories appears in *Folkstories*.

6. On the singer of tales see Albert B. Lord, *Singer of Tales* (New York: Atheneum, 1976).

7. On the mythology of ads see

Pierre Maranda's introduction to *Mythology*, ed. Pierre Maranda (Harmondsworth, Middlesex, Eng.: Penguin Books Ltd., 1972), pp. 7–18.

8. On the dyads of villainy/villainy nullified and lack/lack liquidated see Vladimir Propp, *The Morphology of the Folktale* (Austin and London: University of Texas Press, 1977).

9. Herman Hesse's story "The City" is found in Hesse, *Stories of Five Decades*, trans. R. Manheim and D. Lindley (Toronto and New York: Bantam, 1974), p. 193.

10. These narrative instructions have been used by the Wilsons to collect stories from children in the United States and countries around the world—Australia, Egypt, Finland, and New Guinea. Stories are now also being collected from Brazil, China, Jordan, and Nigeria.

chapter seven

1. On Jerome Singer's fantasy experiences see *The Inner World of Daydreaming* (New York: Harper & Row, 1975), p. 18.

2. On imaginative as opposed to unimaginative children see Dorothy Singer and Jerome L. Singer, *Partners in Play: A Step by Step Guide to Imaginative Play in Children* (New York: Harper & Row, Publishers, 1977) also in Brian Sutton-Smith, ed., *Play and Learning* (New York: Gardner 1979).

3. On children's imagination and imagination games see Richard de Mille, *Put Your Mother on the Ceiling* (New York: Penguin Books, 1976).

4. On Leonardo's imaginary animal see Pamela Taylor, *The Notebooks of Leonardo da Vinci* (New York: New American Library of World Literature, 1960), p. 63.

5. *Space Visitors* was adapted from a lesson devised by Evelyn Pender of Tallahassee, Florida, an art teacher and master's degree student at the Florida State University.

6. On the mythical world called Middle Earth see J.R.R. Tolkien, *The Lord of the Rings* (New York: Ballantine Books, 1978).

7. On the mythical land of Narnia see C.S. Lewis, *Chronicles of Narnia* (New York: Collier Books, 1977).

chapter eight

1. See Bruner, "Learning the Mother Tongue."

2. The story of the boy who learned to communicate using *Amislan* was related by Moscowitz "The Acquisition of Language."

3. Brent Wilson's version of the city derived from Walter Schmögner's pictorial version of *Die Stadt* by Hermann Hesse (Frankfurt: Insel Verlag, 1977).

chapter nine

1. Books we have suggested for gifted children in order to expand and extend their graphic abilities include books on anatomy, e.g., George Bridgman, *Complete Guide to Drawing from Life* (New York: Weathervane Books, 1978) and drawing the figure in action, e.g., Burne Hogarth, *Dynamic Figure Drawing* (New York: Watson-Guptill; 1970) and references such as Muybridge, *Human Figure in Motion; Animals in Motion*.

2. On an unusually gifted autistic child see *Nadia*.

3. On the influence of television on the stories of boys see Sutton-Smith, *Folkstories*.

Bibliography

The route of drawing development outlined in this book is one of interaction between the child's innate propensities and those influences from outside the child. Of all the outside influences the most potent are the graphic—drawings, illustration, painting, and photography. We have said that it is best to allow children to seek their own sources, as, indeed, many of the children in this book have done, and to make available resources such as picture encyclopedias and dictionaries that contain images from which the child might derive necessary graphic information. There remains the question, however, of more explicit "how to draw" books and

one might ask, "Should the child or young person be allowed or encouraged to use these 'how to draw' books?"

Our answer is a qualified "yes"—on two counts. The first qualification is that these books should be offered when and if the child indicates an interest and a desire for this kind of assistance. Secondly, the books should be carefully selected. We have tried to provide a starting point here with our own selections from a great number of these books. Although many that we examined teach children to draw employing narrow, idiosyncratic and rigid schemata, others employ means that are general and flexible.

Our belief is that there is essentially no distinction between good "how to draw" books written for adults and those written for children. Both can prove useful to the child who is anxious for this type of instruction. Thus, most of the books in the following list have been written primarily for adults but may be presented to some children by age nine or ten and to most interested young people by the age of twelve.

Ames, Lee J. *Draw 50 Dinosaurs*. New York: Doubleday & Company, Inc., 1977.
———. *Draw 50 Airplanes, Aircraft and Spacecraft*. New York: Doubleday & Company, Inc., 1977.

———. *Draw 50 Boats, Ships, Trucks and Trains.* New York: Doubleday & Company, Inc., 1977.

In these books a former Walt Disney animator describes a step-by-step, easy to follow approach to drawing. They provide children with the basic perspective of machines, aircraft, etc., as well as the form of animals. Although the figures are somewhat rigid, they deal with basic structure and may allow individuals to invent and embellish.

BRIDGMAN, GEORGE B. *Bridgman's Complete Guide to Drawing From Life.* New York: Weathervane Books, 1978.

When it comes to drawing figures in the robust style of Michelangelo, Bridgman has no equal. His sense of anatomy and figures in action is superb.

CALDER, ALEXANDER and LIEDL, CHARLES. *Animal Sketching* (6th ed.). Pelham, N.Y.: Bridgman Publishers, Inc., 1941. Also: New York: Dover Publications, Inc., 1973.

This little book is an excellent demonstration of Calder's facility and ability to reduce form and action to a few exquisite lines. Recommended for older children.

CALDERON, W. FRANK. *Animal Painting and Anatomy.* New York: Dover Publications, Inc., 1975.

This Dover reprint of the original 1936 text is excellent, showing the relationship between the successful drawing of animals and their anatomical construction. Highly recommended for older children with a strong interest in drawing animals.

EDWARDS, BETTY. *Drawing on the Right Side of the Brain.* Los Angeles: J. P. Tarcher, Inc., 1979.

Although based on highly questionable assumptions about the role of the hemispheres of the brain in drawing development, this popular book does provide

a rudimentary drawing program. It also includes useful exercises such as working from drawings that have been placed upside down.

HOGARTH, BURNE. *Dynamic Figure Drawing.* New York: Watson-Guptill Publications, 1970.

———. *Drawing Dynamic Hands.* New York: Watson-Guptill Publications, 1977.

———. *Drawing the Human Head.* New York: Watson-Guptill Publications, 1965.

The reader of these books benefits from the many years during which Burne Hogarth drew the adventures of "Tarzan." His facile drawings and knowledge of anatomical detail make these books a dynamic resource.

LEE, STAN and BUSCEMA, JOHN. *How to Draw Comics the Marvel Way.* New York: Simon and Schuster, 1977.

This book is for every young person who dreams of glory as an artist in the Marvel Comics tradition. No ordinary cartooning book, but a serious look at a serious art form.

LESLIE, CLARE WALKER. *Nature Drawing: A Tool for Learning.* Englewood Cliffs, N.J.: Prentice-Hall, Inc., 1980.

A book for learning about nature as well as techniques of drawing. Many illustrations, including drawings of animals that appeal to young artists.

MUYBRIDGE, EADWEARD. *The Human Figure in Motion.* New York: Dover Publications, 1955.

———. *Animals in Motion.* New York: Dover Publications, 1957.

These photographic studies of figures and animals in motion are the result of Maybridge's pioneering technique whereby a battery of cameras capture a sequence of movements, often from several vantage points. Invaluable for those who would understand the ways in which humans and animals move.

RICE, DON, ED. *Fishes, Reptiles and Amphibians.* New York: Van Nostrand Reinhold, 1981.

———. *Animals.* New York: Van Nostrand Reinhold, 1979.

———. *Birds.* New York: Van Nostrand Reinhold, 1980.

These books consist entirely of 19th-century engravings of animals. The highly detailed plates provide superb and accurate reference material for artists of all ages.

SIMMONS, SEYMOUR III, WINER, MARC S. A. *Drawing: The Creative Process.* Englewood Cliffs, N.J.: Prentice-Hall, Inc., 1977.

This comprehensive book presents the basic elements of drawing, including perspective, composition, the anatomy of the human figure, portraits, animal drawing, and numerous techniques. Includes many fine illustrations.

SIMON, HOWARD. *Techniques of Drawing.* New York: Dover Publications, Inc., 1972.

The drawing lessons in this book are based on the problems that artists—from Leonardo to Rembrandt to Picasso—have had to solve.

ZAIDENBERG, ARTHUR. *How to Draw Wild Animals.* New York: Abelard-Schuman, 1958.

———. *How to Draw Birds, Fish & Reptiles.* New York: Abelard-Schumann, 1962.

———. *How to Draw Dogs, Cats and Horses.* New York: Abelard-Schumann, 1959.

Zaidenberg's books are produced specifically for children, although they may be utilized by adults as well. His plans for drawing animals based on the circle as the underlying structural element are simple to follow and general enough to allow for subsequent invention on the part of the artist.

Index

A

Action, 59, 61, 70–71, 83, 93–96, 102, 158
 running, 59, 93–94, 156
Animals, 86–87, 123–25
 imaginary, 127–28
Art (*see also* Child Art; School Art; Spontaneous Art):
 as a means of coming to know, 22
 as mirror, 28
 in the culture, 64, 66–73
Artists:
 as models, 66
 borrow images, 66, 76, 77
 comic-book artists (*see also* Comics), 78

B

Bettelheim, Bruno, 102
Boredom, 16–17, 36
Borrowing (*see* Copying)

C

Characters (*see also* Drawing Development; Human Figure), 107, 110, 117
Child Art, xv, xvi, 39, 61
Circles:
 as design, 50–51, 53
 as person (*see also* Tadpole Figure, Global Figure), 54–55
 multiple application, 45, 46
Cizek, Franz, 39
Comics (*see also* Artists; Media), 67, 70, 71, 73, 77–79, 101, 111, 117
Contrast:
 child's natural preference for (*see also* Innate Principles), 41, 42
Conventions (*see also* Comics; Media), 76, 77–79
 sound effects, 109
Copying, 63, 66, 76
Creativity (*see also* Invention), 77–79
Cultural Influence (*see also* Influence; Media), 63–79

D

de Mille, Richard, 120–21
Death:
 as theme (*see also* Story Drawings), 36
Designs (*see also* Circles; Drawing Development), 53–54
Drawing:
 and imagination, 120
 as concrete, 3, 4, 36
 as flexible, 36
 from actual objects, 96–99
 functions of, 4, 23–37
 games (*see also* Drawing Games; Imagination Games), 85–96
 how children learn (*see also* Language) 40, 48, 63–79
 in settings, 96–97
 talking with children about, 36, 49–61
Drawing Abilities, 161–63
 gifted, 162
 sexual differences, 163
 slow learner, 162–63